INVESTIGATING CULT TV

Series Editor: Stacey Abbott

The **Investigating Cult TV** series is a fresh forum for discussion and debate about the changing nature of cult television. It sets out to reconsider cult television and its intricate networks of fandom by inviting authors to rethink how cult TV is conceived, produced, programmed, and consumed. It will also challenge traditional distinctions between cult and quality television.

Offering an accessible path through the intricacies and pleasures of cult TV, the books in this series will interest scholars, students, and fans alike. They will include close studies of individual contemporary television shows. They will also reconsider genres at the heart of cult programming such as science fiction, horror, and fantasy, as well as genres like teen TV, animation, and reality TV when these have strong claims to cult status. Books will also examine themes or trends that are key to the past, present, and future of cult television.

Published and forthcoming in **Investigating Cult TV** series:

The Cult TV Book edited by Stacey Abbott
Dexter: *Investigating Cutting Edge Television* edited by Douglas L. Howard
Investigating Alias edited by Stacey Abbott and Simon Brown
Investigating Charmed edited by Karin Beeler and Stan Beeler
Investigating Farscape by Jes Battis
Love and Monsters: *The* Doctor Who *Experience, 1979 to the Present* by Miles Booy
Torchwood Declassified: *Investigating Mainstream Cult Television* edited by Rebecca Williams
TV Horror: *Investigating the Darker Side of the Small Screen* edited by Lorna Jowett and Stacey Abbott

Ideas and submissions for **Investigating Cult TV** to
s.abbott@roehampton.ac.uk
philippabrewster@gmail.com

TORCHWOOD
DECLASSIFIED

INVESTIGATING MAINSTREAM CULT TELEVISION

EDITED BY
REBECCA WILLIAMS

I.B. TAURIS

LONDON · NEW YORK

Published in 2013 by I.B.Tauris & Co Ltd
6 Salem Road, London W2 4BU
175 Fifth Avenue, New York NY 10010
www.ibtauris.com

Distributed in the United States and Canada
Exclusively by Palgrave Macmillan
175 Fifth Avenue, New York NY 10010

ISBN: 978 1 78076 177 0 (HB)
 978 1 78076 178 7 (PB)

A full CIP record for this book is available from the British Library
A full CIP record is available from the Library of Congress

Library of Congress Catalog Card Number: available

Printed and bound in Great Britain by T.J. International, Padstow, Cornwall

CONTENTS

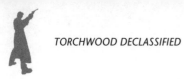

ACKNOWLEDGEMENTS

M any people have been instrumental in seeing this collection through to completion. Philippa Brewster and Stacey Abbott at I.B.Tauris have been supportive and encouraging from the project's inception. Their help and backing has been invaluable.

The contributors have also produced interesting and exciting chapters, and have been a pleasure to work with. My thanks therefore to Ross P. Garner, Gareth James, Matt Hills, Benjamin W.L. Derhy, Stacey Abbott, Karen Lury, Rosanne Welch, Martin Griffin, Stephen Lacey, Lindsay Bryde, Jeanette Vermeulen and Craig Haslop. I hope that they are all as pleased with the final product as I am.

Extra thanks must also go to Matt Hills for his encouragement throughout the process of completing the book and his support over the course of my doctoral research and beyond. I am also indebted to my colleagues at the University of Glamorgan for their support of the symposium that was the origin of this collection, and my work on this project. Thanks, therefore, to Ruth McElroy, Huw Jones, Steve Blandford, Stephen Lacey and Caitriona Noonan for their encouragement along the way. I'd also like to thank all of those who presented at or attended the 'Investigating Torchwood' symposium for their lively debates and interesting thoughts on the show.

I'd like to thank those who have supported me, from both inside and outside academia. Thanks therefore to Inger-Lise Kalviknes

Bore, Nasheli Jimenze-del-val, Lucy Bennett, Bertha Chin, Stacy Lynch, Emma Cooke, Beth Setters, Rachel Pugh and Katie Hicks.

My family have been endlessly supportive and I thank Mum, Dad and Gareth from the bottom of my heart. Finally, deepest thanks to Ross for the discussion and debate, the cups of tea and pretty much everything else in-between.

NOTES ON CONTRIBUTORS

Stacey Abbott is Reader in Film and Television Studies at Roehampton University where she teaches courses on world cinema, film genres, the history of animation and the modern vampire in film and television. She is the author of *Celluloid Vampires* (2007), *Angel: TV Milestone* (2009) and TV *Horror* (2013). She is the editor and co-editor of *TV Goes to Hell: An Unofficial Road Map of Supernatural* (2011), *The Cult TV Book* (2010), *Investigating Alias: Secrets and Spies* (2007) and *Reading Angel: The TV Spin-off With a Soul* (2005). She is also the General Editor for the *Investigating Cult TV* series at I.B.Tauris. She has had the good fortune to have been able to write about a number of her favourite television shows including *Buffy the Vampire Slayer, Dark Shadows, Firefly, Lost, True Blood* and *Ultraviolet.*

Lindsay Bryde is a dramatist, professor, critic, blogger and life-long Who-vian (Tennant is her Doctor). She completed an MFA in Creative Writing – Dramatic Writing at Adelphi University and an MA in English at Fredonia State University. She is a member of the adjunct faculty at Adelphi University and an online teaching assistant with Ashford University. She has presented for Fordham University ('Art of Outrage'), Pop Culture Association of the South and New England American Studies Association. Recently Lindsay Bryde co-chaired her first seminar at the annual conference held by the Northeast Modern Language Association. Her one-act plays *Isobel, I Wish You Well, Music for the Pain* and *The Naked Man* were

produced by Fredonia State University's Department of Theatre & Dance. She spent a nine-show season as a carpenter with the Tony-award winning Williamstown Theatre Festival. Her film reviews and fashion advice columns can been found at The Examiner.com, FlashlightWorthy.com, *Entertainment This Week* and her blog harleyquinn386.blogspot.com. Follow Lindsay Bryde on Twitter @ harleyquinn386.

Benjamin W.L. Derhy is part-time Lecturer at Paris West University (formerly Paris X Nanterre), where he also conducted a distance learning project supervised by the head of Faculty. His teaching currently focuses on *Film & Television, Critical Writing, New Media, Communication and Sociology*. He also lectures at Paris School of Business, where he teaches Marketing at MBA level, most notably Consumer Behaviour as applied to Arts & Culture. Derhy is con-currently doing a PhD at the School of Film, Television and Media Studies of the University of East Anglia, where he was recently appointed co-organiser of the Film & Television Research Seminar Series. His thesis explores the discourses of 'success' within the transatlantic anglophone television industry. Derhy also holds experience in promotional, political and institutional communica-tion. Recent academic writings include papers on BBC and HBO's branding strategies, enduring and widespread fandom, the use of fan-pages in politics and the role of social media in fan activities. His research interests include audience research, cult/mainstream, fandom, industrial sociology, international distribution, interpre-tive organizational research, production research, social media and transmedia.

Ross P. Garner is Lecturer in Media and Cultural Studies in the School of Journalism, Media and Cultural Studies at Cardiff University. He completed his PhD on discourses of nostalgia in post-2005 British time-travel television dramas and has contributed to forthcoming edited collections on *Doctor Who* for I.B.Tauris. His primary research interests concern fictional television and forms of nostalgia.

Martin Griffin is Associate Professor in the Department of English at the University of Tennessee, Knoxville. His 2009 book *Ashes of the Mind: War and Memory in Northern Literature, 1865–1900* examines

the role played by the politics of memorialisation in the work of American writers after the Civil War. His current project is *Once Upon a Time in a Globalized World*, a jointly authored (with Constance Devereaux) study of the significance of narrative for policy decisions and their consequences, especially in respect of globalisation, transnationalism and cultural exchange. He is also editing a collection of essays entitled *American Political Fictions*, a survey of the interplay of literary genres and American political ideas from the Puritans to the contemporary era.

Craig Haslop gained his MA, and is now close to completing his doctoral research investigating sexuality in *Torchwood* through audience research, at the University of Sussex. He is a visiting lecturer at Brunel University teaching Gender and Sexuality in the Screen Media department and also an associate tutor teaching undergraduate modules TV: Fictions and Entertainments and Questioning the Media. His research interests include queer audience studies, sexual and gender representation in film and television and the relations between sexuality and cult TV.

Matt Hills is Professor of Film and TV Studies at Aberystwyth University. The author of five books, including *Fan Cultures* (2002) and *Triumph of a Time Lord* (2010), Matt has published widely on cult media and fandom. Recent work includes chapters on the BBC TV series *Sherlock*, representations of *Twilight* fans, *Doctor Who*'s paratexts, cult stardom, and fans' re-readings of *Inception*. Matt is currently working on a book-length study of *Torchwood* for I.B.Tauris.

Gareth James completed his PhD in 2011 at the University of Exeter. His thesis explored the institutional history of Home Box Office, paying particular attention to how the American cable network's early history affects its current branding and programming strategies. The thesis was primarily concerned with questions of television and media history. His current research interests are in American film and television history, with a focus on producing revised institutional accounts of key companies. This research explores in particular connections between media history, forms of industrial practice and production cultures, as well as the development of marketing and branding strategies. Other research interests include American

independent cinema, horror cinema, film exhibition, theme parks, convergence studies, and the history and current practices of the BBC. He has published encyclopedia articles on American independent cinema, particularly films and genre cycles, and has contributed to student textbooks covering the basic features of the sector. In addition, he has published articles online dealing with gender and *Buffy the Vampire Slayer*, and the failure of feature film *Southland Tales* as a transmedia franchise. His forthcoming publications include an analysis of horror studio After Dark Films, a study of the relationship between theme park design and the film authorship of Clive Barker, and contributions for an encyclopedia on Scottish cinema.

Stephen Lacey is Professor of Drama, Film and Television in the Cardiff School of Creative and Cultural Industries at the University of Glamorgan. He has published widely on post-war British theatre and television drama, including *Tony Garnett* (2006) and *Cathy Come Home* (2010). He is co-investigator on a major AHRC-funded project, 'Spaces of Television: Production, Site and Style' and was co-researcher on 'Screening the Nation: Landmark Television in Wales' for the BBC Trust and Audience Council Wales (2009–2010). He is a founding editor of *Critical Studies in Television*.

Karen Lury is Professor of Film and Television Studies in the School of Culture and Creative Arts at the University of Glasgow, Scotland. She has published widely in film and television studies investigating programmes and media as diverse as *CSI*, children's television, popular music and amateur film. Her most recent monograph, *The Child in Film: Tears, Fears and Fairytales*, was in 2010 published by I.B.Tauris. She is currently working on an AHRC-funded project, 'Children and Amateur Media in Scotland'. She is an editor of the film and television studies journal, *Screen*.

Jeannette Vermeulen majored in writing and cultural studies in the Faculty of Arts and Social Sciences at the University of Technology, Sydney. She completed an honours thesis analysing the role of social media on personal identity and human experience, as well as gaining a Master of Creative Writing at the same institute. She has a keen scholarly interest in the psychology of subcultures and specialised activities, with particular regards to its effect on personal

expression and identity formation, and intends to undertake a PhD to further explore these issues.

Rosanne Welch began teaching One-Hour Television Writing, Story Structure and Critical Studies in Television at California State University, Fullerton after a career as a television writer/producer with credits including FOX's original *Beverly Hills 90210* and CBS's Emmy-winning *Picket Fences* and six years as a writer/producer on the top-rated TV drama *Touched by an Angel*. In 1998 she researched, wrote and co-produced a two-part special documentary for ABC NEWS/ Nightline entitled *Bill Clinton and the Boys Nation Class of 1963*. As a member of the Editorial Advisory Board for *Written By Magazine: The Magazine of the Writers Guild of America, West* Welch has interviewed writers and show-runners including Shawn Ryan, Kenny Johnson, Stephen J. Cannell and Russell T. Davies. Her essay 'When White Boys Write Black: A Comparison of Race Representation on *Doctor Who* during the Tenure of two Different Writer-Producers' appears in *Doctor Who and Race: An Anthology* (2013). She is the author of *The Encyclopedia of Women in Aviation and Space* and has been published in *The Journal of Screenwriting*. She earned her PhD from Claremont Graduate University in California with a dissertation on the work of married screenwriter couples in Hollywood from the 1930s to the 1960s which covered Frances and Albert Hackett (*The Thin Man*), Ruth Gordon and Garson Kanin (*Adam's Rib*) and Dorothy Parker and Alan Campbell (*A Star Is Born*).

Rebecca Williams is Lecturer in Communication, Cultural and Media Studies at the University of South Wales. She has written on *Torchwood,* horror and place for *Critical Studies in Television* and about female fans of David Tennant in the edited collection *British Science-Fiction Film & Television* (2010). She has also published on television more broadly in journals such as *Popular Communication, Participations, Continuum, Television & New Media* and *Media History*. She recently worked on a BBC Audience Council project examining the links between production and reception of *Doctor Who* and *Torchwood* in Wales. Her current research projects include celebrity in small nations, fan responses to the ends of television series, and the representations of place and history in television horror.

INTRODUCTION

Torchwood: Bridging the Mainstream/Cult Rift

Rebecca Williams

Torchwood, the first spin-off from the long-running series *Doctor Who* (which ran on BBC1 between 1963 and 1989 and from 2005 onwards), has attracted large audiences and a loyal fan base since its first airing in 2006 on the UK digital channel BBC3. Its first episodes attracted the channel's highest-ever ratings and its popularity saw its second series aired on BBC2. The third series 'Children of Earth' was promoted to prime time on BBC1 where it was screened across five consecutive evenings, attracting an average audience of 6 million viewers. Its fourth and, at the time of writing, final series was a BBC Worldwide co-production with the US network Starz and this series, subtitled 'Miracle Day', was aired in 2011. Its global reach, however, had been cemented earlier in its run since its first series proved to be an enormous international success for the BBC, screened in Korea, Japan, Italy, Spain, Israel, Australasia, Russia and across Latin America. Much academic attention has focused on *Torchwood*'s parent show *Doctor Who* in both its classic and contemporary forms.[1] This book seeks to expand on this work as well as contributing to emerging studies of *Torchwood* such as Andrew Ireland's *Illuminating Torchwood*[2] and analysis of the show's use of the horror genre and its representations of Wales.[3] Debates over 'cult' remain central to the concerns of this book, as part of a series on cult television, allowing us to analyse *Torchwood*

in its own right but also in relation to our broader understandings of cult TV. These include issues of representation, audience and fan responses, and institutional contexts since, as the meanings and understandings of cult television shift, we must 'consider how the evolving broadcast and communications landscape of the past fifty years has affected cult TV and its audiences'.[4]

Torchwood's cult status is contestable for a range of reasons, many of which will be explored in this book. There are numerous aspects of the show which construct it as a cult text, including its generic premise as a science-fiction/fantasy show, its loyal fan base and its positioning and marketing by producers and networks. As this book will explore, however, cult television is not a fixed category and has been subject to technological, industry and marketing shifts in recent years. One of the key developments in theorising about cult TV has been the blurring of the boundaries between cult and mainstream shows. It has been widely acknowledged that 'there's a common notion that "cult" is anti-mainstream, existing outside the supposed parameters of mainstream culture and entertainment'.[5] However, some scholars have considered 'the notion of "main-stream cult" TV shows, designed to reach a wide range of audiences and intended to be read fannishly as well as less closely'.[6] It is within this context that *Torchwood*'s status as cult/mainstream must be examined. This is especially pertinent given the show's trajectory across channels and production contexts, moving from the niche of BBC3 towards the prime time BBC1 slot of 'Children of Earth' and beyond into an international co-production for 'Miracle Day'. Such movement complicates our understanding of *Torchwood* as a cult text, forcing consideration of how the target audiences and brand-ing of these various channels might reposition *Torchwood*'s 'cult-ness'. *Torchwood*'s complex status as a cult/mainstream TV show is a theme that is thus threaded throughout the collection.

The first part of the book examines the institutional aspects of *Torchwood*, considering production contexts, branding and multi-platforming. Given the show's somewhat complex production his-tory and its movement from niche to mainstream status, this part seeks to explore *Torchwood* and its position as a cult show. Indeed, its origins as a spin-off from *Doctor Who* affect how we consider it as a cult text since it is a programme which both invokes and limits intertextuality with its parent text, but is also one which can be

perceived as explicitly constructed to hail a cult audience.[7] This part pays attention to such issues and also examines the institutional and production contexts that have shaped the show. Considering its move from the niche digital channel BBC3 to BBC2 and then to 'event television' status as a flagship drama on BBC1, these chapters consider the impact of this upon its cult status. Furthermore, its most recent incarnation as an international, global television production informs much of the discussion in this part, allowing consideration of the programme's position within the international landscape of television.

Ross P. Garner's chapter opens this part by exploring *Torchwood*'s beginnings as a BBC-produced spin-off. Although its genesis as a spin-off from *Doctor Who* is well documented, it has yet to be fully explored in academic studies of the show. Garner's chapter attempts to address this by considering the strategies employed by the BBC to both link the show to, and distance it from, its parent show. In considering the 'intertextual barricades' put in place to prevent *Doctor Who*'s child audiences from watching the series, Garner offers a broader understanding of the spin-off within the contemporary television landscape of TVIII. The chapter also situates discussions of *Torchwood* within the context of the varying requirements of different BBC channels and its position as a public service broadcaster. Gareth James's chapter continues within the context of *Torchwood*'s status as a product of public service broadcasting, examining its relationship with the wider production and distribution context of BBC Worldwide. With particular focus on the show's export to the United States, James maps out the history of the BBC's transatlantic branding to consider *Torchwood* as an example of BBC America's brand identity as 'cool but high quality'. In exploring the international dimensions of *Torchwood*, James argues that the show has played a crucial role in the BBC's shifting relationship with the US television market that both builds on and distinguishes itself from the marketing of its parent show *Doctor Who*. Benjamin W.L. Derhy moves on to explore how the fourth series of *Torchwood*, 'Miracle Day', offered potential for synthesis between the show and established US-based cult TV writers such as Jane Espenson (of *Buffy the Vampire Slayer, Angel* and *Firefly*) and John Shiban (from *The X-Files*). This chapter examines how this attempt to construct cult status in a new context of transatlantic co-production failed to fully work.

In examining online fan responses to the perceived failures of 'Miracle Day' Derhy's chapter explores the limits to deliberate 'cultishness' of texts when loyal audiences respond negatively to changes to programmes. The final chapter in this part, Matt Hills' exploration of tie-ins such as comics and radio episodes, considers the branding and merchandising potential of cult shows such as *Torchwood*. Drawing on Henry Jenkins' concept of 'transmedia storytelling',[8] Hills examines the show's non-television texts by considering audio books and novels. Arguing against the idea that transmedia refers only to digital materials, Hills considers the importance of both new and old media to tie-ins. His chapter also explores the possibilities of, and limits to, continuing *Torchwood*'s narrative world outside of the television series, exploring how these offer the opportunity to explore past narrative periods (such as being set in The Hub after it is destroyed in the TV series) or characters and their relationships.

The second part changes focus to examine *Torchwood* in terms of its aesthetics and televisuality. Karen Lury's chapter on empire and archives focuses on the third series 'Children of Earth' to explore the representations of the British Empire in *Torchwood*. Emphasising the use of sound in the series, Lury considers the links between the loss of Empire and the loss of childhood in 'Children of Earth', offering a reading of the show that moves beyond simply reading it as 'cult' towards a more nuanced textual analysis. Martin Griffin and Rosanne Welch's chapter continues the analysis of 'Children of Earth' through consideration of the representation of the government and the family in the series. This chapter suggests that 'Children of Earth' is characterised by competing representations of authority. Like Lury's linkage of British Empire with representations of children, Griffin and Welch jointly explore depictions of military or governmental authority and parental authority. Drawing on an exclusive interview with Russell T. Davies, the chapter somewhat polemically posits that 'Children of Earth's conclusion presents a dramatic failure in its use of the death of a child as a narrative device and that this can be linked to the series' move from niche channels towards the more mainstream BBC1. The final chapter in this part, Stacey Abbott's discussion of horror and monstrosity in *Torchwood*, offers an analysis of the show's position as a TV horror text. Abbott suggests that the 'everything changes' of series 1 and 2 voiceover is a change in how humanity and monstrosity is considered, and how

the confines and boundaries of the body are broken down. Drawing on a wider re-valuation of horror as a valid television genre, Abbott argues that *Torchwood*'s depictions of violations of established boundaries such as life and death, or human and monster offers a complex blurring of the lines between cult and horror genres.

Cult television has rarely been considered in relation to place and location outside of discussions of fan 'pilgrimage' to places of importance.[9] However, the book's third part explores the relationship between place and *Torchwood*'s production and representation, as well as its links to discourses of local stardom and celebrity. It considers the linkage between *Torchwood* and issues of space, place and location which have been seen as important, given *Torchwood*'s production history (as a BBC Cymru Wales production) and its representations of Wales and Welsh characters. Indeed the Welshness (or otherwise) of the programme continued to influence press reporting even during the fourth series 'Miracle Day', which split its action between Wales and Los Angeles. For example, executive producer Julie Gardner suggested that Wales would still feature heavily:

> The Welsh setting still features in a really significant way as we move forwards so when we start filming in January, we will start filming in Wales.... There will be beautiful landscapes. Gwen Cooper [Eve Myles] is still that character. She's still Welsh. Her story will take place in the US but also very much in the UK, so that flavour of Wales will be very apparent.[10]

Furthermore, creator Russell T. Davies insisted that,

> The story now leaves Cardiff... but in the same breath, it never leaves Cardiff, or south Wales. The Welsh story threads through the ten episodes and, of course, wherever you are in the world we've got Gwen Cooper there, played by Eve Myles, and her husband Rhys, played by Kai Owen. You've got Gwen's Mum and Dad, played by two fine Welsh actors ... so Wales never leaves the show. It can travel anywhere. It can go to Washington, it's going to Los Angeles, it's going to go to Buenos Aires but no matter what happens it's still fundamentally Welsh, right at its heart.[11]

The importance of Wales as a location is explored in Stephen Lacey's chapter which takes as its starting point John Barrowman's famous

claim that 'When you see Cardiff on film, it looks like LA'. Drawing on textual analysis and empirical audience research, Lacey's chapter considers the interplay between space, genre and realism in *Torchwood*. In considering the relationship between *Torchwood*'s original Cardiff setting and its use of place, the chapter presents the argument that the combination of a form of realism – of place as well as theme – with the conventions of different genres give a multi-faceted view of Cardiff and of South Wales generally. It also examines the use of accent, echoing Lury's chapter on sound, to explore the often neglected role that voice, speech and sound play in constructions of place and identity. Following this, Rebecca Williams' chapter 'Tonight's the Night with... Captain Jack? John Barrowman: Celebrity/Subcultural Celebrity/Localebrity?' seeks to extend understandings of the importance of place by considering the star image of John Barrowman. Moving away from analysis of the character of Captain Jack Harkness and instead focusing on how Barrowman's star image is circulated through, and beyond, *Torchwood*, this chapter uses the notion of the 'localebrity' to consider the impact of cult/mainstream celebrity and how this links to Barrowman's status as a very visible (adopted) resident of South Wales.

The final part considers *Torchwood*'s reception, paying attention to both cult and mainstream audiences, as well as considering their more specific responses to the show. The loyal fandom which has built around the show is worthy of study. For example, the response by certain fans to the death of the character of Ianto in Series 3 allows consideration of fan/producer interactions and exploration of fan attachments to onscreen characters and relationships, whilst the creation of an impromptu shrine to the character (which is located in Cardiff Bay) speaks to debates over fan productivity, pilgrimage and place. Since it has been widely argued that 'It is not possible to produce a cult text'[12] and that cult status can only be accorded by fan/audience responses, consideration of *Torchwood*'s reception is crucial to understanding its shifting positions from cult to more mainstream status. Jancovich and Hunt note that 'cult TV is defined not by any feature shared by the shows themselves, but rather by the ways in which they are appropriated by specific groups'.[13] Indeed, the link between audiences and cult status is long established in studies of cult texts, and the final part of the book

explores audience responses to *Torchwood* in a range of ways. Taking a more 'fan-scholar'[14] position, Jeannette Vermeulen and Lindsay Bryde's chapters consider the fandom's responses to developments within the narrative of *Torchwood* itself. Lindsay Bryde explores the relationship between *Torchwood* and *Doctor Who* to examine how some fans were polarised by the character of Captain Jack Harkness. In analysing the links between the two shows, and how these are also prevented,[15] Bryde also examines fan frustration with narrative developments in 'Children of Earth' and 'Miracle Day'. In linking this to both the character of Captain Jack and to John Barrowman as a performer, Bryde takes into account issues of dislike and dissatisfaction from the fandom's point of view. Jeannette Vermeulen considers fan reactions to the representations of gender and sexuality in the show, exploring positive reactions to the characters of Jack and Ianto and to the broader representations of transgressive characters on screen. Indeed, *Torchwood* is of interest to our understandings of television, given its seemingly progressive depictions of sexuality and gender. The character of Captain Jack as an 'omnisexual' figure, same-sex kisses between characters and the representation of Jack's relationship with Ianto (and his involvement with other men in 'Miracle Day') suggests that *Torchwood* privileges fluid notions of sexual identity. However, as the show moves from BBC3 towards BBC1, its representations of sexuality become more restricted, culminating in an emphasis on heteronormativity and family in 'Children of Earth'. Whilst these themes have been discussed in other academic work on *Torchwood*,[16] Vermeulen also considers the fan response to Ianto's death at the end of 'Children of Earth'. Viewing this as both part of wider dissatisfaction with the show from some fans and through the lens of upset at the loss of a positive onscreen portrayal of diverse and transgressive characters, she explores the importance of identification for fans of cult texts. Finally, Craig Haslop's chapter takes issues around sexuality and gender in the show and considers these with reference to his own research through focus groups with members of the LGBT community. In acknowledging the limits to *Torchwood*'s apparently progressive representations of sexuality, Haslop's chapter reminds us that audience responses are not fixed or standardised and that how they respond to, and use, cult texts such as *Torchwood* is dependent on their own backgrounds and experiences.

There can be 'no final and absolute classification of the media cult'.[17] However, academic interrogation of shows such as *Torchwood* is crucial to understandings of cult television and to studies of TV more broadly. The audience responses, aesthetics and unique scheduling and institutional nature of *Torchwood* make it an ideal text for examination and development of how we understand and theorise about cult TV. In examining aesthetics, production strategies and audience responses, the collection considers *Torchwood* as a case study of a text that employs notions of cult in a range of ways whilst also negotiating a position with the mainstream of television drama texts. Beyond this, however, it seeks to contribute to an ongoing set of debates over what 'cult' status means, and how such texts embody a range of tensions and contradictions surrounding a range of industrial, cultural and audience contexts.

Notes

1. See for example David Butler (ed), *Time and Relative Dissertations in Space: Critical Perspectives on Doctor Who* (Manchester, 2007); Ross P. Garner, Melissa Beattie and Una McCormack (eds), *Impossible Worlds, Impossible Things: Cultural Perspectives on 'Doctor Who', 'Torchwood' and the 'Sarah Jane Adventures'* (Cambridge, 2010); Matt Hills, *Triumph of a Time Lord* (London, 2010); and John Tulloch and Henry Jenkins, *Science-Fiction Audiences* (London, 1995).
2. Andrew Ireland, *Illuminating Torchwood: Essays on Narrative, Character and Sexuality in the BBC Series* (North Carolina, 2010).
3. Rebecca Williams, 'Cannibals in the Brecon Beacons: *Torchwood*, Place and Television Horror', *Critical Studies in Television* 6/2 (2011), pp. 61–73.
4. Stacey Abbott, 'Introduction', in S. Abbott (ed), *The Cult TV Book* (London, 2010), p. 2.
5. Matt Hills, 'Mainstream Cult', in S. Abbott (ed), *The Cult TV Book* (London, 2010), p. 67.
6. Ibid., p. 73.
7. Andrew Ireland, 'Playing to the Crowd: *Torchwood* Knows We're Watching', in A. Ireland (ed), *Illuminating Torchwood*.
8. Henry Jenkins, (2007) 'Transmedia Storytelling 101', *Confessions of an Aca-Fan*. Online. Available http://www.henryjenkins.org/2007/03/transmedia_storytelling_101.html. (12 January 2012).
9. Matt Hills, *Fan Cultures* (London, 2002).
10. Caitriona Whiteman (2010) 'Davies: "New *Torchwood* Has Global Sweep"'. *Digital Spy*. Online. Available http://www.digitalspy.co.uk/tv/s8/torchwood/news/a258540/davies-new-torchwood-has-global-sweep.html (12 January 2012).

11. Russell T. Davies (2011) 'Torchwood writer Russell T. Davies on new thriller', BBC Wales News. Online. Available http://www.bbc.co.uk/news/uk-wales-12338396 (12 January 2012).
12. Catherine Johnson, 'Cult TV and the Television Industry', in S. Abbott (ed), The Cult TV Book (London, 2010), p. 135.
13. Mark Jancovich and Nathan Hunt, 'The Mainstream, Distinction and Cult TV', in S. Gwenllian-Jones and R. E. Pearson (eds), Cult Television (Minneapolis and London, 2004), p. 27.
14. Hills: Fan Cultures, p. 2.
15. See also Garner in this book.
16. See, for example, the chapters in Part III: Sexuality and Torchwood in A. Ireland (ed), Illuminating Torchwood; and Lee Barron, 'Invaders from Space, Time Travel and Omnisexuality', in T. Hochscherf and J. Leggott (eds), British Science Fiction Film and Television: Critical Essays (Jefferson, North Carolina, 2011).
17. Hills: 'Mainstream Cult', p. 131.

Part I

MEDIA INSTITUTIONS, BRANDING AND MULTI-PLATFORMING

ACCESS DENIED? NEGOTIATING PUBLIC SERVICE AND COMMERCIAL TENSIONS THROUGH *TORCHWOOD'S* INTERTEXTUAL BARRICADE

Ross P. Garner

Introduction

Much of the emerging academic work discussing *Torchwood* has foregrounded the programme's appeal(s) to 'cult' audiences as the key interpretive framework through which to explore the series. Matt Hills' discussion of *Torchwood* within *The Essential Cult TV Reader* explicitly demonstrates this point[1] but Rebecca Williams' analysis of how the series 'has linked representations of horror with location'[2] is premised upon wider associations between the horror genre and the academic study of 'cult' television.[3] Similarly, Umberto Eco's argument equating 'cult' status with intertextuality and a 'rickety' textual structure[4] can be identified in Andrew Ireland's assessment that:

> [i]t is the unusual fusion of science fiction drama, soap, sex, violence, representation of bisexuality and homosexuality, notions of the gothic and the uncanny, the Other and the hero, that makes [*Torchwood*] such a 'fresh' text to study.[5]

This preceding work has made associations between *Torchwood*'s production context and its 'textual strategies',[6] such as Williams' recognition that horrific imagery for the 'Children of Earth' mini-series 'need[ed] to be "toned down" for the imagined audience of BBC1'.[7] Nevertheless, prioritising the series' myriad overlaps with 'cult' discourses overlooks other ways of critically engaging with *Torchwood*. For example, from the perspective of *Torchwood*'s industrial commissioning and development, one key element of the programme is its status as a 'spin-off' from *Doctor Who*. Spin-off products are, as will be outlined in this chapter, frequently associated with commercially motivated production contexts and the priorities of these generate tension in relation to *Torchwood*'s institutional development since it is a product of the BBC's ongoing public service responsibilities. This chapter uses *Torchwood* as a case study partly for exploring wider issues surrounding the intersections between 'public service' and 'commercial' televisual systems by demonstrating how the production of spin-off texts is shaped by, and responds to, issues arising from the national broadcasting context of commissioning. However, rather than subscribing to simplistic oppositions between 'commercial' and 'public service' television models, this chapter instead recognises that the BBC combines 'public service' and 'commercial' requirements in its contemporary practices.[8]

The structure of the chapter is as follows: firstly, existing scholarly ideas regarding the spin-off are reviewed to demonstrate how these have been primarily framed in terms of commercial discourses concerning the exploitation of textual elements (e.g. characters) that have proven popularity with audiences. As becomes evident, this set of ideas becomes complicated if applied to *Torchwood* since its status as a spin-off from 'the family-friendly *Doctor Who*' generates tensions for the BBC concerning its institutional responsibilities towards protecting child audiences from *Torchwood*'s aforementioned 'adult' themes.[9] The remainder of the chapter then explores the various strategies implemented by the BBC within both promotional material for *Torchwood* and the text itself to discourage children from watching. The discussion primarily focuses on the construction and negotiation of an 'intertextual barricade' between *Torchwood* and the diegesis of its parent series throughout the former's four series and notes how, even during instances where this

barricade becomes relaxed and/or crossed, anxieties remain identifiable. Thus, *Torchwood* may well be 'a unique television drama series' but this chapter argues that this classification comes partly from the divergent pressures working upon the series due to its continually shifting production context and the strategies employed for '(re-)negotiating the series' relations with its parent series.[10]

Constructing the barricade: *Torchwood*-as-spin-off, *Torchwood*-as-public service product

Within television studies, discourses engaging with 'spin-off' programmes frequently account for the genesis of these series by stressing their commercial logic. Peter S. Grant and Chris Wood demonstrate this interpretive approach by discussing how the initial success of the original *CSI* has been capitalised on by its producers. The subsequent appearances of *CSI: Miami*, and then *CSI: New York*, are viewed as examples of a process of 'cloning previous successes through sequels, prequels or "franchise" extensions' that is further identifiable within the American television industry through such examples as *Law and Order*.[11] These practices are viewed negatively by Grant and Wood since they argue that '[w]hatever their creative merit, every clone absorbs money and screen time that might otherwise bring audiences a new voice or different perspective on the world'.[12] Overlapping interpretations of spin-offs are evident elsewhere in television studies. Jonathan Bignell defines such programmes as 'designed to exploit the reputation, meaning or commercial success of a previous one'[13] whilst Jonathan Hardy names spin-offs as one component of the widespread 'commercial intertextuality' dominating industrial practices at present.[14] Irrespective of the value judgements made concerning their (lack of) creativity, the dominant discourse surrounding television spin-offs is drawn from wider media and cultural studies perspectives which posit that new products generated by profit-driven systems are primarily 'meant to serve the function of creating synergy by locating a successful device and carrying it to another'.[15] The recurrence of this stance in academic work discussing production processes within 'mainstream' American cinema provides one example of how entrenched these ideas are.[16]

Locating *Torchwood*'s first series in relation to established discourses concerning 'the spin-off' is problematic, however. On the one hand, the programme's inclusion of Captain Jack Harkness (John Barrowman), a character introduced during the first series of the re-launched *Doctor Who*, as one of *Torchwood*'s lead characters is readable as a 'clever marketing' strategy used by the programme's producers to 'increas[e] the possibility that a viewer hooked on one... series... may become an avid viewer of the other'.[17] A reading of *Torchwood* that settles purely upon the 'commercial' logic underpinning the series' genesis is too reductive, however. What this overlooks is how the programme's status as a series commissioned by the BBC under public service requirements impacts upon *Torchwood*'s (initial and ongoing) status as a spin-off. Most significant to understanding *Torchwood* in this context is the fact that, since returning in 2005, parent series *Doctor Who* has established itself as a '"consensus" audience grabber'[18] through continually demonstrating 'broad demographic appeal... and... be[ing] viewed by the whole family'.[19] The 'dark, wild and sexy' tone intended for *Torchwood* in the press release announcing its commissioning is therefore immediately problematic for the BBC since, from an institutional perspective, it suggests divergent pulls operating across the programme's development.[20] This is because, since *Doctor Who*'s cross-generational appeal includes children, *Torchwood*'s status as a spin-off from *Doctor Who* compromises some aspects of the BBC's charter. Throughout its history, the BBC has been continually required to display 'responsibility to avoid harmful material' for children.[21] This means that children have long been recognised as 'an institutional category' within the BBC and have consequently been addressed as such in terms of both programming provision and regulation of content.[22] Consequently, the Corporation has adopted what some have viewed as a 'paternalistic' attitude towards children and the programming produced for them.[23] This stance continues today since the internally imposed service licence for the BBC's child-centred CBBC channel states that 'CBBC should provide a stimulating, creative and enjoyable environment that is also safe and trusted'.[24] Rather than simply creating a series that would establish an audience off the back of popular characters in *Doctor Who*, then, specific strategies would have to be mobilised for *Torchwood* to achieve crossover appeal

whilst simultaneously discouraging children from experiencing the programme's 'sex-fuelled viscera'.[25] On a wider level, though, the tensions between public service responsibilities and audience expectations for spin-off programmes mean that the development of *Torchwood*'s first series complicates established ideas concerning such forms of programming in television studies.

To address anxieties regarding child viewers, *Torchwood*'s producers chose to instigate a variety of strategies to downplay the programme's appeal to young audiences – starting with the series' initial press release. Davies' statement that *Torchwood* would be '*X Files* meets *This Life*' is significant because of the intertextual associations it forges with preceding forms of TV drama.[26] *The X-Files* has an established position within scholarly discourse (and beyond) as a programme that generated 'cult' appeal amongst audience groups,[27] whilst also courting 'quality' demographics through its 'visual... emphasis on concealment' that allowed fantastic and horrific imagery to be depicted without excessive gore.[28] At the same time, comparing *Torchwood* to *This Life* activates associations of the latter's appeal to 'quality' audiences through its socially-realist subject matter,[29] as well as bringing in associations of 'cult' appeal.[30] Crucially, though, associating *Torchwood* with *This Life* signifies the former programme's child-unfriendliness to tele-literate audiences since *This Life* garnered a reputation for controversial content over the course of its two series by including frank representations of sex, drug taking, and homosexuality.[31] Matt Hills' assertion that 'it is hard to view *Torchwood* as anything other than cult by design' appears relevant here since the promotional launch of the series identifies two programmes with established appeal to such audiences as direct points of reference for *Torchwood*.[32] However, it is further arguable that 'cult' appeal was combined with discursive strategies designed to also attract 'quality' demographics, evaluations of *Torchwood* as a 'quality' programme being especially significant due to the series' status as a BBC product where the production of 'quality' programming works to demonstrate the 'public value' of the corporation.[33] Crucially though, from the outset, promotional strategies also position *Torchwood* as unsuitable for *Doctor Who*'s child fans.

Similar discouraging strategies can be observed in the launch pattern for *Torchwood*'s first episodes. The decision to show the

first two instalments back-to-back at 9 pm on a Sunday evening on BBC3 provides further evidence of the BBC's eagerness to signify *Torchwood*'s 'adult' status. Firstly, the choice of channel for launching *Torchwood* gestures towards its intended demographic. Prior to the digital switchover, which began in the UK in 2008, BBC3 was a digital-only channel with a remit (which continues today) for specifically targeting 'youth' audiences aged between their late teens and early thirties.[34] Using BBC3 as the launchpad for *Torchwood* may be read in relation to the BBC's other institutional priorities at the time, such as 'encourag[ing] people to enter the digital world by offering unique and high quality content on a range of digital platforms'.[35] From this perspective, *Torchwood* can be seen as raising audience awareness of the BBC's digital channels by moving viewers to BBC3 from the established home of *Doctor Who* on BBC1. Irrespective of this, though, choosing to first-run Series 1 of *Torchwood* on BBC3 means that the programme 'is contextualised as a minority or niche drama rather than a mainstream (and thus BBC1) show' like its parent series.[36] Secondly, its scheduling time positions the programme '[a]s a "post-watershed" program... following the long-standing convention in British TV that equates this time slot with material not suitable for children'.[37] Thirdly, the choice of day for launching *Torchwood* adds to its 'adult' connotations since, whilst in the UK 'Saturday-evening schedules are... traditionally constructed for family viewing', Sunday evenings carry a different set of connotations since this day leads in to the start of a new working – or, in the case of children, schooling – week.[38] Thus, although 9 pm on Sundays has an established history for transmitting drama on 'mainstream' channels such as BBC1 and ITV1, the forms of drama occupying these slots, such as ITV1's *Wild at Heart* or heritage/nostalgia dramas like *Inspector George Gently*, are characterised by a 'safer' tone.[39] The combined effect of the scheduling of *Torchwood*'s launch is therefore readable as an extension of the strategies discussed in relation to the programme's initial press release since clear attempts are maintained to signify the programme's difference to *Doctor Who* in terms of its intended (non-child) audience.

A variety of textual strategies identifiable in *Torchwood*'s first two episodes also demonstrates the series' conscious anti-child appeals. These include the use of swearing, Captain Jack's enigmatic presence in 'Everything Changes' (1.1) suggesting a less clear-cut heroic

version of the character than that last seen in *Doctor Who* episode 'The Parting of the Ways' (1.13), or the presence of an alien sex parasite as 'monster-of-the-week' in 'Day One' (1.2).[40] However, given the expectations mentioned above for intertextual borrowings between a spin-off programme and its parent series, it is arguable that one of the most significant examples of how *Torchwood*'s status as a BBC product impacts upon the format of its first series is the construction of an intertextual barricade between *Doctor Who* and itself. For example, whereas the first proper episodes of Series 1 of fellow *Who* spin-off *The Sarah Jane Adventures* used continuity between the parent series and itself by including the Slitheen – monsters previously seen in the first series of *Doctor Who* – as villains, such cross-franchise pleasures were not offered to *Torchwood*. Instead, references to *Doctor Who* are largely absent from these episodes (and the entire first series) so as to indicate that *Torchwood* is distinct and separate from its parent series.

Evidence of *Torchwood*'s intertextual barricade between itself and *Doctor Who* is nowhere more evident than when attempts are made to create a crossover between the two programmes in the episode 'Cyberwoman' (1.4). This story is directly linked to the end of Series 2 of *Doctor Who* as it is premised upon the revelation that Ianto Jones (Gareth David Lloyd), an ex-employee of the Torchwood Institute destroyed in 'Doomsday' (2.13), has been hiding his half-Cyber-converted girlfriend (Caroline Chikezie) in the cellars of the Hub. The episode is therefore significant as it is the only one from *Torchwood*'s first series that is directly linked to narrative events from the parent series. Neil Perryman outlines the production context surrounding 'Cyberwoman', and alludes to the construction of *Torchwood*'s intertextual barricade throughout its first series, as follows:

> The *Torchwood* production team discussed doing a Dalek episode, but thought that it might entice children to watch it, so decided best not. However, this does not really square with their decision to use the Cybermen instead..., monsters that also appeal massively to children (having appeared in four episodes of the second season of *Doctor Who*).[41]

Torchwood's 'Cyber*woman*' was distanced from the Cyber*men* of *Doctor Who*; aspects of the visual design of the character provide

examples of just one way that the character was recoded via passing through the programme's intertextual barricade. This reconfiguring involves explicitly constructing visual aspects of the cyber-character through discourses relating to 'cult' tastes. The design of *Torchwood*'s Cyberwoman preserves signifiers of the Cybermen by retaining the iconic handlebars on the costume's helmet, but the levels of flesh displayed, as well as the S&M/bondage connotations of the costume, suggest the implementation of a strategy designed to distance the character from its peers in *Doctor Who*.[42] These changes to the design of the Cyberwoman for *Torchwood* could be located in relation to existing branding strategies used by *Doctor Who,* such as the requirement for each 'new' appearance by a recurring villain to offer variation on the established design in aid of generating ancillary merchandise such as action figures.[43] Such a reading would, however, overlook the institutional pressures operating upon *Torchwood*'s first series discussed here, including the direct targeting of 'cult' audiences through encoding the Cyberwoman's costume through the link between 'cult' appeal and 'adult' entertainment forms such as pornography. Gayln Studlar notes that the 'depiction of sex often appears lewd or pornographic' in cult films since the representation of sexual acts in these movies can include:[44]

> sadomasochism, fetishism, transvestisism, homosexuality, voyeurism, exhibitionism, necrophilia, bestiality, and myriad other sexual 'abnormalities' considered to be the essence of perversion.[45]

The adult design of the Cyberwoman's costume is therefore clearly coded (and overtly referenced in the episode) to suggest that *Doctor Who*'s established cyborgs have been re-envisioned to appeal to a combination of masculine/cult/adult tastes.[46]

As is suggested throughout this book, though, the overall format of *Torchwood* is difficult to pin down due to the programme's ongoing movement across different BBC channels within the UK and, in the case of 'Miracle Day', onto the international stage as a co-production with Starz. This movement raises questions concerning how the intertextual barricade between *Torchwood* and *Doctor Who* has been renegotiated across subsequent series. The next section of this chapter addresses these issues and argues that, despite 'Children of Earth' and 'Miracle Day' suggesting the BBC adopting

a more casual attitude towards the barricade, links between the two shows remain minimal and where they do occur are still used to connote *Torchwood*'s distance from *Doctor Who*.

Negotiating the barricades: *Torchwood*'s movement across BBC channels

Torchwood's second series saw a number of institutional manoeuvrings impact upon the intended audience(s) for the programme. For example, in July 2007 the BBC announced that *Torchwood* would be promoted to first-run status on BBC2 with the justification for this being the high ratings achieved by the first series.[47] This promotion therefore partly reverses one of the BBC's institutional policies that saw the programme premier on BBC3. This is because, whilst Series 1 can be regarded as an attempt to raise audience awareness of the Corporation's digital-only channels, Series 2 intersects with BBC2's requirement at the time:

> to highlight the benefits of digital to the non-digital audience...
> [by] show[ing] some of the best output from the BBC's digital
> channels and us[ing] its airtime to promote the take-up of digital
> platforms.[48]

Coinciding with Series 2 of *Torchwood* switching channels is an apparent alteration in the programme's stance towards younger audiences. In the build-up to the launch of Series 2 in January 2008, the BBC released a press statement detailing that '[i]n response to audience demand, younger fans will now have the opportunity of watching a specially edited pre-watershed repeat'.[49] Thus, as the BBC later made clear to concerned adults through the programme's official website:

> Series 2 of *Torchwood* was shown in two different versions. A post-
> Watershed version, intended for the adult audience, was broadcast
> after 9 pm. A specially edited pre-Watershed version, suitable for a
> family audience, was shown before 9 pm.[50]

Moreover, the BBC's apparent change in attitude towards potential child viewers appears – at first glance – to correspond with a

relaxing of the intertextual barricade between *Torchwood* and *Doctor Who*. This is nowhere more evident than the early announcement in publicity that Series 2 would feature a guest appearance from just-departed *Who* companion Martha Jones (Freema Agyeman) for two episodes.[51] Yet Martha's appearance was announced in terms that suggest, in relation to promotional strategies, the continued presence of *Torchwood*'s intertextual barricade. The BBC's press release quotes Agyeman as saying 'Martha has grown up a lot since Doctor Who. She's now a fully qualified doctor and a bit hardened by life experiences'.[52] This statement implies a recoding of the character from the Martha previously seen in *Doctor Who*'s third series. However, despite first glimpses of the character in 'Reset' (2.6) connoting a more 'professional' side through such costuming choices as smart suits, a substantial recoding of the character is not evident beyond these choices. Martha instead displays character traits established in *Doctor Who* and the script for 'Reset' makes direct references to plot points from 'The Sound of Drums/Last of the Time Lords' (3.12/3.13) as it echoes the dialogue from these episodes. Most notably Martha's motto of 'be invisible' when going undercover and infiltrating The Pharm in 'Reset' directly echoes the Doctor's (David Tennant) statement about using a perception filter to be 'like ghosts' when tracking the Master (John Simm) to UNIT airbase The Valliant in 'The Sound of Drums'. There subsequently appears to be a dissonance between the promotional strategies used for announcing Agyeman's guest appearance and those mobilised within the broadcast episodes since, whilst the former suggests alterations to the character, textual evidence makes such a reading difficult to sustain. Remnants of the BBC's institutional anxiety surrounding *Torchwood*'s borrowing of characters/actors from *Doctor Who* is therefore evident in publicity material for Series 2 since discursive strategies are mobilised that connote the distinct nature of Martha's character within the context of the former programme. Thus, although at face value the intertextual barricade appears to have been less strictly constructed for Series 2, closer inspection of publicity material suggests its presence in a diminished manner.

Further evidence of an institutional barricade operating across *Torchwood*'s second series is identifiable if it is noted that Martha's appearance is the only direct reference to the programme's parent series. Although Jack makes enigmatic statements such as 'I found

my Doctor' and 'I saw the end of the world' when probed about his disappearance throughout 'Kiss Kiss, Bang Bang' (2.1), Martha provides the clearest explicit link to *Doctor Who.*

This is especially significant if, again, *Torchwood*'s development is compared with *The Sarah Jane Adventures.* Whereas the latter programme continually borrows and recodes monsters from *Doctor Who* such as the Sontarans (Anthony O'Donnell – see 'The Last Sontaran' (2.1/2.1) and 'Enemy of the Bane' (2.11/2.12)) and the Judoon (Paul Kasey – see 'Prisoner of the Judoon' (3.1/2.3)) in a comedic manner, the same cannot be said for *Torchwood.* Within the context of this chapter's discussion it appears significant that, post-'Cyberwoman', the only instance of a *Doctor Who* monster appearing in the Torchwood Hub has been a Dalek during 'The Stolen Earth/Journey's End' (4.12/4.13) – the finalé episodes of *Doctor Who*'s fourth series. This absence suggests that whereas the 'hyperdiegesis'[53] of *The Sarah Jane Adventures* regularly establishes continuity with 'the metatextual backstory'[54] of both 'classic' and post-2005 *Who* – for a variety of reasons that includes both budgetary restrictions for children's television and/or the wider textual history of Sarah Jane Smith's character (played by Elisabeth Sladen) – *Torchwood* is not afforded the same opportunities. In terms of the programme's intertextual barricade, then, it is arguable that negotiations of this blockage can only occur within the context of pre-watershed, Saturday evening 'family' viewing.

Torchwood's promotion to the status of a primetime post-watershed BBC1 series offers further opportunities for analysing the programme's negotiation of its intertextual barricade. For example, in the context of the current discussion, it is highly significant that during the build-up to the transmission of the first episode of 'Children of Earth', the official *Torchwood* website announced that '*Torchwood: Children of Earth* will be broadcast after the Watershed and is intended for an adult audience'.[55] This BBC statement provides a clear warning to parents about the programme's expected content and its unsuitability for younger viewers. It is perhaps not surprising, then, that, in line with being re-positioned as adult-only drama on BBC1, direct crossover episodes between *Torchwood* and *Doctor Who* remain a continued absence for the series. Of course, *Torchwood*'s avoidance of crossover episodes for its third and fourth series can be located in line with other production requirements for

contemporary TV drama series. Richard Berger argues that during its second series, *Torchwood* 'steps out of the long shadow of the TARDIS, and defines itself as a science fiction series for grown ups'.[56] What is partly alluded to here is the need for *Torchwood* to develop and achieve its own distinct identity as a television series – something that is essential at present given that 'the ... circumstances of TVIII ... have foregrounded branding of distinctive product ... to maximise visibility in a crowded market-place'.[57] By extension it appears logical that, as the series moves into its third and fourth series, *Torchwood* should become less dependent on its status as a spin-off and instead develop its own individuated brand identity.

More than this, though, institutional requirements for drama programming on BBC1 also discourage the possibility of crossover episodes during *Torchwood*'s third channel-specific incarnation. Internal documentation for BBC1 states that part of the channel's aim for its drama output is to offer audiences '[a] wide range of drama, including... strongly-authored contemporary series'.[58] Crossover episodes could be included within the 'wide range' of drama on BBC1 since, in aspiring 'to be the BBC's most popular mixed-genre television service',[59] the channel is required to provide a range of dramas that attempt to satisfy and reflect the tastes of the entire British public.[60] At the same time, though, crossover episodes could compromise the connotations of 'quality', 'innovation' and/or 'authored' drama underpinning this statement due to the associations between spin-off texts, commercial motivations and a subsequent lack of originality. This second reading of BBC1's intended aims for its primetime drama is further supported if it is considered that, throughout the transmission of 'Children of Earth' on BBC1, '[c]ontinuity ... flags the schedule for BBC1 ... as "the one to watch"; using this phrase to imply both the channel itself and selected programmes constructed as "Event TV"'.[61] Thus, given that both 'Children of Earth' and 'Miracle Day' have been 'publicised ... as ... landmark television "event[s]"' in the UK, it becomes evident that *Torchwood* on BBC1 has been internally defined as 'quality' television rather than as a programme reliant on its status as a spin-off from *Doctor Who*.[62]

Yet, whilst *Torchwood*'s internal (re)positioning as 'quality' television on BBC1 may (or may not) have distanced the programme's possibility for crossover episodes, both 'Children of Earth' and 'Miracle Day' have occasionally crossed the programme's intertextual

barricade. These transgressions are most frequent throughout 'Miracle Day' with episode seven, 'Immortal Sins' (4.7), displaying the most sustained examples. This is because the episode not only explains its alien Brain Spawn 'amid a flurry of intertextual references to *Doctor Who* and, potentially, the child-orientated *Sarah Jane Adventures*'.[63] It also directly and explicitly evokes *Torchwood*'s parent series by paralleling the Doctor–companion relationship through Captain Jack's encounter with Angelo Colasanto (Daniele Favilli). Such direct references to both metatextual and formal elements of *Torchwood*'s parent franchise, as well as momentary mentions of *Who* monsters the Silurians in series finale 'The Blood Line' (4.10), imply that 'Miracle Day' loosens the programme's intertextual barricade. The increased frequency with which the *Doctor Who* franchise is invoked throughout 'Miracle Day' could be accounted for crudely by referring to established ideas regarding spin-offs and accrediting such elements to the serial's status as a co-production of the BBC and a commercially funded US pay-per-view cable station. However, a more nuanced institutional reading of this feature of 'Miracle Day' can be provided by recognising that, as a network, Starz exemplifies a tendency within the US television industry outlined by Simon Brown:

> the link between quality and cult has been exploited in recent years by a number of smaller cable channels, less preoccupied with garnering the kind of vast audiences expected by the major networks. Seeing the potential of building a loyal fan base, they have abandoned cult genres and instead sought to produce programmes whose cult status is linked instead to quality by an adherence to provocative plotlines and/or aesthetics. These shows deliberately set themselves apart from "regular TV" through a quirkiness, an edginess, or a general boundary-pushing fearlessness in their subject matter but do so within essentially mainstream rather than cult genres.[64]

'Miracle Day' intersects with this industrial trend by threading its science fiction premise of human immortality through the conventions of 'mainstream' genres such as the political thriller and/or social realist drama by exploring issues such as healthcare provision and philosophical questions of 'life' and 'death'.[65] Moreover, through setting up its 'no-one dies' premise through having convicted

paedophile Oswald Danes (Bill Pullman) survive a lethal injection, 'Miracle Day' foregrounds its 'edgy' content from the opening of its first episode. Yet, if the same opening scene is read from the perspective of the BBC and its public service responsibilities, the same sequence suggests a narrative strategy employed to immediately connote the attitude of 'Miracle Day' towards younger audiences since a character proposing a direct diegetic 'threat' to children is immediately established. This sequence therefore carefully combines the requirements of both the national production contexts for 'Miracle Day' in that it is readable in relation to the demands of both US pay-per-view cable and UK public service institutions. In the context of the current discussion, though, it is also arguable that the scene enables 'Miracle Day' to display a less anxious attitude towards *Torchwood*'s intertextual barricade in later episodes since the serial immediately foregrounds its child-unfriendliness.

Hills offers further support for considering 'Miracle Day' as displaying a *laissez-faire* attitude towards its intertextual barricade with *Doctor Who* by discussing edits made to the sexual content included in the episode 'Dead of Night' (4.3) when it was transmitted in the UK. This discussion implies that, within the context of 'Miracle Day', the intertextual barricade has become refocused. Rather than being constructed in relation to anxieties concerning *Torchwood*'s interactions with its parent series, the problem for 'Miracle Day' instead relates to John Barrowman's celebrity persona and his visibility elsewhere in BBC1's schedules as the presenter of Saturday night pre-watershed variety series *Tonight's the Night*:

> Jack's not been in *Who* for a couple of years; this may not be as active an issue as it once was. By contrast, Barrowman-the-personality-presenter is very much a live concern. It's the transmission of *Tonight's the Night* that's currently running alongside *Torchwood*, not *Who*.[66]

Hills recognises that, similar to how *Torchwood*'s previous series have had to construct an intertextual barricade between the series and *Doctor Who*,

> there can't be too much Captain Jack in John Barrowman the 7 pm BBC1 TV personality, and a clear semiotic divide has to be established between the two as far as BBC brand management goes.[67]

This is a highly valid argument and offers support for a wider point emerging across this chapter which is that *Torchwood*'s intertextual barricade should be understood as a dynamic construction that has mutated in accordance with the programme's ongoing migration across BBC channels in the UK. However, contrary to Hills' point concerning *Torchwood*'s relations with *Doctor Who* being less of an issue in the broadcast context of 'Miracle Day', it is also arguable that violations of the barricade within 'Miracle Day' still reinforce the semiotic differentiation between *Torchwood* and its parent series. This is because, much like when the hyperdiegesis of *Doctor Who* is invoked in Gwen's video message during 'Day Five' (3.5) of 'Children of Earth', references to *Doctor Who* underpin *Torchwood*'s distinctness. For example, Jack's admission that he doesn't know the origins of The Blessing in 'The Blood Line' is readable as an attempt to signify how the diegesis of *Torchwood* is distinct from that of its parent series since this alien object is not explainable in terms of metatextual continuity. This is not to argue that this is the only way that this sequence can be read, though. It is equally arguable that Jack's explanation can be understood in relation to Hills' arguments concerning 'mainstream-cult' appeal. This is because, following Hills' argument, the entity's mysterious status implies a rejection of 'invented language for imagined technologies and aliens... assumed to distinguish science fiction from "mainstream" media content'.[68] In other words, by evoking crossfranchise continuity through mentioning *Doctor Who* monsters such as Silurians, but then immediately rejecting this as speculation, this crossing of the intertextual barricade instantaneously suggests, but rejects, classifying 'Miracle Day' as a singularly 'cult' series. Yet, if this example is placed alongside other examples from both 'Miracle Day' and 'Children of Earth', each of these instances work to connote *Torchwood*'s ongoing detachment from its parent series. For instance, the characterisation of the Jack–Angelo relationship as ultimately leading to misunderstanding on behalf of the 'companion' and graphic physical harm to Jack is starkly different from *Doctor Who*'s focus on the equivalent character's 'developing attachment to the Doctor and the toll it takes on her other relationships'.[69] At the same time, Gwen's video appeal to the Doctor in 'Day Five' connotes that the version of Earth in this series of *Torchwood* is not that seen by audiences for *Doctor Who*. Instead of being populated

by self-sacrificing and good-natured humans (alongside the odd nefarious individual), this is a vision of Earth that includes 'morally corrupt human characters ... undermining our narrative expectation that it is these characters who will protect the public from the alien threat'.[70] In each of these instances, then, *Torchwood*'s institutional barricade is crossed to demonstrate the differences between the two series. Whether in terms of signifying different structuring of character relationships, alternative representations of shared diegetic locations or otherwise, each of these instances continues to highlight *Torchwood*'s remoteness from the world(s) of its wider franchise.

Conclusion

This chapter has discussed *Torchwood*'s four series from an institutional perspective, focusing primarily on the programme's status as a 'spin-off' and how audience expectations for such a product have in part been compromised due to the series' status as a BBC product. Most noticeably, the tensions between these divergent pulls upon the form of the series have generated concerns for the BBC regarding the possibility of child audiences viewing 'harmful' and/ or inappropriate material within *Torchwood*. These concerns led the BBC to implement a range of strategies to discourage children from watching *Torchwood*'s first series. One of the most significant of these has been the construction of an intertextual barricade between the programme and *Doctor Who*. This is because, rather than offering audiences the expected enjoyments of a spin-off such as the possibility of crossover episodes, *Torchwood* has denied viewers these pleasures by keeping interaction between the two shows minimal. Alternatively, on occasions when crossovers have occurred, these cases have all been encoded in a manner that reasserts *Torchwood*'s differences in terms of target audience. Thus, whilst the design of the Cyberwoman's costume in 'Cyberwoman' helps reinforce the first series' conscious address to cult audience niches, evocations of *Doctor Who* within both 'Children of Earth' and 'Miracle Day' become recoded either in terms of 'adult'-oriented themes (e.g. Jack and Angelo) or distance the series' diegesis from that of its predecessor (e.g. the lack of explanation behind the Blessing).

In summary, then, *Torchwood*'s institutional context enforces a denial of access to the world of its parent series unless significant revisions are made to its intertextual borrowings in aid of signifying their 'adult' nature.

On a wider level, though, this chapter has sought to complicate some of the established ideas regarding the analysis of TV drama spin-offs. Academic work discussing reality television has offered an institutional perspective on the global sale of programme formats by recognising that 'formats can be adapted to local interests, tastes and norms'.[71] However, with regard to the study of televised drama, arguments are less developed since, despite recent arguments beginning to address the re-making and/or recontextualising of dramatic forms within different national television contexts,[72] the dominant perspective towards spin-off series continues to stress commercial logic and a lack of originality. James Chapman's reading of *Ashes to Ashes* as offering audiences 'essentially the same formula as *Life on Mars*' provides one recent example of this ongoing line of thinking.[73] Contrary to this position, this chapter has demonstrated through the example of *Torchwood* that increased critical attention should be paid to the production of spin-offs within specific national contexts and that attempts to capitalise upon previously successful TV drama series need to display sensitivity to the (shifting) national broadcasting structures in which they originate and circulate.

Notes

1. See Matt Hills, '*Torchwood*', in D. Lavery (ed), *The Essential Cult TV Reader* (Lexington, 2010).
2. Williams: 'Cannibals in the Brecon Beacons', pp. 61–73.
3. See, for example, Sara Gwenllian-Jones and Roberta E. Pearson, 'Introduction', in S. Gwenllian-Jones and R. E. Pearson (eds), *Cult Television* (Minneapolis, 2004), p. xii.
4. Umberto Eco, '*Casablanca*: Cult Movies and Intertextual Collage', in E. Mathijs and X. Mendik (eds), *The Cult Film Reader* (Maidenhead, 2008), p. 68.
5. Andrew Ireland, 'Introduction – Reading the Rift', in A. Ireland (ed), *Illuminating Torchwood*, p. 7.
6. Catherine Johnson, *Telefantasy* (London, 2005), p. 6.
7. Williams: 'Cannibals in the Brecon Beacons', p. 67.
8. See, for example, Robin Nelson, *State of Play: Contemporary 'High-End' TV Drama* (Manchester, 2007), pp. 56–70.

9. Williams: 'Cannibals in the Brecon Beacons', p. 62.

10. Ireland: 'Introduction – Reading the Rift', p. 1.

11. Peter S. Grant and Chris Wood, *Blockbusters and Trade Wars: Popular Culture in a Globalised World* (Vancouver, 2004), p. 71.

12. Grant and Wood: *Blockbusters and Trade Wars,* p. 72.

13. Jonathan Bignell, *An Introduction to Television Studies* (London, 2004), p. 314.

14. Jonathan Hardy, 'Mapping Commercial Intertextuality: HBO's *True Blood*', *Convergence: The International Journal of Research into New Media Technologies* 17/1 (2011), pp. 7–17, p. 7.

15. Rick Altman, *Film/Genre* (London, 1999), p. 44.

16. See, for example, Peter Krämer, *The New Hollywood: From Bonnie and Clyde to Star Wars* (London, 2005), p. 11.

17. Angela Ndalianis, 'Television and the Neo-Baroque', in M. Hammond and L. Mazdon (eds), *The Contemporary Television Series* (Edinburgh, 2005) p. 90.

18. Hills: *Triumph of a Time Lord*, p. 211.

19. Johnson: *Telefantasy*, p. 133.

20. Russell T. Davies in BBC Press Office. 'Torchwood to Air on BBC Two'. *BBC Online* Saturday 7th July 2007a. Online. Available http://www.bbc.co.uk/pressoffice/pressreleases/stories/2007/07_july/16/torchwood.shtml (06 January 2012).

21. Máire Messenger Davies and David Machin, '"It Helps People Make Their Decisions": Dating Games, Public Service Broadcasting and the Negotiation of Identity in Middle-childhood', *Childhood: A Journal of Global Child Research* 7/2 (2000), pp. 173–91, p. 176.

22. Ibid., p. 174.

23. See Máire Messenger Davies, *Dear BBC: Children, Television Storytelling and the Public Sphere* (Cambridge, 2001), p. 30.

24. BBC Trust. CBBC Service Licence. *BBC Online* Monday 10 May 2010. Online. Available http://www.bbc.co.uk/bbctrust/assets/files/pdf/regulatory_framework/service_licences/tv/2010/cbbc_may10.pdf (4 January 2012), p. 1.

25. Neil Perryman, '*Doctor Who* and the Convergence of Media: A Case Study in "Transmedia Storytelling"', *Convergence: The International Journal of Research into New Media Technologies* 14/1 (2008), pp. 21–39, p. 36.

26. Davies in BBC Press Office, 'Captain Jack to Get His Own Series in New Russell T. Davies drama for BBC Three', online.

27. See Jimmie L. Reeves, Marc C. Rodgers and Michael Epstein, 'Rewriting Popularity: The Cult Files', in D. Lavery, A. Hague and M. Cartwright (eds), *Deny All Knowledge: Reading the X-Files* (London, 1996).

28. Johnson: *Telefantasy*, p. 104.

29. See Lez Cooke, *British Television Drama: A History* (London, 2003), pp. 179–80.

30. See Stephen Lacey, '*This Life*', in D. Lavery (ed), *The Essential Cult TV Reader* (Lexington, 2010a).

31. See Cooke: *British Television Drama*, pp. 179–81. See also Glen Creeber, *Serial Television: Big Drama on the Small Screen* (London, 2004), pp. 122–8.

32. Hills: *Torchwood*, p. 275.
33. See Mary Debrett, *Reinventing Public Service Television for the Digital Future* (Bristol, 2010), p. 35.
34. BBC Trust. BBC Three Service Licence. *BBC Online* Monday 10 May 2010. Online. Available http://www.bbc.co.uk/bbctrust/assets/files/pdf/regulatory_framework/service_licences/tv/2010/bbc_three_may10.pdf (4 January 2012), p. 1.
35. BBC Trust. BBC Three Service Licence. *BBC Online* Monday 18 December 2006. Online. Available http://www.bbc.co.uk/bbctrust/assets/files/pdf/regulatory_framework/service_licences/tv/tv_servicelicences/bbcthree_servicelicence_18dec2006.pdf (4 January 2012), p. 2.
36. Hills: *Torchwood*, p. 276.
37. Ibid.
38. Johnson: *Telefantasy*, p. 133.
39. See also Phil Wickham, '*New Tricks* and the Invisible Audience', *Critical Studies in Television* 5/1 (2010), pp. 77–8.
40. Jason Mittell, 'Narrative Complexity in Contemporary American Television', *The Velvet Light Trap* 58/Fall (2006), p. 33.
41. Perryman: '*Doctor Who* and the Convergence of Media', p. 36.
42. See also Piers D. Britton, *TARDISbound: Navigating the Universes of Doctor Who* (London, 2011), p. 26 on the 'structuring icons' of *Doctor Who*.
43. See Hills: *Triumph of a Time Lord*, pp. 67–8. Ironically, a Cyberwoman was included in the first wave of *Torchwood* action figures that were released in 2008 following the programme's second series having been broadcast.
44. Gaylin Studlar 'Midnight S/Excess: Cult Configurations of Femininity and the Perverse', in J. P. Telotte (ed), *The Cult Film Experience: Beyond All Reason* (Austin, 1991), p. 141.
45. Ibid., p. 138.
46. See Joanne Hollows, 'The Masculinity of Cult', in M. Jancovich, A.L. Reboll, J. Stringer and A. Wills (eds), *Defining Cult Movies: The Cultural Politics of Oppositional Taste* (Manchester, 2003), pp. 42–5.
47. BBC Press Office. 'Torchwood to Air on BBC Two'.
48. BBC Trust. BBC Two Service Licence. *BBC Online* Monday 30 April 2007. Online. Available http://www.bbc.co.uk/bbctrust/assets/files/pdf/regulatory_framework/service_licences/tv/tv_servicelicences/bbctwo_servicelicence_30apr2007.pdf (6 January 2012), p. 2.
49. BBC Press Office. 'Torchwood Premiers on BBC Two in New Year'. *BBC Online* Wednesday 12 December 2007. Online. Available http://www.bbc.co.uk/pressoffice/pressreleases/stories/2007/12_december/03/torchwood.shtml (6 January 2012).
50. BBC. BBC – Torchwood – The Show. *BBC Online*. Online. Available http://www.bbc.co.uk/torchwood/faq/torchwood_show.shtml (6 January 2012).
51. BBC Press Office. 'Torchwood to Air on BBC Two'.
52. BBC Press Office. 'A New Face for Torchwood and a New Look for Martha.' *BBC Online* Wednesday 15 August 2007. Online. Available http://www.bbc.co.uk/pressoffice/pressreleases/stories/2007/08_august/15/torchwood.shtml (6 January 2012).
53. Hills: *Fan Cultures*, p. 137.

54. Sara Gwenllian-Jones, 'The Sex Lives of Cult Television Characters', *Screen* 43/1 (2002), pp. 79–90, p. 83.
55. BBC. 'BBC – Torchwood – The Show'.
56. Richard Berger, 'Screwing Aliens and Screwing with Aliens', in A. Ireland (ed), *Illuminating Torchwood: Essays on Narrative, Character and Sexuality in the BBC Series* (Jefferson, North Carolina, 2010), p. 72.
57. Nelson: *State of Play*, pp. 74.
58. BBC Trust. 'BBC One Service Licence. *BBC Online* Tuesday 8 April 2008. Online. Available http://www.bbc.co.uk/bbctrust/assets/files/pdf/regulatory_ framework/service_licences/tv/2008/bbc_one_Apr08.pdf (10 February 2012), p. 5.
59. Ibid., p. 1.
60. See Julian Petley, 'Public Service Broadcasting in the UK', in D. Gomery and L. Hockley (eds), *Television Industries* (London, 2006), pp. 42–4.
61. Nelson: *State of Play*, p. 56.
62. Williams: 'Cannibals in the Brecon Beacons', p. 68.
63. Matt Hills, 'Torchwood Miracle Day, Episode Seven: Who's Buying Who?', *Antenna: Responses to Media and Culture* Friday 26 August 2011. Online. Available http://blog.commarts.wisc.edu/2011/08/26/torchwood-miracle-day-episode-seven-whos-buying-who/. (10 February 2012).
64. Simon Brown, 'Cult Channels: Showtime, FX, and Cult TV', in S. Abbott (ed), *The Cult TV Book* (London, 2010), p. 157.
65. See also Matt Hills, 'Torchwood Miracle Day, Episode Six: Stuck in the Middle?', *Antenna: Responses to Media and Culture* Friday 19 August 2011. Online. Available http://blog.commarts.wisc.edu/2011/08/19/torchwood-miracle-day-episode-six-stuck-in-the-middle/ (7 March 2012).
66. Matt Hills, 'Torchwood Miracle Day, Episode Three: Tonight's the Night?', *Antenna: Responses to Media and Culture* Friday 29 July 2011. Online. Available http://blog.commarts.wisc.edu/2011/07/29/torchwood-miracle-day-episode-three-tonights-the-night/ (10 February 2012). See also Williams in this book.
67. Ibid.
68. Hills: *Triumph of a Time Lord*, p. 223.
69. Kim Newman, *BFI TV Classics: Doctor Who – A Critical Reading of the Series* (London, 2005), p. 114.
70. Williams: 'Cannibals in the Brecon Beacons', p. 68.
71. Susan Murray, 'Selling TV Formats', in D. Gomery and L. Hockley (eds), *Television Industries* (London, 2006), p. 96.
72. See, for example, Amy Holdsworth, *Television, Memory and Nostalgia* (Basingstoke, 2011), pp. 105–7.
73. Chapman, James, 'Not "Another Bloody Cop Show": *Life on Mars* and British Television Drama', *Film International* 7/2 (2009), p. 16.

'COOL BUT HIGH QUALITY': *TORCHWOOD*, BBC AMERICA AND TRANSATLANTIC BRANDING, 1998–2011

Gareth James

In June 2010 it was announced that *Torchwood*'s fourth season would be a co-production between the BBC and the American pay cable channel Starz. The deal can be understood as part of the BBC's changing relationship as a public broadcaster and global corporation to the US and global television markets since the late 1990s, and *Torchwood*'s success on cable channel BBC America from 2007. *Torchwood* emerged at a time of significant adaptation for the BBC and the television industry as a whole in the mid-2000s, with a boom in digital technologies intensifying the global interaction of branded networks and programmes. Marketing strong brand identities across media and international audiences has become an increasingly crucial strategy for retaining audience loyalties as viewing options multiply. While consistent thematic value across network lineups is stressed, individual television programmes are also developed and promoted to appeal to a range of international and specialist audiences, while being re-packaged for ancillary markets.

In this context, *Torchwood* can be primarily viewed as part of contemporary trends for mainstream cult programming, and particularly cult fantasy series, balancing appeals to small but passionate

audiences with genre settings and mythologies against more conventional plots and character identification. Building on earlier precedents like *Star Trek* or *The X-Files,* new digital markets and global co-production have increased the potential of programmes like *Battlestar Galactica, Lost* and the BBC's *Doctor Who* to become crossover hits and multimedia franchises. At the same time, individual programmes seek global accessibility in ways ranging from international casts and settings to standardised formats.

Torchwood primarily fits into these trends as a more adult-themed spin-off from *Doctor Who*, combining a science-fiction mythology with episodic investigations and content spanning sex, violence and relationships. Moreover, by tying together a Welsh setting with influences from an American cult series, *Torchwood* has participated in a broader impulse towards transatlantic appeal for the BBC in seeking out US distribution. With international deals managed by the corporation's commercial arm BBC Worldwide, the Starz co-production reflected an ongoing process of reducing risk by seeking out transatlantic and global audiences. This chapter aims to significantly expand on *Torchwood*'s crucial role in the development of these strategies, providing a history of how the series' hybrid qualities as a mainstream cult hit mapped onto broader efforts by the BBC to consistently brand itself for the US market.

A particular focus can be how *Torchwood* related to BBC America as a hub for exhibiting and marketing BBC programmes and the brand as a whole from its launch in 1998, negotiating audience loyalty with the promotion of series for remakes and licensing of rights as franchises. Central to this brand-building have been variations on longer negotiations over transatlantic value between the BBC's reputation for public broadcasting quality and more commercial marketing of programmes, often in partnership with American networks and studios. The chapter will argue that *Torchwood*'s 2007 premiere bridged a range of experiments in combining these approaches, with its mainstream cult status blending Anglophile loyalty on BBC America with fantasy genre formats.

Closely linked to, but also distinct from the parallel success of *Doctor Who*, *Torchwood*'s move to Starz in 2011 subsequently emerged within a series of ownership shifts over its parent show. In this way *Torchwood* led trends for a current wave of transatlantic cult series while adapting in 2011 to experimenting with new options

for extending Anglo-American partnerships. By first exploring shifts in the BBC's US identity by the 1990s and then exploring the development of BBC America as a channel brand from 1998 to 2002, it is possible to examine how *Torchwood* significantly built on mainstream cult experiments from 2003 to 2009, before contextualising the move to Starz against *Doctor Who* and wider trends by 2011.

Transatlantic relationships: the BBC in America

The BBC's relationship to the American and world television market has rarely been static. The BBC has traditionally represented an ideal for public broadcasting as a vital part of everyday life, from radio in the 1920s to the post-war growth of television.[1] Funded in the UK by licence fees, the BBC's historical mandate has been to cater to a wide range of audiences with a mixture of entertaining and educational programming. By contrast, the American television industry grew in the post-war era from broadcast networks NBC, CBS and ABC as off-shoots of advertising and sponsor-funded radio networks, with a stronger mandate for commercial appeal to wide audiences. Crossover between the two industries, early leaders in English-language broadcasting, has however been a significant part of their development.

Production format exchanges and a shared grip on distributing programmes to worldwide television markets allowed for multiple crossovers, particularly after the rise of ITV as a commercial competitor to the BBC by the 1960s.[2] Jeffrey Miller suggests that US and British television exchange intensified in the late 1960s and early 1970s as distribution deals with American non-profit network PBS aligned with efforts to attract a range of viewers with programmes either tailored for international audiences, or specialised as examples of British quality.[3] For the latter, the early success of PBS-broadcast comedies like *Fawlty Towers* and *Monty Python's Flying Circus*, science-fiction series like *Doctor Who*, and costume dramas produced early examples of a cult-like following for British television on American screens.

The value of this partnership increased in the 1980s and 1990s as corporate mergers and new technologies streamlined the global production, distribution and marketing of programming for new

exhibition outlets. Video and cable technology joined to new networks and channels, from Channels 4 and 5 in the UK, and SKY satellite television in Europe, to US broadcaster FOX and a range of subscription and advertising-supported channels like HBO and MTV in the USA. As television choices and methods of delivery expanded, television companies faced increasing challenges to brand themselves for audiences.

As an industrial strategy, branding can be understood through the cross-promotion of copyrighted properties across media platforms, with the aim of retaining audience loyalty to consistently marketed themes, values and packaged entertainment services beyond single productions. Film branding trends in the 1980s and 1990s intensified strategies for packaging and cross-promoting productions as part of wider merchandising empires and conglomerate ownership, while aggressively marketing more specialist labels through specialist outlets. Television branding evolved within these strategies, with Catherine Johnson identifying an exchange between network, or channel branding, and programme branding by the end of the 1990s.[4]

Network branding involves the creation of an exhibition identity based in consistent slogans, programme schedules and promotional campaigns emphasising demographic and thematic value. This approach became particularly valuable for networks seeking out more specific cross-media demographics from the 1980s, with MTV and Nickelodeon in the USA representing key examples. By comparison, programme branding has increased in importance over the past fifteen years as digital distribution and global merchandising intensified the marketing of distinctive formats able to generate surplus merchandise and commercial tie-in opportunities.[5] Successful early examples of an exchange between strong network brands and programme franchises included *The Simpsons*.

The BBC therefore found itself under pressure by the mid-1990s to compete on a global stage with strongly branded channels and distinctive content, while retaining national public service values. Supported by Conservative and New Labour deregulation of exports and encouragement of commercial partnerships, BBC Worldwide was created in 1994 to distribute programming, manage BBC-branded channels and exploit the commercial potential of properties within and outside of the UK.[6] Intended to return profits

back to the licence-fee funded BBC, Worldwide targeted increased levels of transatlantic collaboration and US distribution. From 1998 this involved developing BBC America as a hub for expanded transatlantic activity.

'Completely British: completely different': launching BBC America: 1998–2002

BBC America was the most high-profile of a range of new international channel experiments for the corporation in the late 1990s. Having made previous investments in European and Middle Eastern cable markets, while adding new UK digital channels to rerun the BBC archives, the corporation entered into a deal with documentary and nature brand Discovery Communications for BBC America in 1997. Designed to win revenue from advertising and a percentage of profits from cable and satellite operators, BBC America was initially based in Maryland and was led by Paul Lee as general manager.[7] Lee's first challenge was to create a channel lineup and marketing campaign that could establish a strong brand identity for advertisers and operators.

To do so, the channel had to remain consistent with the public service principles of its corporate parent, while positioning itself as more commercially appealing than previous associations between the BBC and non-profit American broadcasters like PBS. The corporation primarily targeted affluent, predominantly urban, aged 18–49 and 25–54 US demographics, a group traditionally defined by 'quality' over audience size, and reached through distinctive programming soliciting cultural value alongside familiar entertainment genres and appeals. A long-term strategy for selling British television to American partners as quality entertainment, competition for this demographic was fierce by 1998, both from primetime shows on broadcast television and established pay cable channels like HBO.

HBO had begun to shift its brand away from uncut movies and sports to more high-quality original programming in the period, through series like *Sex and the City* and *The Sopranos* that promoted creative and censorship freedoms alongside high production values. Deborah Jaramillo suggests that HBO demonstrated the value

of primarily marketing a whole specialist channel around quality programming. Able to both attract lucrative demographics while generating content for re-packaging for foreign television and emerging DVD markets by corporate owner Time Warner, HBO led a boom in cable as a home for new programming and alternative business television business models in the 2000s.[8]

BBC America's greatest asset – the iconic status of the BBC brand and its predominant associations with quality programming for non-commercial outlets like PBS – carried some branding complications, however. Discussions of the channel's early marketing by DeSanto, Petherbridge[9] and Becker[10] focus on the difficulty of breaking free from perceptions of costume dramas and nature documentaries to promote BBC programming as something 'more modern, relevant and cutting-edge'.[11] Between 1998 and 2001, the channel approached this problem by re-packaging British series as attractive to an Anglophile cult audience that could act as the base for later, more general quality marketing and particular hit series.

Launched on 29 March 1998, BBC America had increased its programming from 6 to 24 hours a day by 2000. The initial schedule included news, repeats of established cult series like *Fawlty Towers,* and new primetime series from the UK. Emphasising the latter became an important strategy for BBC America in distinguishing itself as an exclusive alternative to other BBC ventures, with industry newspaper *Daily Variety* noting that the channel provided 'stateside exposure to the kind of gritty contempo drama and cutting-edge comedy that the pubcaster currently has a hard time selling to US webs'.[12] Early successes included *Absolutely Fabulous,* the surreal comedy *The League of Gentlemen* and twenty-something drama *This Life.* Moreover, BBC America became an important home for more regionally-based BBC programming such as *Hamish MacBeth* that would have otherwise struggled to gain wide distribution. Similar success was found with fantasy miniseries *Gormenghast* in 2000 which ran on the channel a year before its premiere on PBS.

Establishing BBC America as the exclusive destination for BBC programming also overlapped with increased co-production deals for documentaries, original films and miniseries with HBO, maintaining a small but valuable parallel presence in the pay cable market. Particular successes included the epic miniseries *Band of Brothers* in 2001, and built on a history of co-productions between the BBC

and US cable partners. At the same time, BBC America benefited from productions developed with multiple international partners, most notably 1999's documentary series *Walking with Dinosaurs*. This was joined by growing success with a lineup of reality, life-style and game-show programming in the same period. Cheaply produced and extensively scheduled across daytime and evening slots, series like *Castaway*, *Changing Rooms*, *Ground Force* and *The Weakest Link* provided strong ratings as formats that could be easily marketed to general audiences and advertisers.

Between 1998 and 2001, BBC America attempted to collectively market this broad mix of programming to Americans as a brand appealing to diverse forms of Anglophilia, or a love of British culture. DeSanto and Petherbridge suggest that the BBC linked the channel to late 1990s trends for 'Cool Britannia', aligning with the international popularity of Britpop, London fashion and the film industry.[13] This included efforts to build viewer loyalty through British culture-themed newsletters and the websites bbcamerica. com and britbeat.com. A transatlantic brand identity was defined in this context by a form of Anglophilia that framed British culture as a boutique choice for discriminating audiences and stressed craft, social commentary and cosmopolitan entertainment.

For BBC America's Paul Lee, the channel's programming could act as a gateway to promoting British media culture as a whole, where the 'best stuff being produced is very fresh, not backward-looking at all, and reflects the buzz of England right now. We'd love to create a cult audience for that in the States'.[14] Lee's empha-sis on a specific Anglophile brand of cult television reflected the changing perception of 'cult' appeal within the industry. From rare examples of marginal but much-loved series, cult television's value for attracting niche audiences and its frequent embodiment in genre or fantasy programming – able to generate merchandise and adaptations to new media – provided strong material for branding channels and franchises. However, Lee's linking of cult television through Anglophilia also demonstrated an awareness of the term's links to forms of subcultural identification, in this case to hip forms of London-based and wider British culture.

With the channel reaching 15 million viewers by the end of 2001, new marketing campaigns attempted to target different audience segments while promoting the overall quality of the brand. While

retaining the hard-core cult viewers who wanted a stream of British programming, broader campaigns could reach potentially much larger quality audiences able to bring BBC America higher advertising rates. In 2001 the channel therefore hired two advertising agencies to develop complementary marketing campaigns. The East Coast-based Arnold Worldwide, which had previously worked with Volkswagen, provided national campaigns that highlighted the quality and cosmopolitanism of the BBC America brand. By comparison, KB&P, a small San Francisco agency, worked on lower budget promotions that emphasised cult comedies as irreverent entertainment for younger audiences. The overall aim for the channel's marketing manager Kate Meyer therefore became to reinforce a brand identity as 'cool, but high quality', with new slogans identifying BBC America as 'Completely British. Completely Different'.[15]

By 2002, BBC America's increasingly settled brand identity, ratings and advertising revenue led to it being described by the corporation as a 'model for other markets around the world'.[16] This worked in several ways. While providing brand loyalty for advertisers and the corporation, the channel also acted as a springboard for marketing BBC content on new digital platforms. Nicki Strange suggests that the BBC's digital strategy in the early 2000s reacted to perceived risks over digital start-ups by adapting already proven marketing campaigns and channel programming strategies.[17] While targeting a long-term convergence of media content on digital platforms, BBC America tested out new forms of distribution like On Demand, as well as interactive marketing content on bbcamerica. com as bonus extensions of a strong overall channel identity. The more advanced digital infrastructure of the US market also made it valuable for finding distribution, exhibition and marketing strategies that could be shared across transatlantic markets.

One of the key elements in this strategy was to use fast-growing cable channels like BBC America as launchpads for programmes that could be re-worked into branded vehicles for advertiser tie-ins, franchise licensing and new media extensions. Globalised markets demanded productions that could cross borders, highlighting regional specificity and international accessibility.[18] Reality television and game shows became early ideals for this process, with clearly defined formats easily reconfigured for local hosts, contestants, and culturally specific questions and challenges. By 2002 BBC America

contributed to this process by building awareness for American remakes of *The Weakest Link*, while also experimenting with a New York-set special of *Ground Force*.

Adapting British comedies and dramas for American television presented greater challenges, however. *This Life* and sitcom *Coupling*, both well received on BBC America, were failures when remade for NBC and reflected longer-term problems in adapting British programmes rooted in culturally specific humour, themes and politics for US audiences.[19] A divide consequently opened between BBC America's core Anglophile fans, where national authenticity was key to brand loyalty, and the continued drive to broaden audiences. In this way, challenges remained by 2002 for making BBC America a more widely recognised brand capable of anchoring BBC Worldwide's broader pursuit of Anglo-American and other transnational hybrids. Between 2003 and 2009 the channel targeted programming that could balance these appeals, and found particular success with cult fantasy series like *Doctor Who* and, to an arguably more significant extent, *Torchwood*.

'The essence of the channel': *Torchwood*, cult fantasy and transatlanticism, 2003–2009

BBC Worldwide experienced a number of key institutional changes between 2003 and 2004. CEO Rupert Gavin was replaced by John Smith in 2003 after a series of clashes between Gavin and BBC Director-General Greg Dyke, and a renewed emphasis was placed on streamlining the division as an extension of, rather than an distinct entity from, the core BBC brand.[20] Questions over the BBC's near-monopoly of British programme distribution also led to revised agreements with independent producers to carry non-BBC content from producers such as Hat Trick and Kudos that had originally aired on ITV and Channel 4 in the UK.[21] The decision had a significant impact on BBC America's programming lineup, bringing a number of more broadly-marketed and adult-themed series like *Footballers' Wives*, *Bad Girls* and *Teachers* to the channel by 2005.

Shifting BBC America away from solely being an outlet for the broadcaster to a promotional site for contemporary British programming also coincided with the departure of CEO Paul Lee in 2004

and the appointment of American executive Bill Hillary. Moving the channel's base from Maryland to New York, Hillary pushed for stronger transatlantic partnerships, a policy continued from 2006 by his successor Garth Ancier. The channel had already benefited under Lee in 2003 and 2004 from a number of key series that had gained significant critical attention and ratings success, refocusing transatlantic quality appeals around the slogan 'Advanced Viewers Only'. The summer 2003 premiere of lesbian-themed costume drama *Tipping the Velvet* in 2002 was particularly held up by the American press as embodying the channel's more provocative identity, with *USA Today* reflecting on how 'this is not the snooty BBC we used to know'.[22]

The identification of the BBC America and the BBC brand as a whole with mainstream cult television reached a new landmark in the period with the US premiere of *The Office*.[23] Mixing a fly-on-the-wall documentary spoof structure with acidic humour, its transatlantic appeal lay in both a distinctly English setting, but also in the influence of more offbeat, adult-themed US cable comedies such as HBO's *The Larry Sanders Show* and *Curb Your Enthusiasm*. *The Office* went on to embody a new ideal for British-made programmes that could cross from Anglophile to more mainstream US tastes by combining a local sensibility with an American-styled format. These hybrid appeals acted as a prototype for more successful American remakes, with NBC's adaptation of the series as *The Office: An American Workplace* identified by Jeffrey Griffin as successfully translating the original strengths of the British format into more specifically American plots, character types and cultural references.[24] Demonstrating BBC America's increasing value as an Anglophile platform for individual transatlantic programmes, *The Office* was joined by 2007 by a string of successful cult fantasy series.

Cult fantasy programming had become an increasingly valuable part of BBC America's schedule by the mid-2000s. Deals to feature more non-BBC programming included the licensing of older cult and more mainstream hits such as *The Prisoner* and *The Avengers* in daytime slots.[25] Partnerships with Kudos Productions also led to a successful US reception for time-travelling police drama *Life on Mars* in 2006. However, in 2007 the focus of British fantasy series in the USA was squarely on *Doctor Who* and *Torchwood*. The successful reboot of the former in 2005 formed part of what Roberta

Pearson views as a boom in mainstream cult television in the period, embodied by US hits like *Lost,* promoted across traditional and new media platforms to global fans.[26] The new incarnation of *Doctor Who* – pitched to cult fans, family and general audiences – served as a landmark series for the BBC and represented one of the corporation's most successful global franchises by 2006. However, it was arguably *Torchwood* that had a more immediate impact on BBC America between 2007 and 2009, reflecting a brief but important gap in programme ownership for the corporation.

Doctor Who was first licensed in the USA to the Sci-Fi Channel in 2006, rather than the BBC-branded channel. Although it picked up repeat rights later that year, the decision reflected how much, at least in 2006, *Doctor Who* was considered a more appropriate fit for other channels. With a long history of airing on PBS stations, and with support from Canadian broadcaster CBC, the series had the potential to reach a much larger audience on the more-established science fiction-branded channel. It is also important to remember that *Doctor Who* was also a lucrative children's brand in terms of merchandising for BBC Worldwide, reducing some of its continuity with the more adult-themed BBC America. However, the decision was later acknowledged as lacking foresight by BBC Worldwide, with Ancier admitting that 'we wouldn't have sold it' to another channel if given the chance again.[27] The recognition that a cult series like *Doctor Who* could reach a wide range of audiences led to the decision by the channel to later invest in the similarly pitched, if less successful, *Robin Hood* and ITV1's *Primeval*.

By contrast, *Torchwood* was arguably an ideal fit for BBC America, arriving in *Doctor Who*'s first-run absence to become the channel's most important ratings and brand-building series in 2007 and 2008. *Torchwood* premiered in September 2007, and the second season followed in January 2008 and became the channel's highest-rated series, attracting an average of 750,000 viewers per episode.[28] Planned by Russell T. Davies as a darker complement to *Doctor Who*, *Torchwood*'s kinetic visual style, adult content and thematic maturity distinguished it on its 2006 BBC3 premiere. The more specialised digital channel, sharing BBC America's younger upscale focus, offered further opportunities for streamlining the relationship between a maturing UK digital infrastructure and the niche US brand. Moreover, while still a cult fantasy series, *Torchwood*'s

BBC3 roots drew it closer to the wave of more adult-themed, urban-styled BBC, ITV and Channel 4 series that had contributed to BBC America's exclusive appeal.

Torchwood was significant in this respect for containing more distinct Anglophile appeals within a transatlantic format, sharing the crossover flexibility demonstrated by *The Office* in 2004. In this context, Matt Hills offers a definition of the series' international identity as

> less mid-Atlantic or transatlantic than bi-Atlantic, indicating a textual hybridity of U.S. TV industry form and Welsh TV industry content that seeks to intertextually link conventions and styles of U.S. genre and cult television with a very much localised agenda.[29]

The series' Cardiff setting, idiosyncratic cultural references and regional accents therefore provided Anglophile appeal within a format combining American crime procedural and science-fiction appeals alongside influences from contemporary British realist comedy and drama.

While sharing a BBC Wales production base with *Doctor Who* and co-financing by Canadian broadcaster CBC for its first year, *Torchwood* was more clearly in line with BBC America's history of adult, primetime programming, with Hills noting how early reviewers described the series as '*This Life* meets *The X-Files*'.[30] For BBC America executive Richard de Croce, *Torchwood* could act as a signature series able to represent 'the essence of the channel – it's sexy, action-packed and a little bit subversive'.[31] Compared to *Doctor Who*'s co-licensing between the Sci-Fi Channel, BBC America and by 2009 individual PBS stations, *Torchwood*'s exclusivity led Ancier to emphasise the importance of getting 'the brand credit for it, which is very important to BBC America'.[32]

Its signature status also linked together a revamp of the weekly schedule by the end of 2007. This involved dividing the week into themed primetime blocks, from 'Murder Mondays' (thrillers), to 'Tuesday Nitro' (action), 'Wicked Wednesday' (soaps), 'Big Thursday' (personality-led chat and reality series), 'Crime Scene Fridays', and 'Adventure Sundays'. *Torchwood* led 'Supernatural Saturdays' alongside repeats of *Doctor Who*, *Primeval*, *Life on Mars*, co-production *Jekyll* in 2007 and the independently produced import *Hex*.[33]

Torchwood's branding value worked here through its ability to tie together various theme nights, combining elements of crime procedurals, action series, and adult soaps.[34]

While *Doctor Who* had established a wider reach by 2008 as one of the corporation's most iconic programme brands, *Torchwood* had a more comprehensive role to play in reinforcing BBC America as the stable base for the corporation's brand identity in the USA. This signature appeal extended to the series' use as a test site for new distribution ventures, becoming one of the first BBC programmes to be licensed to iTunes in April 2008.[35] In this way, *Torchwood* represented a unique variation on the BBC's Anglophile-shaped cult and mainstream marketing and production strategies. Taking a broad view of the series as part of its institutional history through BBC America is important for understanding why its specific variation on these cult and mainstream cycles achieved success in this period. No less complex than *Doctor Who*'s multiple audience appeals, *Torchwood*'s particular suitability to BBC America's brand history and marketing in 2007 and 2008 makes it a more specific touchstone for understanding the corporation's recent transatlantic identity.

However, *Torchwood*'s importance for BBC America peaked in the summer of 2009 with the five-night special 'Children of Earth'. Marketed as a major event for the channel brand, it accompanied a new high-definition channel feed and was supported by new episodes of *Doctor Who* and the launch of the supernatural drama *Being Human*. Helping BBC America to its highest week of ratings to date,[36] *Torchwood*'s cross-promotion with *Being Human* reflected the latter series' influence, with its local Bristol setting and format influences from US cult fantasy extending Hills' 'bi-Atlantic' approach to production. The popularity of regionally based British programming extended in the same period to Channel 4's *Skins* and superhero-themed *Misfits*. However, the promotion of new *Doctor Who* specials marked a turning point for *Torchwood*'s particular future on the channel, with BBC Worldwide acquiring exclusive first-run rights to the parent series from 2010.[37] *Doctor Who*'s re-positioning as the channel's signature series saw *Torchwood* take on a more specialist appeal, reflecting new experiments in merging channel and programme branding for BBC Worldwide.

BBC America's role as a site for Anglophile programming had established the channel as a vital link in BBC Worldwide's global

branding success, with the division as a whole passing $1 billion in sales by 2008.[38] After ten years, BBC America's Anglophile base and launch of individual programme brands remained crucial for transatlantic partnerships, but still experienced pressure to produce more easily marketable hybrids. Problems over adapting British sensibilities were repeated with US-produced remakes like *Life on Mars* and *Viva Laughlin*, adapted from the BBC's *Blackpool*. More successful efforts included taking successful US crime formats and adapting them for British settings, a process most notably reflected by the ITV Studios and NBC-developed *Law and Order: UK* and the BBC America co-production *Luther*.

'Miracle Day': 2011

Torchwood's 2011 revival on Starz tied into these trends as a new kind of transatlantic hybrid for the BBC, building on the success of the BBC America brand but varying its appeals into a more specialist subscription context. With BBC America moving to support some of the production costs of *Doctor Who*, BBC Worldwide was able to negotiate a parallel deal with pay cable network Starz for a new miniseries of *Torchwood* after an initial deal with the FOX broadcast network fell through.[39] Starz, a 1990s-launched subscription film channel that followed HBO and Showtime in developing a specialist collection of original programming to distinguish its brand, extended the BBC's long relationship with the sector.

As previously noted, pay cable offered clear affinities with the BBC's licence-fee model, and while lacking the advertising revenue of broadcast network partnerships, provided important branding value as quality channels. HBO and Showtime had become key partners for the BBC and other British channels in the 2000s, with co-productions like *Extras* providing exhibition for series deemed too adult or offbeat for larger venues. In this way *Torchwood's* adult tone, losing ground to *Doctor Who* on the expanding BBC America, could find a new home on pay cable without sacrificing explicit content.

Pay cable had also proved that cult fantasy series produced for subscription audiences could still find rich afterlives on DVD and

other distribution markets, with HBO finding success with *True Blood* and *Game of Thrones*. Starz had already broken into this area with gory historical miniseries like *Spartacus: Blood and Sand* in 2010. While building on pay cable's precedent for cult series, *Torchwood* also achieved more particular success by stressing a bi-atlantic identity, making culture clashes between American, Welsh and English characters a central feature of its ten-episode season. This emphasis on disjuncture and alienation provided a more unusual response to the challenge of merging American and British sensibilities, foregrounding national difference as a way of both promoting and reflexively commenting on the difficulties of transatlantic exchange.

Again, this strategy saw *Torchwood* share links with BBC America's co-production of *Doctor Who*'s US-set season opener in 2011, but on a much broader thematic and format-wide scale. Reflecting a more conscious embodiment of cultural display and debate for its more specialist audiences, this carried over the Anglophile viewers of BBC America, and was also used as a marketing tool for the BBC's partnership with Showtime for *Episodes,* a comedy focusing on a failed attempt to produce an American remake of a British sitcom.

'Miracle Day' consequently acted as a new type of pay cable hybrid for the BBC, complementing the wide range of transatlantic-themed programming produced between the UK and the US and marketed primarily through BBC America. For the latter, *Doctor Who* and other cult fantasy series continue to anchor the crossover marketing of the channel, which now reaches approximately 70 million viewers. With Garth Ancier replaced as the CEO of BBC America by Herb Scannnell in 2010, this reliance on cult series also extended from 2011 to include modifying the British-only schedule to acquire repeats of *The X-Files* and *Battlestar Galactica*, which were put into rotation during the day.

Conclusion

Whether as a landmark in the evolving transatlantic identity of BBC America, or as a prototype for more specialised Anglo-American partnerships, *Torchwood* has played a crucial role in the BBC's

shifting relationship to the US television market. The series' most recent incarnation on Starz reflects a long process of brand-building which has targeted solutions to the corporation's attempts to generate transatlantic appeal through BBC Worldwide in the 1990s and 2000s. Moreover, *Torchwood*'s embodiment of cult fantasy tropes as one way of finding 'bi-Atlantic' appeal was also linked to, but arguably distinct from, *Doctor Who*'s success in the past few years. While in some respects the result of an ownership delay for the parent series, *Torchwood* was perhaps the most comprehensive hybrid of the BBC's transatlantic branding strategies in the 2000s, tying into and taking forward the corporation's 'cool but high quality' identity.

Notes

1. For arguably the most comprehensive history of the early BBC and British broadcasting as a whole see Asa Briggs, *The History of Broadcasting in the United Kingdom* (Oxford, 1995).
2. See Michele Hilmes, *Network Nations: A Transnational History of American and British Broadcasting* (London, 2011) for a recent overview of the relationship between the two industries.
3. Jeffrey Miller, *Something Completely Different: British Television and American Culture* (London, 2000).
4. Catherine Johnson, 'Tele-branding in TVIII: The Network as Brand and the Programme as Brand', *New Review of Film and Television Studies* 5/1 (2007), pp. 5–24.
5. Johnson: 'Tele-branding in TVIII', p. 7.
6. Jeanette Steemers, *Selling Television: British Television in the Global Marketplace* (London, 2004).
7. Adam Dawtrey, 'BBC and Discovery Form Joint Venture', *Daily Variety*, 20 March 1998, p. 5.
8. Deborah Jaramillo, 'The Family Racket: AOL Time Warner, HBO, *The Sopranos*, and the Construction of a Quality Brand', *Journal of Communication Inquiry* 26/4 (2002), pp. 59–75.
9. Barbara DeSanto and Jo Petherbridge, 'BBC America: How Britain Won the Colonies Back', in D. Moses and B. DeSanto (eds), *Public Relations Cases: International Perspectives* (London, 2002), pp. 39–50.
10. Christine Becker, 'From High Culture to Hip Culture: The Transformation of the BBC into BBC America', in M. Hampton and J. Wiener (eds), *Anglo-American Media Interactions, 1850–2000* (New York, 2007), pp. 275–94.
11. DeSanto and Petherbridge: 'BBC America: How Britain Won the Colonies Back', p. 41.

12. Dawtrey: 'BBC and Discovery Form Joint Venture', p. 5

13. DeSanto and Petherbridge: 'BBC America: How Britain Won the Colonies Back', p. 48.

14. Lawrie Mifflin, 'A BBC Cable Channel is on the Way to the US', *New York Times*, 9 December 1997, p. 1.

15. Justin M. Norton, 'BBC Taps Two Shows', *Adweek*, 12 March 2001.

16. BBC Worldwide, *Annual Report 1999–2000* (London, 2000), p. 14.

17. Nicki Strange, 'Multiplatforming Public Service: The BBC's "Bundled Project"', in J. Bennett and N. Strange (eds), *Television as Digital Media* (Durham, 2011), pp. 132–57.

18. Albert Moran, 'Introduction: "Descent and Modification"', in A. Moran (ed), *TV Formats Worldwide: Localizing Global Programs* (Bristol, 2009), p. 15.

19. Iain Robert Smith, '"It's a Very Curious English Thing": Failed Pilots for American Remakes of British Television', *Flowtv.org*. Online. Available http://flowtv.org/2011/08/failed-pilots/ (4 August 2011).

20. Erich Boehm, 'Gavin: BBC Shift is not Setting Rift', *Daily Variety*, 12 March 2001, p. 25.

21. John Dempsey, 'BBC US Doubles Budget', *Daily Variety*, 20 January 2005, p. 35.

22. Jeff Germillion, 'Sex, Please, We're British; BBC America is Cable's Latest Darling, Serving Up Racy Comedy, Edgy Drama', *Adweek*, 9 June 2003.

23. For an overview of the development, success and broader contexts of the British version of *The Office*, see Ben Walters, *The Office* (London, 2005).

24. Jeffrey Griffin, 'The Americanization of *The Office:* A Comparison of the Offbeat NBC Sitcom and its British Predecessor', *Journal of Popular Film and Television* 35/4 (2008), pp. 154–63.

25. Anon. 'Programming', *Cablefax*, 13 May 2004.

26. Roberta Pearson, 'Observations on Cult Television', in S. Abbott (ed), *The Cult TV Book* (London, 2010), pp. 7–18.

27. Sam Thielman, 'BBC America Calls *Doctor*', *Daily Variety*, 28 May 2009, p. 3.

28. Eric Pfanner, 'BBC Finds Balance between Worlds is Tough to Strike', *The International Herald Tribune,* 3 March 2008, p. 13.

29. Matt Hills, '*Torchwood*', in D. Lavery (ed), *The Essential Cult Television Reader* (Lexington, 2010), p. 280.

30. Hills: '*Torchwood*', p. 280.

31. Sam Thielman, '*Who* Just Want US Nets Ordered', *Variety*, 11 February 2008–17 February 2008, p. 26.

32. Thielman: 'BBC America Calls *Doctor*', p. 3.

33. Kimberly Nordyke, 'BBC America Plays New Theme', *Hollywood Reporter*, 3 April 2007, p. 2.

34. For a good discussion of the practice and effect of themed night branding for broadcast networks, see Nancy San Martin, '"Must See TV": Programming Identity on NBC Thursdays', in M. Jancovich and J. Lyons (eds), *Quality Popular Television: Cult TV, the Industry and Fans* (London, 2003).

35. Robin Parker, 'BBC uploads new shows to iTunes', Broadcast, 19 February 2008.
36. Rick Kissell, 'Summer's Stalwarts', *Daily Variety*, 12 August 2009, News, p. 4.
37. Thielman: 'BBC America Calls *Doctor*', p. 3
38. BBC Worldwide, *Annual Report 2008–2009* (London, 2009).
39. James Hibberd, 'Starz Picks Up British Show *Torchwood*', *Hollywood Reporter*, 7 July 2010.

CULT YET? THE 'MIRACLE' OF INTERNATIONALIZATION
Benjamin W.L. Derhy*

Introduction

F ar from only having a cult-like following, *Doctor Who* – celebrating its fiftieth anniversary in 2013 – has been a major mainstream success in the UK for decades. It is with this extraordinary added baggage that *Torchwood* started on BBC3; a small spin-off from a massively successful programme, loved by three generations of Britons. This chapter analyses how the use of US cult television writers on Series 4 was received by the fans, and has therefore impacted *Torchwood*'s status as cult. Before doing so, however, the chapter briefly analyses 'cult TV as a part of broader patterns within changing TV industries',[1] particularly in relation to the cult's progressive merging with the mainstream label.

While there are still ongoing debates as to whether a programme is cult due to its production or its reception,[2] and while such a notion cannot be precisely, undoubtedly and holistically defined, many scholars, such as Jancovich and Hunt,[3] argue that in order to be deemed cult, a show must have a passionate and engaged audience. A mainstream programme, on the other hand, can be described as a 'cross-generational... prime-time show that

appeals... across the socio-economic groups', according to British producer John Bartlett.[4] Even though cult and mainstream have historically been opposite labels, such a rift is becoming superfluous due to the 'widening popularity' of cult texts.[5] 'As fandom diversifies', Jenkins explains,[6] 'it moves from cult status towards the cultural mainstream', resulting in 'mass cult', or 'sustained metacult',[7] as illustrated by the likes of *Doctor Who*, *The X-Files* or *Lost*.

Torchwood before 'Miracle Day'[8]

In order to evaluate how *Torchwood*'s status as cult or mainstream has evolved between 'Children of Earth' (COE) and 'Miracle Day' (MD), it is necessary to first assess the state of the programme as it was before the latest instalment.

Cult status

With regard to its production, in a noticeable effort to appeal to a cult audience the pre-'Miracle Day' *Torchwood*, particularly in 'Children of Earth', used several elements listed by the cult TV writer Jane Espenson as a means to encourage engagement from the audience, including complex story arcs, creating a world, having a documentary aspect and creating complex characters.[9] Being produced so, however, does not guarantee cult consumption. With regard to the latter, very involved, sometimes frantic, audience practices are clearly visible. The very active message boards,[10] counting millions of messages,[11] and overcrowded fan fiction repertories[12] all attest to the major following enjoyed by *Torchwood* prior to its *Miracle* days. Reviews and comments were also extremely positive, with 'Children of Earth' often being dubbed 'the best yet!' and described as 'incredibly compelling ... and powerful'[13] by fans. Perhaps paramount to their passion for *Torchwood*, however, is the memorial dedicated to Ianto set up at Mermaid Quay in Cardiff in 2009 after the character was killed; the memorial still exists to this day. Pre-'Miracle Day' *Torchwood* could, therefore, be deemed a cult programme precisely because of the way it was constructed as one by the audience.

Mainstream status

While *Torchwood*'s cult status had already been discussed in academia,[14] the show's position in relation to the mainstream received less attention, an issue which this book seeks to address. The latter, however, is particularly interesting as it further demonstrates the extent to which a cult programme can be successfully adapted to a mainstream audience, both textually and logistically.

'Children of Earth' made a number of changes in an apparent attempt to facilitate its viewing by a wider audience. Those included shifting the action to a major world city, cutting ties with its most cliché elements and changing the scale of the menace. The many changes undertaken by *Torchwood,* including of channels, proved rewarding as is evidenced by the ratings evolution. After an initial run on BBC3, averaging 1.4 million viewers, the second series moved to BBC2 before 'COE' upgraded to BBC1 and aired on five consecutive days, with an average of 6.5 million viewers each.[15] The show also performed well around the globe,[16] in particular in the USA, where 'COE' (along with *Doctor Who*) not only provided BBC America with its 'best-ever ratings' in 2009[17] with half a million viewers,[18] but also became 'number one in iTunes Top TV Seasons charts' in the USA.[19]

Nevertheless, while this evolution of the programme, both textually and in terms of ratings, may be seen as a sign of *Torchwood*'s tangible aptitude at becoming a mass cult programme on an international scale, the show certainly could not be so deemed just yet.

How 'Miracle Day's writers changed *Torchwood?*

While the core team, general theme and tone of the show remained unchanged in the latest series, the collaboration between BBC Wales, BBC Worldwide, and US premium channel Starz resulted in visible changes for the programme. Creator Russell T. Davies had already conceded wishing to imitate cult American programmes such as *Buffy* and *Angel* with *Torchwood* before the latter was even made,[20] certainly so as to appeal to a so-called cult audience as well as, to a degree, a mainstream one, by positioning *Torchwood* as part of what some deem quality TV, which encompasses the aforementioned Joss

Whedon programmes.[21] In his boldest move in that direction yet, *Torchwood*'s creator made one of the most notable changes by hiring cult (and mainstream) US writers (along with a few British ones) of the likes of Jane Espenson (*Angel, Battlestar Galactica, Buffy*), John Shiban (*Breaking Bad, Supernatural, The X-Files*), and Doris Egan (*Dark Angel, House, Smallville*) – while still retaining much of his creative power – in an obvious attempt to attract cult, or genre fans to the programme. Additionally, 'Miracle Day' used several of the cultish elements listed by cult writer Jane Espenson and outlined above.[22] For instance, while the story arc aspect was kept with one and the same intrigue lasting throughout the entire series, perhaps the most blatant change was that of the plot: in an ever ambitious move, the new writing team lead by Davies decided to go where no sci-fi series had ever gone before. Alien abductions, superheroes, or avant-garde technology had previously been incorporated. In order to potentially reach the imagination – and interest – of a broader public, the writers made the radical decision to stop all death on Earth. It is with this plot, probably requiring of the audience one of the highest levels of suspension of disbelief ever, that 'Miracle Day' took off.

In order to render the uncanny story more credible to the viewer, the writers blended factual reality elements with pseudo – or fringe – reality theories and beliefs. While the former concretised itself through in-camp modules meant to burn millions of people across the world, in a reimagining of Nazi barbarism, or through current and past catastrophes such as economic crises and global epidemics, the latter made use of the pseudoscience theory of morphic fields as well as of recurrent conspiracy theories such as the very American concept of '*FEMA* camps'.[23]

Another element noticeable at the outset was *Torchwood*'s sustained documentary facet, developed with 'Children of Earth'. This can be seen in Esther's investigation of the Torchwood Institute through both online databases and physical archives, in Rex following an autopsy on hospital security cameras, and in the heavy use of news reports to set the tone in the premiere. This reaches its paroxysm by mid-series, with Rex documenting the atrocities committed in the overflow camps from the inside with his handheld camera.

Remaining on the course set earlier on for the show, the writers maintained a high level of moral dilemma for both the characters and the viewers, notably through the soon-brought-forth wish to

terminate the 'miracle' and the immortality it brought to the human race in order to stop the disastrous consequences it was going to cause the latter. Other quagmires of the likes of what to do with an expanding population soon followed, along with Gwen and Jack's respective choice to kill one another if it meant saving themselves or their family, or the decision to sacrifice Jack, Rex and Esther so as to let humanity die.

The implementation of those same four elements – meant to theoretically further stimulate cult consumption – testifies once more to *Torchwood*'s intent to become a cult show. In the hope of also appealing to the broader American public, however, the writers also made a number of changes to the original format. For instance, the writers decided to play down aspects such as the British/ Welsh element, while, nevertheless, aiming it exotically towards the American and global audience. This resulted in an apparent Americanisation of *Torchwood* on several levels. First of all, in terms of characters, most of the show's parts, both lead and supporting, became American, the only regular with Welsh intonations being Gwen (Rhys being little featured overall, and Jack sporting his habitual US accent). The new blood brought by the all-American cast composed of Mekhi Phifer, Alexa Havins, Arlene Tur, Bill Pullman and Lauren Ambrose surely expressed 'this ain't Cardiff any more'. Furthermore, the general setting of the story most predominately featured LA California, leaving barely any room for Cardiff, and little for Wales. Finally, feeling liberated by the US cable policies – which are much less restrictive on aspects such as language, violence or sexuality than national networks – the American writers pushed each of these three things even further.[24]

Audience reactions

Cult status

As previously explained, *Torchwood* was already defined as cult by fans and academics alike long before 'Miracle Day' aired. By getting a new deal for an expensive international co-production, Davies and his team here in the UK had the opportunity to make *Torchwood* a true reference for the genre (of the likes of *Buffy* or *Battlestar*) by

retaining its current fans, and by gaining a new, larger cult following across the pond, which would subsequently construct the show as a cult text, in America this time.

Because directors frequently change in television, 'writers and stories become the focus for [fans'] validations of quality'.[25] Surprisingly enough, though, the background of the cult TV writers of 'Miracle Day' was totally disregarded by many fans, who were neither particularly appreciative of their presence – seeing it as a cult move confirming the cultness of the show – nor apprehended it cynically as a commercial attempt to exploit them. This is not to say, however, that faithful viewers were indifferent to the writers' performance, which was largely reproved. The decidedly violent criticisms, in a manner reminiscent of the concept of 'snarking',[26] could be divided into two categories: problems resulting from what was perceived as the writers' incompetence, and also various political agendas ascribed to the writers.

Most of the complaints related to the writers' skills concerned three main points, including the slow plot development, the disjointed storytelling and the lack of realism over details. First and foremost, the pace of 'Miracle Day' was colourfully bashed by the show's fan base, judging it had 'been dragged on like a half dead dog'. 'Jack Bauer would have had this wrapped up in a day'[27] several argued, referring to the heroics of the lead character in the series *24*. Other fans blamed the writers, whose plan, they believed, was to 'just come up with one plot and drag it on through the season'. Similarly, faithful viewers voiced their criticism of the 'very disjointed and uneven' storytelling,[28] with one fan summarising others' frustration in so many words: 'it's been diabolical. It's... completely inconsistent in pacing, plotting, and characters between the episodes.'[29] Finally, while the undying population plot was accepted fairly well, the writer's alleged lack of effort in terms of accuracy over details was heavily disliked: 'It would have been more believable to have had the Daleks... administering over the "Modules",' one said, while others confronted a thermal scan app: 'They really put the fiction into science fiction. How hard would it have been to have ... an actual thermal imager?'[30] or the wide, vertical crack: '[W]as it some kind of subconscious admission? "There is a giant, unfillable CRACK in this story!"' Here, the very violence exhibited in those debates outlines the idea that supportive feedback is not the

only form of output fostered by cult TV, which could hence be seen as an object exposed to very critical analyses, whether good or bad, from its ever-passionate audience.

Regarding the agenda attributed to the writers by the fans, the three main complaints were the commercial Americanisation of the programme, the so-called gay agenda and the left-wing propaganda. While the mere announcement of the deal with Starz for the anticipated new series had induced waves of criticism from British fans, the actual airing of the episodes triggered an overflow of disapprobation. Besides stating that 'every cliché about the Welsh... has been used', fans denounced the 'poor characterisation' which they attributed to the writers' wish to have *Torchwood* 'dumbed down for the US market'. Consequently, in accordance with their belief in the 'industry's tendency to ruin established shows in the pursuit of the mainstream audience',[31] fans felt 'the heart and soul has been ripped out of *Torchwood* by [this] re-positioning', which, they postulated, was 'clearly a commercial, rather than creative, decision'.

Furthermore, many fans deplored the number of sexual scenes, several even protesting to the BBC over the 'sex-fi' programme.[32] While some viewers explained that they did not 'believe a sci-fi show should contain' such scenes, deemed 'forced and purposefully explicit', most tackled the alleged gay agenda of the writing staff: 'Is the central theme about Captain Jack's gay liaisons, or is it a writer's indulgence?' many wondered, while several went as far as henceforth seeing the once charming hero as a 'sexual predator'. Finally, the last recurring item of blame concerned the way politics was handled in *Miracle Day*, an argument that 'It was like the writers had to hit the ... audience over the head with their continuous political messages'. Others expressed disdain for this political agenda as a 'left wing diatribe focused on promoting socialized medicine and anything liberal'.

Interestingly enough, apart from Davies, whose silence despite 'the growing criticism' was sometimes pointed out, the anger of fans was strictly directed towards the writers' work, regardless of who they were. Indeed, the writing staff was bashed in a general manner, the names of the writers per se being completely obliterated in the fans' feedback as demonstrated by the above quotes. While one might think this reflected the viewers' ignorance of who the writers were, it seems doubtful that such an engaged audience would

ignore – or not Google – which programmes Espenson, Shiban or Egan had previously worked on. Furthermore, that the individuality of the writers was practically invisible appears to show a deliberate snubbing of the writers resulting from the fans' frustration.

All in all, the vast majority of fans seemed to be disappointed by the directions the writers chose to take with 'Miracle Day', noting as one did 'It's a miracle that this dross was ever made', like many similarly constructed wordplays on the latest series, which they described as 'an insult to the viewer's intelligence', 'quickly descending into farce'. Fortunately for the writers, some positive feedback was nevertheless left by some, who described the fourth series as 'a bit overblown... and Hollywoodish, but with a gripping plot based on a good idea' and as an enjoyable 'sci fi drama with a likeable cast, well produced and well acted', which took 'risks exploring dark themes in humanity'. These comments were so overshadowed by criticisms, however, and paled in comparison to the violence of the latter, that they could hardly weigh in the balance. By October 2011, weeks after 'Miracle Day' had finished airing on both sides of the Atlantic, 87 fans (mainly British) had commented on writer Jane Espenson's BBC TV blog entry,[33] 71 per cent of whom were negative towards the writers and the series in general.[34] Strikingly similar results were obtained from more international reviews made on IMDb, where 71 per cent of the fans were likewise disenchanted.[35] This acute sense of dissatisfaction not only reflects how unpredictable cult fans' reactions can be, but further reiterates that cult programmes are as vulnerable as any other show.

While these comments and reviews were rather nonreticulate – each person giving his or her own opinion either as an independent comment to Espenson's entry or as a review on IMDb – in interconnected postings from forums where the notion of fan community is much more present, 'flame wars' erupted as fans' norms rubbed 'against each other'. For instance, on the *Torchwood Forum*,[36] or on the Starz forum,[37] those criticising the show were called 'trolls' by fans satisfied by 'Miracle Day', while the latter were, in turn, dubbed 'simple minded cretins' for liking it.[38] Each group denigrated the other and defined it as 'inauthentic', thereby presenting its own taste as 'inherently superior'.[39] This is a classic example of what I am terming an 'escalation of fanness', where different groups attempt to climb the fan community social ladder by affirming their prevailing

authenticity.[40] Two clans arise, here: the 'purists', who only care for the original concept, and the 'allegiant' ones, – greatly outnumbered – who will support the show, no matter what. Despite the very unbalanced result of this debate, what is most remarkable here is that it is precisely this pugnacity, these heated arguments and vehement condemnations of 'Miracle Day', in other words, this passionate involvement from the viewers, which constructs, or rather, reconstructs, *Torchwood* as a cult object. Indeed, while the statements of those who linked cult TV to 'the fervency of a program's audience support',[41] seem quite reductive as they only foreground supportive activities I would argue that *any* kind of frantic involvement is both characteristic of fandom and results in constructing texts as cult.

Despite illustrating the creativity and humour of the fans, and while fan disputes are literally what defines fandom, according to MacDonald,[42] the issue here is that this construction of 'Miracle Day' as a cult text is problematic. This is because the amount of criticism exhibited by these viewers was – in its vast majority – not so much against one another as against the text itself, and this therefore contradicts the supposed satisfaction fans ought to receive from watching a programme they feel strongly about. How long can this 'I love you, neither do I' endure before counterproductive consequences arise? In fact, fans on both sides of the Atlantic were so angered by the series, with a British fan labelling it 'A true tragedy in British Sci Fi', and an American one, 'The Worst Season Ever', that many said they would stop watching 'Torturewood' altogether, – some even stating they already had – which could seriously endanger the future of the show's cult following. Finally, it is interesting to note that fans primarily rejected 'Miracle Day' on their media (such as fora) instead of complaining to the production team through the quite common fan campaigns[43] in order to get an un-Americanised fifth series. One may wonder, therefore, if this may not be the sign of a latent disinterest in *Torchwood* which would thus no longer be worthy of such a campaign.

Mainstream status

Besides the justifications advanced earlier for discussing the mainstream reception of *Torchwood* in this chapter, I concur with Jancovich

when he argues that 'we must also be wary of the tendency to... present as more authentic the tastes and definitions of fans', and must therefore study and discuss the 'other sections of the viewing public'.[44] In addition to their opportunity to grow the fanbase with this co-production, *Torchwood*'s writers also had a chance to both enlarge and diversify their audience on either side of the Atlantic and perhaps even reach mainstream status. This attempt, however, proved unsuccessful. Despite a highly rated debut, overnight figures saw a rapid decline on BBC1, while remaining rather constant on Starz. With an average of 5.2 million viewers in the UK, 20 per cent less than 'Children of Earth', and 1.0 million in the USA,[45] (only half a million more viewers than the third instalment), *Torchwood* has not quite reached the world yet. To understand why 'Miracle Day' did not get better ratings – neither domestically nor abroad – it is once again necessary to turn to the text.

Regarding the British audience, the most easily identifiable reasons may be once again the alleged Americanisation of the show, as well as the amount of sex shown on 'Miracle Day', as evidenced by the 500 complaints sent to the BBC following the airing of episode seven, where the 'out of proportion... homosexual content' had led some viewers 'not to watch [*Torchwood*] any more'. Except when occasionally protesting after being shocked, however, mainstream viewers are much less vocal than those designated as cult. One must therefore strive to understand why the mainstream audience was not seduced. The most obvious reason might be *Torchwood*'s genre, sci-fi not necessarily mixing well with a mainstream audience. The emergence of mass cult programmes of the likes of *Lost* or *The X-Files*, however, and the better ratings of 'Children of Earth' indicate that such can only be a partial answer. Furthermore, as Syfy network President Howe[47] argued, 'The sci-fi... element in *LOST* is irrelevant to a lot of... people...; they're just drawn into ... the characters and the stories, [rather] than ... what's down the hatch.' While this remains possible with an enigmatic island, it does not with the planet becoming immortal. Secondly, the darker tone of 'Miracle Day' may have been a barrier for audiences. As a consequence of the horror, violence, threat and language[48]displayed onscreen, 'Miracle Day' was rated 14 in the USA[49] and 15 in the UK,[50] which can hardly have helped the show reach a mainstream audience.

Regarding the American audience, while any of the aforementioned reasons might have played a part in the programme's appeal,

it was obvious from the start that a massive numerical growth could not have happened. Indeed, pragmatically speaking, any results possibly achieved on Starz (which, despite having a bigger audience than BBC America, remains a small cable channel) would not have been high enough to enable *Torchwood* to become a mass cult programme in America. Such would require a co-production between the BBC and another major US network such as FOX or ABC. Only then would the show stand a real chance, would it manage to seduce audiences as much as 'Children of Earth' did in the UK. As for how one will be able to tell when Torchwood becomes mainstream, perhaps it will be when people think of Harkness rather than Sparrow when they hear of a Captain Jack.

Conclusion

Torchwood has come a long way from its unassuming early episodes to a big-budget, almost cinematic, ambitious production. Though initially highly anticipated, 'Miracle Day' did not live up to fans' expectations. Indeed, it appears that the use of cult television writers to attract a cult following was to no avail, as shown by the lack of response of fans regarding the writers' personalities or backgrounds. Besides, by doing too much to please a prospective American audience and adapt to a different pace, US writers have unwillingly estranged the current – British – fanbase, who, in a snarking manner, deemed 'Miracle Day' as so 'slow and drawn out', it 'puts you into a coma', and as 'stumbling from one unresolved incoherent idea to another'. A distinction seems to have subsequently occurred between what is now deemed by the BBC the 'Original UK Series'[51] and the new, American co-production. While the original show remains as cult as it was, 'Miracle Day' has been made into a cult object by the very debates and condemnations that have caused it to be treated as a failed offshoot of *Torchwood* by many angered fans who threatened to stop watching the programme. Such an outrage coming from three-quarters of *Torchwood*'s fanbase, who judged it as 'desperately disappointing' and having let its 'core fan base badly down', gives an intense example of how fans can be exasperated if they feel cheated by their programme, and how the creative staff should always attempt to remain true to a show's spirit. Money and location do little good if the writing disappoints. It furthermore

evinces that neither using cult television writers with successful track records nor using cultish textual elements guarantees any sort of success as longtime fans appear to have been much more sensitive to general issues such as the programme's Americanisation, the sex scenes, the political messages, the pace and minor inconsistencies, than to cult elements per se.

By illustrating how this very deconstruction of 'Miracle Day' by the audience from a critical standpoint has in fact constructed it as a cult text, this case study suggests that any form of passionate involvement, not simply positive ones, can construct texts as cult. Furthermore, these heated debates illustrate how unpredictable audience reactions can be and how we, as academics, should not necessarily expect fans to produce supportive material, even in relation to a formerly beloved cult programme of theirs.

Notes

* This chapter is dedicated to my cherished grandmother, Madeleine Derhy – ma petite Mamy de mon coeur – who truly was one of my two parents, and always surrounded my mother and I with unconditional love and support. I love you and miss you immensely.

1. 'Internationalization' was intentionally written with a 'z', to evoke the American writing style.
 Matt Hills, 'Defining Cult TV; Texts, Inter-texts and Fan Audiences', in R.C. Allen and A. Hill (eds), *The Television Studies Reader* (London, 2004), p. 522.

2. See Matt Hills, 'Mainstream Cult' in S. Abbott (ed) *The Cult TV Book* (New York, 2010); David Lavery, 'Introduction', in D. Lavery (ed), *The Essential Cult Television Reader* (Kentucky 2010); and Sara Gwenllian-Jones and Roberta E. Pearson, 'Introduction', in S. Gwenllian-Jones and R.E. Pearson (eds), *Cult Television* (Minneapolis, 2004), p. xvi.

3. Mark Jancovich and Nathan Hunt, 'The Mainstream, Distinction, and Cult TV', in S. Gwenllian-Jones and R.E. Pearson (eds), *Cult Television* (Minneapolis, 2004), p. 27.

4. John Bartlett, Research interview. Conducted on 11 May 2011.

5. Jancovich and Hunt: 'The Mainstream, Distinction, and Cult TV', p. 28.

6. Henry Jenkins, 'Interactive Audiences?', in V. Nightingale and K. Ross (eds), *Critical Readings: Media and Audiences* (Maidenhead, 2003), p. 285.

7. Matt Hills, 'Doctor Who', in D. Lavery (ed) *The Essential Cult Television Reader* (Kentucky, 2010), p. 102.

8. In order not to be influenced by 'Miracle Day', I wrote this section before it was aired.

9. Jane Espenson, 'Playing Hard to "Get" – How to Write Cult TV', in S. Abbott (ed), *The Cult TV Book* (New York, 2010), pp. 45–53.

10. Torchwood Forum. Online. Available http://www.torchwoodforum. com/ (6 July and 10 October 2011).

11. There were more than 415,000 posts for this forum alone as of 6 July 2011, before 'Miracle Day' aired.

12. Torchwood Fanfiction Archive. Online. Available http://www.fanfiction. net/tv/Torchwood/ (6 July 2011); Teaspoon: Torchwood. Online. Available http://www.whofic.com/categories.php?catid=16 (6 July 2011).

13. Multiple Reviews, '"Torchwood" Reviews & Ratings'. *Internet Movie Database*. Online postings. Available http://uk.imdb.com/title/tt0485301/ reviews (11 October 2011).

14. For instance, see Matt Hills, 'Torchwood', in Lavery: *The Essential Cult Television Reader*.

15. BARB. Weekly Top 30 Programmes search. Online. Available http://www. barb.co.uk/report/weeklyTopProgrammesOverview (28 September 2011). *BARB* ratings include viewers who recorded the programme and watched it within seven days. They do not include views on *iPlayer*.

16. BBC Worldwide. 'Entertaining the World', *Annual Review 2009–10*. Online. Available http://www.bbcworldwide.com/annual-review/annual-review-2010.aspx (11 July 2011), p. 34–5.

17. BBC Worldwide: 'Entertaining the World', p.28.

18. Robert Seidman, 'Everybody Loves NCIS, Even Young People', *TV by the Numbers*. Online. Available http://tvbythenumbers.zap2it.com/every-body-loves-ncis-even-young-people (26 September 2011).

19. Along with *Top Gear* and *Doctor Who*.

20. Ben Rawson-Jones. 'Davies: "Buffy", "Angel" Inspired "Torchwood"' *DigitalSpy.co.uk*. Online. Available http://www.digitalspy.co.uk/tv/news/ a38295 (11 July 2011).

21. Rhonda Wilcox, and David Lavery (ed), *Fighting the Forces* (Maryland, 2002), p. xxii.

22. Espenson: 'Playing Hard to "Get"', pp. 45–51.

23. Purportedly prospective concentration camps run by Homeland Security.

24. Espenson, quoted in Jenna Busch. 'Writer Jane Espenson on "Game of Thrones," "Torchwood" and "Geek Girls"'. *Huffington Post*. Online. Available http://www.huffingtonpost.com/jenna-busch/jane-espenson-on-game-of-_b_867257.html (3 June 2011).

25. Jancovich and Hunt: 'The Mainstream, Distinction, and Cult TV', p. 34.

26. See Sharon M. Ross, *Beyond The Box* (Oxford, 2008).

27. Multiple. Untitled comments to 'I'm One of the Scriptwriters for Torchwood: Miracle Day'. *BBC TVBlog*. Online postings. Available http://www.bbc. co.uk/blogs/tv/2011/08/torchwood-miracle-day.shtml (11 October 2011).

28. Dsrichard. 'Episode 8', Torchwood – Miracle Day – US Pace, *Digital Spy Forums*. Online posting. Available http://forums.digitalspy.co.uk/show-thread.php?p=52340811, p. 24 (2 September 2011).

29. Nattoyaki. 'Episode 8': Torchwood – Miracle Day – US Pace (8/7/11 on Starz). *Digital Spy Forums*. Online posting. Available http://forums. digitalspy.co.uk/showthread.php?p=52340811 (2 September 2011).

30. Katherinethecat. Comment 'Re: Thermal imaging app, seriously?' on 'Torchwood' (2006). Online posting. Available http://www.imdb.com/title/tt0485301/board/nest/187895558?d=187896831&p=2 (4 September 2011).

31. Jancovich and Hunt: 'The Mainstream, Distinction, and Cult TV', p. 30.

32. Chris Hastings, 'It's supposed to be sci-fi, not sex-fi', *Mail Online*, 29 August 2011. Online. Available http://www.dailymail.co.uk/news/article-2030953 (30 August 2011).

33. Jane Espenson, 'I'm One of the Xcriptwriters for Torchwood: Miracle Day', *BBC TV Blog*, 25 August 2011. Online. Available http://www.bbc.co.uk/blogs/tv/2011/08/torchwood-miracle-day.shtml (30 August 2011).

34. Eighty-four of whom critically commented on 'Miracle Day'. Out of these, two were neutral, 22 positive, and 60 criticised 'MD'. Individuals who made several comments were only counted once.

35. Of the 26 reviews, 21 were relevant, as five did not critically comment on 'Miracle Day', 15 were decidedly negative, and 6 positive.

36. Over 4,300 online messages posted regarding 'Miracle Day'.

37. Starz. Torchwood Message Board. Online. Available: http://community.starz.com/t5/Torchwood/bd-p/torchwood (10 October 2011). 7,600 online postings were made at this site.

38. Multiple. Untitled comments, 'A real let down...' Online postings. Available http://community.starz.com/t5/Torchwood/A-real-let-down-with-tired-writing-cheap-shots-and-PC-speak/td-p/143228/page/9 (10 October 2011).

39. Mark Jancovich, 'A Real Shocker', in G. Turner (ed), *The Film Cultures Reader* (Paris, 2001), p. 476.

40. For more see Pierre Bourdieu, *Distinction* (London, 1984) and Jonathan Gray, Cornel Sandvoss and C. Lee Harrington (eds), *Fandom: Identities and Communities in a Mediated World* (New York, 2007).

41. Robert Holtzclaw, 'Mystery Science Theatre 3000', in D. Lavery (ed), *The Essential Cult Television Reader* (Kentucky, 2010).

42. Andrea MacDonald, 'Uncertain Utopia', in C. Harris and A. Alexander (eds), *Theorizing Fandom* (New York, 1998).

43. For various examples, see Stacey Abbott (ed) *The Cult TV Book* (New York, 2010), pp. 15, 21, 131–3, 218–20.

44. Jancovich: 'A Real Shocker', p. 476.

45. TV by the Numbers. Miracle Day (search). Online. Available http://tvbythenumbers.zap2it.com/?s=Miracle+day (5 September 2011).

47. Howe, David, telephone research interview. Conducted on 17 June 2011.

48. As described by the *BBFC*.

49. Comcast. Torchwood: Miracle Day (2011). *Xfinity*. Online. Available http://xfinitytv.comcast.net/tv/Torchwood%3A-Miracle-Day/171389/full-episodes (9 September 2011).

50. BBFC. Miracle Day. Online. Available http://www.bbfc.co.uk/search/?searchwhere=db&q=Miracle+Day (9 September 2011).

51. Amazon. *Torchwood: The Complete Original UK Series*. *Amazon.com*. Online. Available http://www.amazon.co.uk/Torchwood-Complete-Original-UK-Blu-ray/dp/B0050UEVFU (2 August 2011).

TRANSMEDIA *TORCHWOOD*: INVESTIGATING A TELEVISION SPIN-OFF'S TIE-IN NOVELS AND AUDIO ADVENTURES

Matt Hills

Counting 'Children of Earth' and 'Miracle Day' as a single story each, *Torchwood* has 28 televised tales running across 41 episodes. At the time of writing, however, there have also been 17 novels, a collection of short stories – comprising five different titles – seven radio plays, and six original audio books, with a further four due for release in 2012.[1] Furthermore, 'Miracle Day' was accompanied by an animated motion comic, *Web of Lies*, whilst Series 2 was accompanied by an alternate reality game involving the character Abigail Crowe.[2] This gives a tally of 41 TV episodes and 41 stories across other media. Including short stories and comic strips published in *Torchwood: The Official Magazine*, it becomes clear that there is far more official *Torchwood* story content *not* on television than otherwise. As such, analysing *Torchwood* purely as a TV series seems curiously unhelpful.

In this chapter I will consider *Torchwood*'s media tie-ins, i.e. original stories told outside its originating medium. Prior to 'Miracle Day' – co-produced with US premium cable channel Starz – new media technologies were relatively incidental to *Torchwood*'s life

outside television. Far from using possibilities for interactivity or gaming, *Torchwood* has primarily been used to drive its UK fan-base towards what might be thought of as old media: radio and print. I will thus narrow my focus here to address accompanying novels and audio adventures. Comic strips published in *Torchwood: The Official Magazine* deserve their own separate study, particularly since some of these licensed narratives have facilitated an unusual type of creative fluidity, giving rise to what might be termed actor fic rather than fan fic, and hailing from the likes of John Barrowman and Gareth David-Lloyd.[3] Calling for specific theorisation in terms of 'subcultural celebrity'[4] and the relationship between actors' interpretations of their characters and broadcast continuity, these sorts of comic strip are distinct from the 'fluidity between writing talent working on [tie-ins] and their television counterparts'[5] that's displayed by *Torchwood*'s novels and audios. Here, Phil Ford, Gary Russell, and Joseph Lidster have moved between TV *Torchwood* and its tie-ins.[6]

The fact that *Torchwood* can be analysed via non-TV stories as well as TV texts indicates the importance of addressing it as 'transmedia storytelling', a term defined by Henry Jenkins as 'a process where integral elements of a fiction get dispersed systematically across multiple delivery channels for the purpose of creating a unified and coordinated entertainment experience'.[7] For Jenkins there is an aesthetic unity or coherence constructed via transmedia storytelling. Furthermore, '[i]deally each medium makes it own unique contribution to the unfolding of the story'.[8] This stress on medium specificity adds another level of aesthetic evaluation to Jenkins' model. Jenkins also posits a binary other to transmedia:

> The current licensing system typically generates works that are redundant (allowing no new character background or plot development), watered down (asking new media to slavishly duplicate experiences better achieved through the old), or riddled with sloppy contradictions (failing to respect the core consistency audiences expect within a franchise).[9]

As becomes clear in Jenkins' more recent clarifications, this definition does not inherently imply any digital media presence. Transmedia storytelling can be carried out just as well across old media: 'nothing

here implies that particular media need to be involved for something to become transmedia.... I do not want to prioritise digital media extensions over other kinds of media practices'.[10] On this account, pre-'Miracle Day' *Torchwood* might be described as a 'low end' transmedia system since it did not involve expensive, highly developed online gaming or digital media extensions, and instead the BBC Wales TV series was typically extended via lower-budget media (novels/radio/comic strips/information-based websites). As Jonathan Gray has pointed out, 'public service broadcasters such as... the BBC in the UK... can rarely deliver the same level of [transmedia] expansion as their American ... commercial counterparts'.[11] Instead, *Torchwood*'s public service transmedia has involved] channelling its fans towards Radio 4 – boosting the younger audience for Radio 4 plays – as well as repairing or retconning errors in the TV text:

> [F]ollowing... 'Cyberwoman'... , the official *Torchwood* website provided information... that attempted to correct ... what some fans had regarded as a glaring error in the plot. Fans had asked how the eponymous Cyberwoman was not sucked into the void along with the rest of her kin during the climax to the *Doctor Who* episode 'Doomsday'... and the site retroactively explained away the problem: 'The only exceptions were those being converted with material entirely derived from this side of the void'.[12]

The Torchwood Archives, a book collecting together material from the BBC America 'Captain's Blog',[13] also retconned inconsistencies across Series 1 episodes, such as the fact that nobody seemed to have noticed that Ianto was harbouring a Cyberwoman in the Hub's basement (1.4). According to *The Torchwood Archives*, Captain Jack had been investigating clues to this: 'Energy surges in the lower areas of the Hub remain unexplained.'[14]

Although Jenkins suggests that he is 'not preoccupied with the "newness" of transmedia',[15] allowing the consideration of radio plays and novels as much as ARGs, he does repeatedly position transmedia against older franchising/licensing models which are read as leading to pure narrative repetition, non-medium-specificity, and incoherence. Jenkins even restates this exclusionary binary in his more recent work: 'What I want to exclude... is "business as

usual" projects which are... simply slapping a transmedia label on the same old franchising practices we've seen for decades.'[16] One problem with this extension/pure repetition binary and its structural homologies (medium specificity vs. sameness-across-media) is that as an aesthetic evaluation it potentially reinforces 'perceived low status for tie-in writers and their product'.[17] Reading non-transmedia franchising as 'sloppy', Jenkins creates a monolithic view of old licensing contrasted with newly coherent, integrated transmedia.[18] One difficulty with this model – aesthetically-driven rather than digitally-oriented – is that the aesthetics of transmedia storytelling may be far messier and less clearcut than Jenkins' binary implies.

I have already begun to suggest that *Torchwood*'s public service transmedia – sometimes addressing textual inconsistencies – may be conflictual rather than integrated or coherent, with transmedia content critiquing TV episodes and attempting to 'fix' them (not necessarily convincingly for fans). In what follows, I will consider how *Torchwood*'s transmedia texts are marked by specific tensions between innovation and replication (internationalising *Torchwood* versus offering more of the same from *Torchwood* Cardiff). And I will argue that some transmedia extensions are highly medium-specific whereas others largely reproduce *Torchwood*'s TV format in book/audio form. In short, what Jenkins sets out as a rigid binary between 'old' licensing and 'new' transmedia, I will argue is mixed and blurred across *Torchwood*'s tie-in novels and audios. Some strongly represent a transmedia aesthetic, meeting Jenkins' ideal, while others do so far less clearly. Because Jenkins' model is an aesthetic one, it becomes an empirical question – and, for that matter, subject to interpretation and contestation – whether or not any given tie-in can be thought of as contributing to 'transmedia storytelling'.

BBC Cymru Wales Brand Manager Ian Grutchfield – who has been responsible for overseeing the *Doctor Who* and *Torchwood* brands – suggests that there are key qualities distinguishing a TV show as worthy of brand extension. One of these, Grutchfield argues, is longevity: 'The programme needs to be big enough to justify the approach.... I have said to producers, don't bother looking for lots of spin-offs... for something that isn't planned to run and run.'[19] However, *Torchwood* was already being extended into a first wave of original novels by early 2007.[20] This was after just

one series had aired, and although the show had been re-commissioned, its longer-term future was not inevitably secure – as the breaks between later series would demonstrate. Unlike *Doctor Who*, a very long-running and flagship BBC brand, *Torchwood* seems to have been adjudged suitable for brand extension into novels and radio plays precisely due to its status as a *Doctor Who* spin-off. In essence, *Torchwood* was pre-sold. It was 'cult by design'[21] possessing an anticipatory, dedicated fan culture from the moment of its very first press release thanks to Russell T. Davies's involvement and the link back to its 'mother ship', *Doctor Who*.[22] *Torchwood* could therefore draw on an instant fandom, including professional fan-writers with proven track records as tie-in authors. (Two of the first three authors working on the *Torchwood* range – Andy Lane and Peter Anghelides – had previously written *Doctor Who* tie-ins for Virgin/BBC Books, whilst Dan Abnett had written *Warhammer 40,000* novels.) As M. J. Clarke has argued, tie-in authors are usually required to work to strict deadlines while drawing on fan activities such as close reading:

> tie-in novels... frequently have extremely rapid production cycles and very tight deadlines. This is attributed... to the needs of the licensors/producers who need the novels published either concurrently with a broadcast premiere or hiatus... [T]ie-in writers use fandom... as an informal source of research.... Intimate connection with the series gives tie-in writers easy access to the minutiae of continuity, already seen to be paramount among the concerns of licensors... This fandom also hypothetically gives the writers easier access to their implied reader.[23]

Torchwood had a ready-made fanbase, and a ready-made pool of proven tie-in writers (working from shooting scripts in the first instance), making it highly likely to sustain niche brand extensions aimed squarely at this fandom. Lacking longevity, and impossible to plan as a show that would 'run and run', *Torchwood* nevertheless offered a property ripe for extension across other media. However, its tie-ins were predominantly rooted in cost-effective old media – novels and radio plays – with relatively low production/development costs which could remain economically viable at a niche fan-targeted scale. *Torchwood* was also designed, at least in its initial guise, as a 'very easily budgeted format show for BBC3',[24] with its regular

characters, SUV, and Hub based underneath Cardiff Bay all being eas-ily replicated in tie-in novels: 'In addition, programme brands need to provide opportunities for extension: what Ian Grutchfield ... refers to as having "transferrable characteristics."'[25] *Torchwood*'s design meant that its formatted elements, including Captain Jack Harkness's immortality, the distinctive Cardiff setting and diegetic 'rift', and even the programme's opening voice-over, all constituted highly transferrable characteristics.

At the same time, extending the TV show into a series of novels – and into its first BBC Radio 4 play *Lost Souls* after Series 2[26] – meant that other media beyond television could be used in distinct ways. As radio producer Kate McAll observes of *Lost Souls*, a story based at the Large Hadron Collider, CERN, and broadcast as part of Radio 4's 'Big Bang Day' publicising the LHC's switch-on: 'How much would it have cost to fly everybody to Switzerland and film there? A hell of a lot more than doing it on radio! That's why we're the first people to take Torchwood abroad.'[27] Later audio adventures would also introduce 'Torchwood India' in Delhi,[28] as well as featuring a submarine mission:

> *Submission*, by Ryan Scott, would be a multi-million dollar movie, if it could even be shot at all. Taking in ... a bustling Japanese harbour and US Destroyer, [through] to the bottom of the Mariana Trench, it's nothing if not ambitious, and clearly shows one of the benefits of an audio-only story.[29]

And yet, using the distinctiveness of the medium to 'international-ise' Torchwood threatens to undermine its transferrable character-istics, revising rather than extending the brand. Repositioning the series as a globe-trotting sci-fi thriller rather than a show grounded in Cardiff means potentially damaging its textual authenticity in fans' eyes, and it is notable that after visits to Switzerland and Delhi, *Torchwood*'s audio adventures tend to settle into a more Cardiff-centric approach. Likewise, almost none of the tie-in novels stray from a Cardiff setting. Although *The Men Who Sold the World*[30] is set in the US, this mirrors 'Miracle Day's move to America on TV. Rather than globalising *Torchwood* as a form of brand exten-sion, then, which would offer something un-realisable on a BBC Wales budget, *Torchwood* novels and audios typically extend the

series without undermining its contemporaneous brand identity. They represent a sort of 'Cardiff epic', exploring real-world locations such as the Millennium Stadium and the city centre in ways which would be prohibitively expensive on TV. Peter Anghelides' *Pack Animals*[31] offers perhaps the most notable example of this. Positing an international football game between 'AC Liguria and Cardiff United',[32] Anghelides then sets his novel's finale inside the Millennium Stadium:

> On the pitch, a bizarre assortment of MonstaQuest creatures capered around Gareth...
> 'I shoulda guessed he'd come here, Tosh,' murmured Jack. 'We've known since this place was constructed that it was aligned with the Rift.'[33]

The Stadium is duly wrecked by an alien incursion, and international footballers have 'Retcon added to their team-room drinks'[34] after Captain Jack has flown a Unicorn around the Stadium. Anghelides' depiction of extraterrestrial events in the Millennium Stadium, with the roof being operated as alien energy pours out of the venue, would at the very least have been difficult and potentially costly to film; despite offering an obvious Cardiff location, the Stadium was never used as a key setting within the TV series.

Mark Morris's *Bay of the Dead* follows a similar tie-in strategy by staging a full-scale zombie outbreak across Cardiff. Gwen and Rhys are forced to make their way across the city centre while dodging the undead[35] as a movie marathon called '*The All-Night Zombie Horror Show*' is transmuted into diegetic reality.[36] Like *Pack Animals* before it, this novel deals with fantastical threats crossing over into Cardiff's real landscapes and landmarks, carrying out its collision of the ordinary and extraordinary on a scale which could not have been easily realised on-screen. *Pack Animals* would have called for extensive CGI work, as well as stadium-based filming, and *Bay of the Dead* would have required very large numbers of extras, or substantial CGI work on a TV budget. *Submission*[37] also boasts a sequence which would not have been readily achievable on television, beginning with 'an explosion on the Severn Bridge in its pre-titles'.[38] Rather than taking *Torchwood* out of its formatted milieu and location, such dramas instead aim to represent Cardiff on an epic scale: a brand extension which remains true to *Torchwood*'s Series 1 and

2 format while nevertheless using the distinctive opportunities of print and audio.

Extending the TV series into other 'old media' also allows for specific narrative tricks reflecting the modalities of popular fiction and radio. Interpreting tie-ins merely as a way of avoiding TV's budgetary constraints fails to consider how sound design and page layout can be manipulated. Having said this, however, the majority of *Torchwood* tie-ins tend not to self-reflexively draw attention to their medium, and are instead largely medium-neutral in tone. That is, they use audio or the printed word to approximate and replicate televised *Torchwood* as closely as possible. As *Den of Geek* reviewer Mark Coupe notes of *The Devil and Miss Carew*,[39] it can be described as 'an example of a fairly standard mid-season episode of *Torchwood*'.[40]

By contrast, a small subset of tie-ins draw attention to their status as audio or books rather than TV, creating a '"doubling" of the medium'[41] through their storytelling techniques. In a sense, 'output can be categorised into stories that are... only incidentally audio [or novelistic] adventures, and those that rely on the medium to work, with the former... outweighing the latter'.[42] The second category leads to audio dramas about audio, e.g. *The Dead Line*,[43] and to a published story about publishing a story in Joseph Lidster's 'Consequences'.[44] This focuses on the character of Nina Rogers, a student featured in each of the preceding five novels beginning with Sarah Pinborough's *Into the Silence*[45] and running through *Bay of the Dead*,[46] *The House That Jack Built*,[47] *Risk Assessment*,[48] and *The Undertaker's Gift*.[49] Eagle-eyed readers would have noted Nina's repeated involvement with Torchwood, sometimes at the periphery of their adventures, sometimes more central to proceedings; the fact that this repetition was seeded into the tie-ins gave the character an implied significance. Nina functioned as a repeated meme akin to 'Bad Wolf' and 'Torchwood' itself in the first two series of BBC Wales' *Doctor Who*, but specific to the tie-in books.

The accreting mystery of Nina Rogers is finally explained in Lidster's 'Consequences', where it is discovered that her interest in Torchwood is far from accidental. In fact, Nina Rogers has fallen under the baleful influence of a magical book which can steal people's memories and convert them into stories within its pages. The book is hungry for thrilling tales, and so compels Nina to seek out Torchwood in the hope of capturing their exploits within its covers.

In this tie-in the characters of Torchwood face a diegetic threat whereby they may be erased from memory . . . and trapped in a book. There's a playful recursion here; Lidster's narrative about Torchwood potentially being converted into stories on the page reminds us that this is exactly what we, as tie-in readers, are consuming.

Lidster frames the tale by having Nina narrate her own story to a publisher. The result is a strikingly self-reflexive piece of published fiction. In addition to a genuine title page which proclaims 'Consequences JOSEPH LIDSTER',[50] there is also a fictional title page embedded within the story: 'Torchwood CONSEQUENCES Nina Rogers'.[51] The fictional Nina Rogers' title page is graphically laid out and composed in order to seem more real than Joseph Lidster's title page since it is only in the fictional instance that the *Torchwood* logo is used (2009: 211). And further ontological trickery is deployed when Nina Rogers asks Ianto Jones, 'Am I even real?' to which she gains the response, 'Of course you are'.[52] Throughout, the readers are reminded of the constructedness, and the materiality, of the printed words with which they are engaging.

Despite Lidster's impressively self-referential short story, it is probably James Goss's work that is most notably bound up with the specific 'media' of media tie-ins. For example, his novels *Almost Perfect* and *Risk Assessment* both make elaborate use of chapter titles, layout, and textual effects which have no direct televisual analogue. *Almost Perfect* includes an entire chapter composed of Facebook-style status updates:

> Emma Webster is still looking for love.
>
> Emma Webster is watching Desperate Housewives (again!!!!)
>
> Emma Webster is looking forward to Friday.
>
> Emma Webster is going out again!!![53]

Goss works in a plethora of pop cultural and intratextual references, presenting 1950's Torchwood documents,[54] citing pop lyrics in his chapter headings, and even including a Cardiff 'cameo' by Charlotte Church, menaced by aliens:

> Jack bumped into them at Cardiff Gay Pride. He was covered in mud and a scrap of blood-spattered gingham.... Brendan and Jon followed his glance to where Cardiff's queen of song stood, drenched

> as usual, belting out 'Delilah' over a sodden PA. There was a flash of gingham and a tentacle backstage. Over the rain, Jack could just hear the sound of automatic gunfire.... Brendan leaned in and kissed Jack quickly. 'Go!' he urged. 'Save Charlotte Church.'[55]

As well as reinforcing *Torchwood*'s initial brand identity as a camp Cardiff-centric confection (*Almost Perfect* focuses on the city's gay scene and community), Goss insistently emphasises the textuality and materiality of his literary compositions rather than simulating a TV episode. This authorial tactic reaches its apogee in *Risk Assessment* where each chapter heading is written in the style of a Victorian serial, e.g. 'IX Who Passes By This Road So Late? In which Miss Rogers fails to purchase a train set, and a siege is laid'.[56] This device stresses the diegetic involvement of Torchwood's Assessor from Victorian times, Agnes Havisham: '[Queen Victoria] let me pick my own name... and it was either Agnes Havisham or Betsey Trotwood.'[57] Alongside creating Dickensian pastiche, Goss also integrates in-jokes drawn from fandom, such as naming his alien race after an acronym for DVD extras – value-added material or vam – before pointing out this fact.[58] And he playfully incorporates an episode title from *Doctor Who* (2.13, 'Doomsday') which featured the fall of Torchwood London, while describing events similar to those from 2.13: '"Nonsense," snapped Agnes. "Torchwood [London] can easily contain a semi-active causal breach fifty storeys above the Docks. This is far from Doomsday."'[59]

Such games draw attention to the signifier, outside the requirements of realist storytelling, and beyond any approximation of televised *Torchwood*. They emphasise the written nature of Goss's tie-in novels, using the printed word to highlight its character as a medium. Goss repeats the tactic in his audio *The House of the Dead*,[60] using specific qualities of radio to wrong-foot fan audiences. As M.J. Clarke notes, it is common practice when penning a tie-in to spell out the time frame in which it is set, e.g. indicating where it falls between particular TV episodes. This is important because specifying a tie-in's place in continuity avoids contradicting the TV show, and gives the author and readers or listeners clear parameters for character development. Clarke points out that 'specifying time frame' can allow tie-in writers to 'focus on very specific temporal moments within the life of a property.... This technique cordons

off a space where writers can be certain about the bounds of non-contradiction.'[61] Also studying media tie-ins, Tricia Jenkins similarly observes that '*because* they are officially associated with the television series, authors are limited by what they can do with... characters... media tie-[in] series cannot transgress the basic elements of the broadcast narrative'.[62]

However, Goss subverts this tie-in convention in *The House of the Dead*. Its CD release bears the following guidance: 'set before the TV story "Children of Earth"'.[63] Part of *Torchwood: The Lost Files*, broadcast on Radio 4 leading up to 'Miracle Day's' UK TV premiere, these radio plays were billed as being set between Series 2 and 3. This enabled Gareth David-Lloyd to reprise his role as Ianto Jones, given that the character was controversially killed off in 'Children of Earth'. Goss may indeed not be able to transgress *Torchwood*'s broadcast narratives, but instead he creatively engages with *Torchwood*'s different time frames to achieve a highly transgressive narrative effect. Because it transpires that *The House of the Dead* is set *after* 'Children of Earth' rather than before its canonical TV events: Ianto, who we assume is alive, is actually one of the ghosts under investigation by Captain Jack.

It's an 'ontological shock'[64] – a reworking of our basic story assumptions – which also hinges, in part, on the characteristics of audio drama. Ianto can interact with Gwen's voice without us seeing either character, hence preserving the twist that Ianto is deceased, and that the version of Gwen he's speaking to is an otherworldly impostor. This misdirection would be far more difficult to achieve in TV's visual economy where audiences would expect to see establishing shots of characters who are only spectrally voiced, or impersonated, in *The House of the Dead*. Without visuals, Goss's audio drama is free to more readily mislead audiences. And though Goss can't kill off a character who is alive in the TV series – violating established continuity – by unexpectedly shifting time frame, and exploiting *Torchwood*'s status as sci-fi/fantasy, he can vertiginously switch a character's status from alive to dead with a single line of dialogue. Ultimately limited in terms of what can be done with *Torchwood*'s characters, *The House of the Dead* nevertheless succeeds in powerfully transgressing (fan) audience expectations, cleverly emphasising its modality as audio drama in the process.

In addition to using specific characteristics of the printed word and sound design, *Torchwood*'s book and audio tie-ins also extend the brand in a further way: they repeatedly generate alternate versions or echoes of the Torchwood team as seen on TV. For instance, the Torchwood team are paralleled in Dan Abnett's *Border Princes*. Here, another organisation akin to Torchwood is shown to patrol the Rift elsewhere along its multi-dimensional line, where it is known by a very different label:

> 'The word we use literally translates as "the Stumble" or... "the Misstep". We usually refer to it as "the Border".... The First Senior is dedicated to guarding it...'
>
> 'Uh-huh. Torchwood is dedicated to guarding it too, from this side.'
>
> 'I know. That is why the Principal was inserted amongst you. You are the most interesting and compelling thing on this part of the border.'[65]

Far from being singular or unique, Torchwood is relativised: there are alien, not-quite-knowable versions of it out there whose members might even be productively integrated into Torchwood Cardiff.[66] A variant 'echo'[67] also occurs in Gwen's dreaming in *First Born*, where events of 'Children of Earth' are replayed but this time without Jack Harkness being immortal.[68] And rewritings of Torchwood are developed more directly in Gary Russell's *The Twilight Streets*; in this case an imperialistic, corrupted version of the Torchwood team uses the Rift to ensure its own power base in Cardiff, being led by a husband-and-wife team of Owen and Toshiko.[69]

Alongside other-dimensional incarnations and dark mirrorings of Torchwood Cardiff, there is also the 'Torchwood India' encountered in James Goss's (2009) radio play *Golden Age*. Here, the Duchess, head of Torchwood India, has preserved the 1900s Raj in a 'time store'. Inverting Captain Jack's voice-over motto that 'everything changes', this strain of Torchwood wishes that 'nothing would change'.[70] And the Duchess tells Jack that 'the twentieth century was when everything changed',[71] bitterly referring to India's partition and the end of Empire whilst again inverting Captain Jack's TV credo that 'the twenty-first century is when everything changes'. This brand ident – encapsulating *Torchwood* as a sci-fi thriller – belonged to the TV programme's 'entryway paratext'[72] in Series 1

and 2, being voiced over a standard series of clips preceding each episode. *Torchwood*'s tie-ins bring this paratext into their texts, but they do so via refraction and implicit commentary. Where *Golden Age* issues a culturally relativising challenge by pointing out the massive sociohistorical upheavals of the twentieth century, Joseph Lidster's 'Consequences' offers a more comical take on the brand ident courtesy of character Nina Rogers. Rogers narrates her own story of Torchwood in a manner that, for the knowing (fan) reader, reworks televised *Torchwood*:

> '[I]t's kind of about the main girl, but it's more about this Torchwood thing. So, I thought it could start with like a snappy teaser opening. Something like . . .
>
> Bigger than the police! Way bigger than the army! Catching aliens and fighting zombies! Putting things right that once went wrong! This is the story of a top-secret Government organisation called Torchwood!'[73]

Puncturing the earnestness of *Torchwood*'s branding, this offers a colloquial take on Captain Jack's televised philosophising which frames each of the first 26 episodes. Other tie-ins relativise and refract *Torchwood*'s TV mission statement by re-gendering it: Agnes Havisham concludes her judgement of Torchwood by stating that Gwen, and not Jack, should be the group's leader: '"Under you, Miss Cooper, Gwen dear, I truly believe that the twenty-first century can be when everything changes for the better"'.[74] And Sarah Pinborough elegantly provides a faux book-ending to *Into the Silence* by concluding it with a version of Captain Jack's opening TV voice-over: 'Because this was the twenty-first century. When everything would change. And Captain Jack Harkness intended to be ready'.[75] By transposing the routinised beginning of a TV story into the very final sentences of her novel, Pinborough creates an intertextual loop, with the *Torchwood* brand seeming to circle back into itself.

All these variations on the Torchwood team and its branding voice-over suggest that certain tie-ins operate in a fashion akin to contemporary comic books where established characters are frequently rewritten, reworked and reinvented. This might be expected of tie-ins, since by definition they replay an established narrative universe rather than focusing on wholly original creations. *Torchwood*'s media tie-ins, I would argue, are sometimes

significantly 'prismatic', involving a 'proliferation of copies, reflec-
tions, and variants of existing heroes' in the originating TV show.[76]
And these simulacra of Torchwood offer up condensed, elliptical
yet critical commentaries on the limits of TV *Torchwood*: momen-
tarily replacing Jack's masculine authority with the idea of Gwen as
leader; suggesting that Torchwood's supposed enemies may in fact
be otherworldly versions of itself; linking Torchwood to concepts
and practices of imperialism that Jack's leadership is supposed to
have overcome in the TV series; and challenging the show's focus
on the twenty-first century by seeking to historicise its politically
vacuous notion of 'change' by offering a non-Western, twentieth-
century referent.

Torchwood is far from simply 'extended' by all these prismatic
Torchwoods. Rather, it is revised, however fleetingly or marginally.
Further limits to the TV series' representational regime are also
contested in the tie-ins: unlike the TV show, the Welsh language is
directly featured in Gary Russell's *The Twilight Streets* – both Captain
Jack and his nemesis Bilis Manger have trouble with a translation[77] –
and it is spoken by the alien Vam in James Goss's *Risk Assessment*.[78]
Likewise, the Welsh Assembly is also acknowledged by name[79]
whereas both the Welsh language and Welsh politics are exnomi-
nated within the TV series, where 'Welshness' is instead connoted
by architectural icons and landmarks rather than any sense, how-
ever inchoate, of language or politics.

Sometimes prismatic and transgressive in comparison with
televised *Torchwood*, certain tie-ins also offer a very different set
of pleasures. Although they frequently 'seed the past', retconning
guest characters into the memories and experiences of *Torchwood*
regulars – most often Captain Jack[80] – these tie-ins do not only
'expand' *Torchwood*'s back-story and timeline by filling in Jack's
long history with a host of rivals, lovers, and colleagues.[81] Instead,
these 'filling-in' brand extensions[82] are supplemented by a form of
storytelling that is rather less critical/prismatic, and far more com-
memorative of *Torchwood*'s past phases as a TV show. Televised
Torchwood has been reinvented in each move from series to series,
arguably most radically in the post-Ianto, US/UK change from Series
3 to 4, but also in the move to BBC2 (in Series 2), and the move to
BBC1 without Tosh and Owen (in Series 3). As a TV programme,
Torchwood has consistently been retooled by its production teams,

often to the dismay of dedicated fans. The tie-ins, aimed at a fan readership, have therefore offered a refuge from disliked, unwanted transformations within the television text. For a series whose brand ident has been 'everything changes', tie-ins have ironically offered a chance to turn back the diegetic clock, resist change, and return to the 'golden age' of Series 2, or the pre-Series 3 line-up featuring Ianto. They have repeatedly honoured and commemorated Torchwood's lost icons and character relationships. For example, *Lost Souls* features a number of scenes where Jack and Gwen discuss how they feel about the loss of Tosh and Owen, working to create 'emotional realism'[83] rather than swiftly moving on from the end of Series 2, and so reassuring fans that the characters haven't been forgotten. *The House of the Dead* not only enables Jack and Ianto to be reunited post-*Children of Earth*, but also enables them to proclaim their love for one another. This honours the Jack–Ianto relationship, providing fan service for loyal audiences who felt that the pairing was poorly treated by the events of Series 3.

It is not just deceased characters who are brought back, or remembered, so as to proffer reparation for the TV text's movement onwards into new formats. The Hub itself is commemorated in *Long Time Dead*[84] which tells one more tale about Cardiff after Torchwood has left the city. This does not fill in a gap in *Torchwood*'s timeline, since the official TV narrative has quite simply moved on: from its point of view, there is no gap to be bridged here. However, from the alternative point of view of fandom mourning the loss of the Hub, and the show's Cardiff Bay setting, *Long Time Dead* revisits and commemorates the centrality of the Hub to *Torchwood*'s own history. In *Branding Television,* Catherine Johnson suggests that TV series which effectively sustain branding are likely to display an '"aesthetics of multiplicity" …offering multiple points of engagement'.[85] *Torchwood* has partly achieved this multiplicity through its prismatic and commemorative, memorialising tie-ins. Rather than simply extending *Torchwood* into non-TV media, these tendencies permit the TV brand's developments to be symbolically revised or reversed.

I have investigated *Torchwood*'s tie-ins here in order to argue that relatively few emphasise medium specificity. Nor do all tie-ins meaningfully transform *Torchwood*. Although there can be a prismatic tendency at work providing implicit commentary on limitations of the

Torchwood format, there is also a commemorative dimension to some tie-ins which honour past phases, character relationships, and icons of the TV text. *Contra* theories of transmedia storytelling which construct a binary of 'old' licensing versus 'new' transmedia, I have suggested that *Torchwood*'s tie-ins complicate this opposition. Offering 'more of the same' in some cases, yet challenging, critiquing and expanding the show's narrative universe in others, *Torchwood*'s public service transmedia has been largely non-digital, but also notably mixed in character. I've sought to highlight one implication of defining transmedia aesthetically: some brand extensions may correspond well with this account, even while others fail to do so, or do so far less clearly. Thinking about transmedia storytelling calls for careful study of exactly how tie-ins relate to their originating text's format/brand. *Torchwood* exists beyond television, but sometimes its tie-ins also fall outside rigid definitions or ideals of 'transmedia storytelling'.

Notes

1. See David G. Parker, 'Wrapped Up In Books' in *Torchwood: The Official Magazine,* 23, pp. 79–83.
2. See Phil Ford, 'Where's Your Head At? Abigail Crowe', *Torchwood: The Official Magazine* 3, pp. 60–2, and Phil Ford, *SkyPoint* (London, 2006), p. 165.
3. For example, John Barrowman and Carole E. Barrowman, 'The Selkie', *Torchwood: The Official Magazine* 14, pp. 61–75; Gareth David-Lloyd, 'Shrouded Part One', *Torchwood: The Official Magazine* 21, pp. 51–61, and Gareth David-Lloyd, 'Shrouded Part Two', *Torchwood: The Official Magazine* 22, pp. 63–73.
4. See Matt Hills and Rebecca Williams, '"It's All My Interpretation": Reading Spike Through the Subcultural Celebrity Of James Marsters', *European Journal of Cultural Studies* 8/3 (2005): pp. 345–65.
5. M. J. Clarke, 'The Strict Maze of Media Tie-In Novels', *Communication, Culture and Critique* 2 (2009), p. 435.
6. See James Goss, 'The Lost Episodes', *Torchwood: The Official Magazine* 24, pp. 32–43.
7. Henry Jenkins, 'Transmedia Storytelling 101', *Confessions of an Acafan.* Online. Available http://www.henryjenkins.org/2007/03/transmedia_storytelling_101.html (22 January 2012).
8. Jenkins: 'Transmedia 101'.
9. Henry Jenkins, *Convergence Culture: Where Old and New Media Collide* (New York and London, 2006), p. 105.
10. Henry Jenkins, 'Transmedia 202: Further Reflections'. *Confessions of an Acafan*, Online. Available http://henryjenkins.org/2011/08/defining_transmedia_further_re.html (22 January 2012).

11. Jonathan Gray, *Television Entertainment* (New York and Abingdon, 2008), p. 95.
12. Neil Perryman, '*Doctor Who* and the Convergence of Media: A Case Study in "Transmedia Storytelling"', *Convergence* 14/1 (2008), p. 31.
13. Elizabeth Evans, *Transmedia Television: Audiences, New Media and Daily Life* (London and New York, 2011), p. 182n15.
14. Gary Russell, *The Torchwood Archives* (London, 2008), p. 58.
15. Jenkins: 'Transmedia 202'.
16. Ibid.
17. Clarke: 'Strict Maze', p. 434.
18. Evans: *Transmedia Television*, p. 28.
19. Grutchfield quoted in Catherine Johnson, *Branding Television* (Abingdon and New York, 2012), p. 159.
20. Peter Anghelides, *Another Life* (London, 2007); Andy Lane, *Slow Decay* (London, 2007); Dan Abnett, *Border Princes* (London, 2007).
21. Matt Hills, '*Torchwood*', in D. Lavery (ed), *The Essential Cult TV Reader* (Lexington, 2010), p. 275.
22. John Barrowman with Carole E. Barrowman, *I Am What I Am* (London, 2009), pp. 40–1.
23. Clarke: 'Strict Maze', p. 441 and pp. 443–4.
24. Russell T. Davies quoted in Darren Scott, 'Jack's Back', *Gay Times* August 2011, p. 45.
25. Johnson: *Branding Television*, p. 160.
26. Joseph Lidster, *Lost Souls* (BBC Audiobooks, 2008).
27. Kate McAll in Simon Hugo, 'You're Listening To... Atomic Radio', *Torchwood: The Official Magazine* 9, p. 15.
28. James Goss, *Golden Age* (BBC Audiobooks, 2009).
29. Mark Coupe, 'Torchwood: The Lost Files', *Den Of Geek*. Online. Available http://www.denofgeek.com/television/1009571/torchwood_the_lost_files.html (24 January 2012).
30. Guy Adams, *The Men Who Sold The World* (London, 2011).
31. Peter Anghelides, *Pack Animals* (London, 2008).
32. Ibid., p. 197.
33. Ibid., p. 231.
34. Ibid., p. 248.
35. Mark Morris, *Bay of the Dead* (London, 2009), p. 129.
36. Morris: *Bay of the Dead*, p. 185.
37. Ryan Scott, *The Lost Files: Submission* (BBC/AudioGo, 2011).
38. Coupe: '*Torchwood: The Lost Files*'.
39. Rupert Laight, *The Lost Files: The Devil and Miss Carew* (BBC/AudioGo, 2011).
40. Coupe: '*Torchwood: The Lost Files*'.
41. Britton, Piers, *TARDISbound: Navigating the Universes of Doctor Who* (London and New York, 2011), p. 162.
42. Matt Hills, 'Televisuality Without Television? The Big Finish Audios and Discourses of "Tele-Centric" *Doctor Who*', in D. Butler (ed), *Time and Relative Dissertations in Space: Critical Perspectives on Doctor Who* (Manchester and New York, 2007), p. 288.

43. Phil Ford, *The Dead Line* (BBC Audiobooks, 2009); Phil Ford in Simon Hugo, 'Radio Time', *Torchwood: The Official Magazine* 9, p. 35.
44. Joseph Lidster, 'Consequences', in James Moran, Joseph Lidster, Andrew Cartmel, Sarah Pinborough and David Llewellyn, *Consequences* (London, 2009), pp. 203–52.
45. Sarah Pinborough, *Into the Silence* (London, 2009), p. 200.
46. Morris: *Bay of the Dead*, p. 67.
47. Guy Adams, *The House That Jack Built* (London, 2009), p. 236.
48. James Goss, *Risk Assessment* (London, 2009), p. 91.
49. Trevor Baxendale, *The Undertaker's Gift* (London, 2009), p. 40.
50. Lidster: 'Consequences', p. 203.
51. Ibid., p. 211.
52. Ibid., p. 235.
53. James Goss, *Almost Perfect* (London, 2008), p. 8.
54. Ibid., p. 32.
55. Ibid., pp. 196–8.
56. Goss: *Risk Assessment*, p. 91.
57. Ibid., p. 88.
58. Ibid., pp. 147–8.
59. Ibid., p. 163.
60. Goss, *The Lost Files: The House of the Dead* (BBC/AudioGo, 2011).
61. Clarke: 'Strict Maze', p. 452.
62. Tricia Jenkins, '(Re)Writing *Alias*: An Examination of the Series' Fan Fiction and Media Tie-Ins', in S. Abbott and S. Brown (eds), *Investigating Alias: Secrets and Spies* (London and New York, 2007), p. 171.
63. Goss: *House of the Dead*, back cover.
64. Matt Hills, *The Pleasures of Horror* (London and New York, 2005), p. 39.
65. Abnett: *Border Princes*, p. 246.
66. Stephen James Walker, *Inside the Hub: The Unofficial and Unauthorised Guide to Torchwood Series One* (Tolworth, 2007), p. 234.
67. Clarke: 'Strict Maze', p. 453.
68. James Goss, *First Born* (London, 2011), pp. 67–8.
69. Gary Russell, *The Twilight Streets* (London, 2008), pp. 114–15.
70. Goss: *Golden Age*, track 6.
71. Ibid., track 9.
72. Jonathan Gray, *Show Sold Separately: Promos, Spoilers, and Other Media Paratexts* (New York and London, 2010), p. 35.
73. Lidster: 'Consequences', p. 205.
74. Goss: *Risk Assessment*, p. 234.
75. Pinborough: *Into the Silence*, p. 238.
76. Marc Singer, *Grant Morrison: Combining the Worlds of Contemporary Comics* (Jackson, 2012), p. 252.
77. Russell: *The Twilight Streets*, p. 202.
78. Goss: *Risk Assessment*, p. 59.
79. Ibid.
80. Clarke: 'Strict Maze', p. 452; see also Lynnette Porter, *Tarnished Heroes, Charming Villains and Modern Monsters: Science Fiction in Shades of Gray on Twenty-first Century Television* (Jefferson and London, 2010), p. 255.

81. For example, in David Llewellyn, *Trace Memory* (London, 2008), p. 196, and Trevor Baxendale, *Something in the Water* (London, 2008), pp. 34–5.
82. Stephen James Walker, *Something in the Darkness: The Unofficial and Unauthorised Guide to Torchwood Series Two* (Tolworth, 2008), p. 251.
83. Matt Hills, *Triumph of a Time Lord: Regenerating Doctor Who in the Twenty-First Century* (London and New York, 2010), p. 100.
84. Sarah Pinborough, *Long Time Dead* (London, 2011).
85. Johnson: *Branding Television*, p. 160.

Part II

TORCHWOOD, AESTHETICS AND TELEVISUALITY

LOST BOYS AND THE FANTASY OF EMPIRE: *TORCHWOOD* – 'CHILDREN OF EARTH'

Karen Lury

I n this chapter I explore the relationship between empires and archives. Here the archive is understood as a practice or as a 'governing force' (in the terms that Foucault established and later were developed by other writers). I suggest that these characteristics and the ideological ambitions inherent to the archive as a governing system are expressed, explicitly and implicitly, in the textual operations – the narrative, music and sounds – in the third season of *Torchwood* – 'Children of Earth'. The 'archives of empire' to which the series is subject are several but related: the material and anecdotal archives (the stories, artefacts, ideology) of the British Empire as well as another 'archive of empire' of programmes, novels, radio plays, merchandise and personal memories that have established the fictional 'Universe' of the science fiction family drama, *Doctor Who*, a universe that is, like its eponymous hero, continually regenerated and which has become the preoccupation of an 'imagined community' of fans, writers and producers. Primarily, it is the overlap of these two archives – in terms of themes, preoccupations and characters – which interests me; nonetheless, in the course of my argument it should become clear that the operation of the archive

as a controlling, limiting system – as a form of governance – is equally true for both fictional and actual archives of empire.

Torchwood (*anag.*) (6,3)

As shown in an episode from the new *Doctor Who* ('Tooth and Claw' 2.2), the Torchwood Institute was established by Queen Victoria after an encounter with the Doctor. The Torchwood Institute therefore operates under Royal Charter (perhaps not coincidentally like the BBC itself). One of its most recent administrators (in another episode of the new *Who,* 'Army of Ghosts' (2.12)) observed that Torchwood's remit is underpinned by the directive that 'Her Majesty created the Torchwood Institute with the express intention of keeping Britain great and fighting the alien hordes'. In this regard, it is perhaps with the latter sentiments of the British Empire that – at least initially – the Torchwood Institute might be most closely associated: an empire which, after the military reverses of the Boer War, focused its energies in sustaining a form of patriotism that was reactionary and defensive. The 'end of empire' (the last years of Victoria's reign and before the First World War) is commonly seen as a period in which Imperial sentiment is characterised by paranoia, by the fear of the other, and perversely for a colonial enterprise, a fear of invasion. Torchwood's ties to an empire that has effectively closed in on itself are further stressed in the episode 'Army of Ghosts' when it is mentioned that, despite being located in contemporary London, Torchwood (unlike the rest of the UK) has not moved from previous 'imperial measures' (pounds and ounces) to the current metric system. In the *Torchwood* series, it is a later version of the institute which is featured. As it is now based entirely in one of its satellite locations (Cardiff rather than London) and led by the human, but immortal 'Captain Jack Harkness', this version of the Torchwood Institute does appear to be less antagonistic and more sympathetic to the 'alien hordes' it encounters. Yet 'Captain Jack' is perhaps not so very different from another fictional and once well known imperialist hero from a series of 'penny dreadfuls', Jack Harkaway, who, in terms of boys' literature, has been accused – as we might imagine or similarly suggest of Jack Harkness within

the world of *Torchwood* – of using the British empire as 'a bizarre backdrop for [his] quixotic escapades'.[1]

Despite the dilution of its imperial ambitions, Torchwood's colonial legacy remains central to the plot of the third series. Indeed, following Steven Arata's model, the 'Children of Earth' story might be characterised as a 'reverse colonisation narrative':

> Reverse colonisation narratives... contain the potential for powerful critiques of imperialist ideologies, even if that potential usually remains unrealized. As fantasies, these narratives provide an opportunity to atone for imperial sins, since reverse colonization is often represented as deserved punishment.[2]

'Children of Earth' fits this model because it is clearly a fantasy about 'reverse colonization' that acts for the British as a 'deserved punishment'. The plot involves a powerful alien (called the '456', a monster identified only by the number of the signal on which it can be located or 'heard') that attempts to blackmail the entire adult population of the earth into surrendering 10 per cent of its children. Crucially, it emerges that this is a foreseeable and inevitable progression from the 456's earlier 'trade' with the British. This trade, made in 1965 by the British government, involved the covert exchange of twelve (orphan) children for a powerful anti-virus, a bargain in which Jack Harkness was directly involved. Arguably, 'Children of Earth' might be seen as fitting Arata's model not just because it is about 'reverse colonisation' (and thus the legacy of empire) but also because it attempts a political critique (which is similarly not fully or unequivocally realised).

I have chosen in what follows to focus upon music and sound because there are grounds to suggest that sound is particularly important to *Doctor Who* and this means that it will also be significant for *Torchwood*. The importance of recorded sounds as the material and symbolic 'artefacts' within the archives of *Doctor Who* is evident when Kevin Donnelly describes how important sounds are in bridging the older 'classic' series and the new programme:

> Certain sounds were re-used constantly and this had more status than simply 'sound effects'. The relaunched 2005 series of *Doctor Who* has demonstrated great awareness and respect for these 'sonic

stars', with returning effects including the TARDIS materialisation/ dematerialisation, the Autons' handgun and throbbing ambience created for the Dalek control room.[3]

Donelly's 'sonic stars' are not just identifiers for specific objects or locations in the series but are also sounds that provoke a series of evocative and intensely personal cues for some members of the audience. The deliberate re-employment of specific sound effects functions to provoke audio-based memories so that the new series is seen to be paying due respect to the legacy of the earlier programme. Further, there is even evidence to suggest that the show's soundtrack in its totality is implicated at a very personal level in the memories and childhood of at least some of the audience.[4] Here is academic and fan, Matt Hills, discussing his own interaction with the earlier series of *Doctor Who*:

> Audio recording was a common practice among *Who* fans prior to VCR technology; as a young fan sans VCR, 'Warriors Gate' was the first story that I audio-recorded and the novelty of the fact that I was able to re-experience its soundtrack at will – nostalgically cue-ing memories of the televised story – may somewhat account for the high regard in which I still hold it.[5]

Here the sound recording of the programme demonstrates the literal construction of a personal archive. Thus, while sound is important to any television programme, the materiality, memories and archival value of the sound as it resonates in the *Doctor Who* universe suggests that sound and music is likely to have a similar symbolic weight and archival importance for the producers and audience of *Torchwood* (the *Doctor Who* for 'grown-ups').[6]

The archive of sounds (1): music

The music and scoring for 'Children of Earth' and the earlier two seasons of *Torchwood* were written, orchestrated and conducted by Ben Foster, who had previously worked as the orchestrator for the composer of the new *Who* series, Murray Gold. It is not surprising, therefore, that there is a close association between the music for 'Children of Earth' and the new *Doctor Who*. Both series rely

predominantly on a symphonic romantic classical score which frequently incorporates 'action' elements that could crudely be designated as 'power pop': music that is characterised by driving percussion beats and the occasional use of the 'rockier' sounds of an electric guitar.

Of particular interest is Foster's alliance and his expressed affection for the music of William Walton, a British composer whose work is closely identified with Edward Elgar (the composer of the nationalistic anthem 'Land of Hope and Glory' ritually performed at the annual British classical music concert Last Night of the Proms). Walton, like Elgar, is strongly associated with nationalist and imperial sensibilities, some aspects of which can be heard in the more triumphant and bombastic aspects of *Torchwood*'s musical score. Yet Walton, working in the first part of the twentieth century, was composing at a time in which the British Empire was in decline and some aspects of his music seem to reflect this. Indeed, it can be argued that Walton might – in a manner similar to Elgar – be understood as a composer whose music actually articulates not just the glories of empire but the deflated ambition of a previously powerful nation. This sentiment is recalled poignantly within the *Torchwood* score, particularly in a climatic sequence from 'Day 4' (3.4) in which the 456 has just released a powerful virus which will kill all of the trapped personnel in a government building precisely because it was designed – ironically – to be hermetically sealed from biological or chemical attacks from the outside. This theme, called 'Requiem for the Fallen' on the series' soundtrack CD, has a clear kinship with a composition by Elgar in his cantata 'The Spirit of England (Op. 80)' in which he set to music the poem 'For the Fallen' by Laurence Binyon. This poem includes the famous verse:

> They shall not grow old as we that are left grow old
>
> Age shall not weary them, nor the years condemn
>
> At the going down of the sun and in the morning
>
> We shall remember them.

In the sequence, we see the ordinary personnel within the building die, along with Captain Jack's Torchwood colleague and lover, Ianto Jones. The screams and thuds of the people and falling bodies are muted and replaced with Foster's score, in which a haunting,

climbing refrain is carried by a woman's voice (a sad voice to make listeners feel sad).

Elsewhere in the programme, at limited but conspicuous instances, Foster employs a young boy's treble voice (a chorister from St Paul's Cathedral). This boy's voice can be heard in the climactic 'Children of Earth' theme, and it is also featured in a reprise of an earlier theme 'The First Sacrifice' originally heard over the first introduction to the twelve children as they journey to their fate with the 456 (3.1). This theme is reprised again with the addition of the chorister's voice in 'Clem Remembers', music that is used over a flashback sequence in which the one child of the original twelve who did manage to escape – Clem Macdonald (now an adult) – remembers his journey to and escape from the 456. In the sleeve notes to the CD of the soundtrack, Foster explains the motivation behind the use of the boy's voice: 'I wanted to use a solo voice for the "Children of Earth" theme because I liked the idea that at the heart of it all, there's this one boy who saves the world.' One of the interesting confusions here, articulated in part by the consistent layering, repeating and intermingling of leitmotifs and themes in the score, is who exactly, this 'one boy' is. On the one hand, it would seem, without complications, to refer to Steven Carter, Jack Harkness's unfortunate but beautifully blond, obedient, middle-class grandson, who is ultimately sacrificed by Jack to save the rest of the world's children. On the other hand, it might also refer to Jack himself, the boyish action hero. Jack's back story demonstrates that he, paradigmatically is also a 'lost boy' – originally a time-travelling conman from the 51st century, he has, through his interaction with the Doctor, become immortal (so he too will never 'grow up'). In yet another ghastly echo of both these figures we also catch a glimpse another boy who, 'once upon a time', also saved the world. Again in 'Day 4' Frobisher, the civil servant obliged to negotiate with the 456, is invited to 'come and see' what use was made of the original children bartered by the British government in 1965. Although Frobisher does not personally enter the glass tank filled with clouds of poison gas in which the 456 appears (he sends in a suited and masked soldier who carries a video camera) this allows Frobisher and the watching audience to see and hear the fate of one of the children, still a boy and still alive, in what appears to be eternal suspension, gruesomely attached to the body of the 456.

In this sense, the musical connection to the hope that 'they shall not grow old as we that are left grow old' is given a different and nasty, rather than a simply nostalgic, inflection. All of these eternal boys also conjure up another fictional boy strongly associated with the Edwardian period (and thus the period of the waning of the British empire) – J.M. Barrie's *Peter Pan*. This might remind us that the myth of the British boy-child is, of course, itself implicated in the myths of Britain's empire and Pan is one amongst a host of idealised boys, including *Treasure Island*'s Jim Hawkins, Rudyard Kipling's Kim as well as real figures such as Robert Baden Powell, the notorious imperial 'hero' and founder of the Boy Scout movement. Indeed, Elgar himself, as Jeffrey Richards in his commentary on music and empire has claimed, might also be seen as one of these boys:

> It is clear that Kipling and Elgar were brilliant examples of that Victorian-Edwardian phenomenon, the *puer artemis*, the eternal boy whose literary embodiment was Peter Pan, which is why they empathized so well with children.[7]

The boy chorister's voice therefore refers implicitly to a rather over-loaded symbol of 'eternal boyishness' (rather than to an individual or actual boy). The pure treble tones of the voice represent a sound associated with innocence, resonating with eternal and sublime sentiments precisely because it is temporary, a voice that will be lost by the boy during puberty. In the context of the programme the significance of puberty (and its contaminating properties) is underlined when it is made clear that the 456 are only interested in prepubescent children. It is suggested, for instance, that Clem may have been too old for the monster, which is why he wasn't taken in 1965, implying that puberty was, as he says himself, 'what was wrong with him'. When Clem is first introduced, we learn that he has been confined during most of his adult life to a psychiatric institution because he is incapable of looking after himself. Conveniently, if fatally, his infantilism maintains his connection to the 456 and his death – managed via sound by the 456 as he is 'disconnected' – might be seen as yet another boy-sacrifice, as it reveals to Jack how the 456 can be defeated.

This apparent empathy with and focus on an anonymous and idealised boyhood, as articulated through the music and elsewhere

in the narrative of the programme, is key to the *Torchwood* universe and it is not surprising in as much as *Doctor Who* is similarly pre-occupied with boyish exploits, madcap adventures and schoolboy science. Interestingly however, as the variety of boy figures demonstrates, the boy as featured in *Torchwood* is not just the hero but the victim, with an immortality which shades into a horror of the undead, as it incorporates both a boy-child who has become part monster (the orphan) as well as a boy-man (Harkness) who is also a child killer.

Archive of sounds (2): the mediation of speech

The mediation of voice and speech are central to the plot of 'Children of Earth'. The initial event and dominant conceit within the story is the way in which the 456 makes its presence felt by remotely forcing all the children in the world to pause and then speak its words. (The first phrase is: "They are coming.") Although the monster is later made at least partially visible as a slimy giant, with tentacles but no head or visible mouth, its initial power lies in its voice.

The power of the monster's voice in 'Children of Earth' originates not just in its fascinating qualities but in the monster's ability to throw its voice and its use of the children like ventriloquist's dummies, so that while they 'speak' it is the monster which speaks through them, and always (wherever the children are actually located) in the English language. This peculiarity is noted early on by the Torchwood team but the assumption that this is because English is the world's dominant language (a legacy of empire) is raised only to be quickly discarded. Instead it emerges that the 456 use English because of their initial encounter with the British in 1965, so that for them, it is the language of trade (indeed English remains as the dominant international language in business, science and international communication). Ventriloquism and the function of the English language as the language of international diplomacy and exchange is further underlined by the central role played by the character of the civil servant, Frobisher, who is Permanent Secretary to the British Government's Home Office. As stated, it is Frobisher who prepares for and negotiates with the 456 and great emphasis is placed on the special role that Frobisher can play, as a representative – indeed as a

'mouth-piece' for – the Government but who is not actually elected (therefore he is, as the Prime Minister suggests, usefully 'expendable'). Frobisher's opening exchange with the 456 exemplifies his role as another kind of ventriloquist's dummy. In his opening gambit with the 456, Frobisher attempts to engage the monster with some preliminary diplomatic sentiments. The monster does not at first respond and Frobisher lapses into silence. Only then do we hear the 456's first words as they are transmitted through speakers rather than the children:

456: Speak
Frobisher: I am speaking ...
456: we would speak ...
Frobisher: with who?
456: the world.

The confusion as to who is being directed to 'speak' emphasises the fact that throughout the programme there is a particular fascination with the way in which speech and voice may be continually disconnected from their source and that this dislocation presents an opportunity for the exercise of power, yet also for exposure and vulnerability. Clem's death, for instance, vividly demonstrates the violence that sound – as a material weapon, or signal, used by the 456 – can enforce. Similarly, the vulnerability associated with the mediation of voice and the dislocation of sound is represented by perhaps the most repeated action in the programme when different individuals are located (traced) via their voice-as-signal when they use mobile phones. Even when characters either steal or borrow other people's mobile phones so as to disguise themselves, they are generally 'caught'.

The dislocation of the voice from the body was first widely and technologically realised at the end of the nineteenth century and therefore just on the cusp of the end of empire. As the invention of Edison's phonograph in 1877 allowed for voices to be recorded and replayed at will, this era encountered for the first time the radical uncertainties and anxieties that were experienced by hearing a voice without a body. John Picker observes:

Quite suddenly in the late 1880s, throwing voices became easy, but lost was the control that the ventriloquist had always had over the

placement and timing. With such fiendish possibilities, the opera-
tion of the phonograph carried inherent risk, for the playback was
open to manipulation by anyone with access to the controls. Having
made a record, how would it be used, and when, where, and for
whom would it be played?[8]

Picker's comments identify the contradictory aspects of the real
power and potential anxiety that such audible recordings – and the
archives in which they are stored – inspire. On the one hand, a
recording of the voice seemingly awards power and authority to the
speaker – offering complete control over what is said, and allowing
it to be saved for posterity. On the other hand, once recorded and
detached from the body of the speaker, such recordings become
vulnerable, as they might easily be manipulated and distorted by
future users and listeners in ways that could undermine the origi-
nal authority of the speaker. Mediated and dislocated voices are
everywhere in 'Children of Earth', not just via mobile phone signals
or from the creature who speaks without a mouth, but in the way
in which supposed 'lip-reading software' and the use of shorthand
(a stenographic system also first used at the end of the nineteenth
century) are used by the Torchwood team to investigate and to
secure an advantage over first, the British government, and then
the 456. In fact, Torchwood blackmails the government through
eavesdropping – covertly listening in – as they use an insider to
record sensitive cabinet discussions in which a committee decides
how to select the children they will surrender to the 456.

The series also seems at pains to incorporate a mish-mash of
different voices-as-sound, and the various characters have accents
from the USA, Wales, London and Scotland. It is surely no accident
that Frobisher is Scottish: aside from adding to the programme's
unstable nationalist mix reflecting the artificial construct of the
union of Scotland, England and Wales on which the myth of the
British Empire depended, it is a cliché that the archetypal civil serv-
ant of the British Empire is always Scottish. That the Scottish actor
who plays Frobisher – Peter Capaldi – also plays the notoriously
foul-mouthed Director of Communications Malcolm Tucker in the
BBC sit-com *The Thick of It* (which viciously satirised the New Labour
Government) is possibly a playful co-incidence of casting but it also
confirms the continuation of this archetype.

The programme's heady mix of accents is further amplified as these voices are *differently* mediated via a range of technologies, offering the viewer-as-listener a wide range of tone and timbre. This includes the idiosyncratic qualities and different proximities of the voice as it is heard via the many different mobile phone calls, as the voice of the 456 is replayed via computer software, or when Gwen's voice is emotively captured on a domestic video camera as well as when as other voices are heard, crisply articulated, in the television broadcasts of the variety of anchors in the international news updates which pepper the narrative of the series. And it is not just *how* the voices are mediated but the way they are performed that establishes this patchwork of sound for viewers-as-listeners; it can be heard in the pinched and reserved tones used in the Cabinet briefing room, or in the chaotic but inclusive loudness of a working-class Welsh household made up of yelling kids and bleeping computer games, or in the discreet and hushed tones of the middle-class homes of Steven Carter and Frobisher's children, homes in which the children's sudden silence can be mistaken for good behaviour. Entirely appropriately, the diversity of accents in this soundscape culminates in the unifying signal-as-scream transmitted by Steven Carter which finally destroys the 456 but which unfortunately kills Steven too.

By identifying the cultural and emotional associations set in train by the musical score and the way in which this series uses, mediates and transports voices, I have suggested that the use of sound in the programme reasserts the anxious power dynamics which often featured in a variety of contemporary narratives that articulated the deflated ambitions and paranoia at the end of the British Empire.[9] However, I also suggest that the series is ambiguously but definitely in thrall to a related archive, still imperial, but tied more directly into the ambitions and pleasures of the uncomplicated 'imperial romance', a discourse that has its origins in the many novels, penny dreadfuls and comics published in Britain at the end of the nineteenth century. This literature, along with its associated imperialist sentiment, is represented by many different kinds of texts and social groupings (including militaristic associations such as the Boys' Brigades and the Boy Scout movement) all of which served to promote an ideology of 'juvenile imperialism'. This ideology was sustained, as Patrick Dunae suggests,

[a]t schools, in church groups, in recreational associations – at almost every turn boys were exposed to the imperial idea.... Every Christmas hundreds of juvenile adventure novels appeared, novels that romanticized and glorified the exploits of British empire build-ers. Between times the ardour of young patriots was fanned by dozens of illustrated periodicals which provided readers of all social classes with an enticing array of imperialistic articles and tales.[10]

It cannot be controversial to suggest that *Torchwood* and *Doctor Who* both tap into and borrow from this often overlooked archive of British 'boy-hood' stories dramatising courage, sacrifice, team-work and adversity, or that the excessive production of materials related to juvenile imperialism (books, comics, pamphlets and puz-zles) mirrors the accumulating archive of artefacts that make up the *Doctor Who* universe. Yet, this is a legacy that some fans/writ-ers of *Doctor Who* such as Tat Wood seem to be keen to reject, pleading that the series offers a less black-and-white, more elastic and fragmented universe than the colonial/imperial project would allow.[11] Certainly, these associations operate more intimately and ambiguously than a simple generic association in which science fic-tion adventures are always (more or less) informed by narratives of colonisation, of frontiers to be crossed and strangers encoun-tered. Thus, whilst I acknowledge the complexity of the imperial flavour of *Doctor Who*, the connections I expose here are specific to a particular legacy of the British Empire and a particular and related version of British 'boyhood'. For example, a similar narra-tive of 'monster invasion' (though without the threat to children specifically) is evident in the 1996 film *Independence Day,* but this provides an instance in which the American imperial adventure is articulated and it can be seen to be informed by a different kind of narrative and visual repertoire – supplied by the Western genre – qualities made evident by the individualistic heroics of the hero Steven Hiller (Will Smith) and the geography of the ultimate battle (the desert and outer space). I have also tried to suggest that many aspects of the *Who* universe – especially as it is realised in *Torchwood* – are contradictory (indeed the same might be said of the legacy of the British Empire itself). It seems to me that the new *Who* and 'Children of Earth' are more explicitly in thrall to yet another related archive – the personal memories, fantasies and ongoing fandom of

little boys who grew up watching *Doctor Who*. Of course it is not just little boys who are, or were, fans of *Doctor Who*. However, I do find it compelling that so much publicity for the most recent series emphasises the link between boyhood fandom and the adult male writer's credibility: this is evident both for Davies and now for his successor Steven Moffat. Indeed, the significance of the 'one boy who saves the world' seems pertinent here. My real concern, then, is not so much with the potential taint of the scandal and inequities of the British Empire which might be said to infiltrate the sounds and stories of *Torchwood/Doctor Who* but my sense that the 'boy' at the centre of this universe is over-determined and subject to a conservative guardianship that restricts his (and therefore the series') development.

Empty vessels: the colonised child

> The human infant mortality rate: 29,158 deaths per day. Every three seconds a child dies. Human response is to accept and adapt. (The 456)

In numerous interviews and related publicity for the new *Doctor Who*, Russell T. Davies's enthusiasm about working on the programme was frequently traced back to the excitement he felt when watching it as a small boy. Similarly, in the afterword to an anthology of essays on *Doctor Who* (evocatively entitled 'My Adventures') Paul Magr – a professional writer and contributor both to a series of published *Doctor Who* novels and to the extensive fan culture of *Doctor Who* – articulates that the memory of his childhood drives his obsessive interest in the series.

> No more audios. No more stories. Doesn't matter who asks. And then I've pulled back and recanted and gone into it all over again. Why? Why can't you leave it alone? If you want to write the last word – *your* last word – on *Doctor Who*, well, then it might as well be your last word on your own childhood. [13]

For Magr, the *Who* universe represents the world of his childhood, an 'ordinary British boyhood' that he suggests was otherwise made up of rainy afternoons and dens built in suburban gardens. He

presents this as a childhood made extraordinary by his preoccupation with extending his collection of *Doctor Who* 'stuff' – books, comics, audio recordings as well as visits to dusty exhibitions of old props and costumes. Now as an adult, that preoccupation and the ephemera from his childhood – his personal archive of memories and artefacts – dictates the way he perceives and interacts with the stories he wants to create for *Doctor Who*. In this way the legacy and archives of *Doctor Who* – the stories, characters, themes – are imagined as if they were childhood objects and the archive itself as a child-only domain:[14]

> There are various metaphors that persist, to do with the writing of fiction related to the '*Doctor Who* Universe'. Often these metaphors evoke the toys and games of childhood. Authors refer to 'playing in the sandpit' or 'playing with someone else's Lego'.[15]

If the *Who* universe of fan texts, fan commentaries and personal memories is an archive made for and occupied by the memories of boy children (or by these men returning to their childhood) then real children, real boys (and of course, girls) are marginalised. Indeed, this makes it particularly significant that in 'Children of Earth', the boy's voice is effectively relegated to the musical score: children's speech and agency are otherwise insignificant. Despite the fact that little boys are central to the narrative, the little boy's voice representing a character with an agency and subjectivity of his own is rarely heard. Although Steven Carter does have some dialogue of his own, he says very little and what he does say has no real impact on the progress of the story or even in relation to his own murder. Similarly, although the Welsh children (Ianto's relations and their friends) are noisy, the sounds they make are again peripheral to the action. In an even more violent way, the undead boy who is attached to the 456 *cannot* speak since his mouth appears to be covered by some kind of gas mask.

These little boys are therefore empty vessels through which others speak and who are spoken for – and in this sense (and particularly in relation to the figure of the undead boy) they recall a previous monster from the new series of *Doctor Who*. In 'The Empty Child' (1.9/1.10), a two-episode story from the first season, the monster is revealed to be an unfortunate genetic rebuild of a little boy who has died in the bombing blitz of London during the Second World War.

The boy's face (his eyes and mouth) are covered by – in fact, they have become – a gas mask, and this creature is now an 'empty child', who despite having no mouth, calls out (often through telephones, radio transmitters or other recording technologies such as a typewriter) for his 'Mummy' and spreads his mutation around wartime London like a plague. Not coincidentally – in a narrative also populated by lost boys, with England once more under threat of invasion, and with the myths of the Second World War so strongly associated with plucky Brits and identified so prominently with the last gasps of the British Empire – it is in these episodes that Jack Harkness is first introduced. However, in this story, the Doctor is on hand to save the day, and as he says, triumphantly, (just this time) 'everyone lives!'. In contrast, in the dark, inverted universe of *Torchwood*, the Doctor does not come and nearly everyone dies: at the end of the season Jack effectively runs away, leaving the earth to board a passing space ship (almost as if he were heading toward the 'second star to the right, and straight on til morning ...').

Conclusion

As 'Day 5' (3.5) culminates in the death of nearly all of the Torchwood team as well as Frobisher and his family, 'Children of Earth' would seem to operate as an example of a 'reverse colonisation' story that critiques the legacy and practice of the British Empire. With Steven dead and Jack abandoning humanity, 'Children of Earth' also apparently presents an end to the idealised 'childhood' (or boyhood) that Magr cannot leave alone and throws out the 'Lego' that Magr suggested populates the 'sand pit' of stories, characters and artefacts that constitute the archives of *Doctor Who*. Yet in its repression of the child's voice, in its use of the child as a ventriloquist's dummy, there is another kind of colonisation taking place – another sense in which the series is in thrall to the archives of empire. In its use of children as empty innocent vessels, rather than as difficult noisy agents, the drama substitutes memories of childhood for actual children. For despite the superficial polyphony of 'Children of Earth', it is only the adult's voice that is heard, an adult mourning his own (idealised, forever lost) boyhood. This makes Clem, an adult male tormented by his childhood memories, entirely symptomatic of this trope.

Not surprisingly, Russell T. Davies apparently did not leave his audience entirely without hope (hope at least of another season) and the final scene of the last episode of 'Children of Earth' confirms that the one surviving member of Torchwood left on earth – the steadfast ex-policewoman Gwen – remains happily pregnant by her long suffering husband. For me, this comes as an empty and clichéd promise, reflecting the series' own deflated ambition, since I am certain that this child could never substitute for the endless yearning this programme and the archives of *Doctor Who* express for their version of a forever lost and idealised boyhood. Sharing as it does in the proliferating but intensely personal memories of some members of its audience, 'Children of Earth' demonstrates that *Doctor Who* and its various offspring are destined to be eternally dependent, trapped within a limbo dictated by their own thoroughly scrutinised archives. My point is that these should be understood as imperial archives, which serve to map out the territory of a universe in which the fantasy of a British 'boyhood' remains lost, yet eternally at play within the shadows of a fallen empire.

Notes

1. I assume the similarity of the names is entirely co-incidental. Jack Harkaway is cited in Patrick A. Dunae, 'Boys' Literature and the Idea of Empire, 1870–1914', *Victorian Studies* 24/1 (1980), pp. 105–121, p. 107.
2. Stephen D. Arata, 'The Occidental tourist: *Dracula* and Reverse Colonization', *Victorian Studies* 33/4 (1990), pp. 621–645, p. 623.
3. Kevin J. Donnelly, 'Between Prosaic Functionalism and Sublime Experimentalism: *Doctor Who* and Musical Sound Design', in D. Butler (ed), *Time and Relative Dissertations in Space* (Manchester, 2007), p. 197.
4. This particular history of recording activity surely underpins and impacts on the remaining 'cult' status of the new series of *Doctor Who*, despite its current position, otherwise as mainstream 'Saturday night family drama'.
5. Matt Hills, 'Televisuality Without Television? The Big Finish Audios and Discourses of "Tele-Centric" *Doctor Who*', in Butler: *Time and Relative Dissertations in Space*, p. 290.
6. There are some very useful assessments of the use of sound in science fiction television. Perhaps the most relevant here is Matt Hills, 'Listening from Behind the Sofa?: The (Un) Earthly Use of Sound in BBC Wales *Doctor Who*', *New Review of Film and Television Studies* 9/1 (2011), pp. 28–41.
7. J. Richards, *Imperialism and Music: Britain 1876–1953* (Manchester, 2001), p. 53.

8. John M. Picker, 'The Victorian Aura of the Recorded Voice', *New Literary History* 32 (2001), pp. 769–770.
9. In a longer version of this article, Karen Lury, 'In Thrall to the Archives of Empire: *Torchwood*- "Children of Earth"', *Journal of British Cinema and Television* 8/2 (2011), pp. 252–271. I illustrate this with reference to two key 'end of Empire' novels – *Dracula* by Bram Stoker (1897) and *Heart of Darkness* (published as a novella in 1903) by Joseph Conrad.
10. Dunae: 'Boys' Literature and the Idea of Empire, 1870–1914', pp. 105–106.
11. Tat Wood, 'Empire of the Senses: Narrative Form and Point-of-View in *Doctor Who*', in Butler: *Time and Relative Dissertations in Space*, pp. 89–108.
13. Paul Magr, 'My Adventures', in Butler: *Time and Relative Dissertations in Space*, p. 302.
14. In the promotion for the Punchdrunk Theatre Company's *Doctor Who* experience at Manchester International Festival in 2011 – aimed at 6–12-year-olds – it was made clear that adults would only be allowed access if accompanied by a child.
15. Ibid., p. 303.

VI

CRISIS OF AUTHORITY/ AUTHORING CRISIS: DECISION AND POWER IN *TORCHWOOD* – 'CHILDREN OF EARTH'

Martin Griffin and Rosanne Welch

In many ways, the status of the *Torchwood* cult appeal appeared to be ironclad at the end of the second season in 2008. Following the logic of Umberto Eco's now famous argument in his essay 'Casablanca: Cult Movies and Intertextual Collage', *Torchwood* had earned its cult status, as *Casablanca* had done, by overloading the viewer with eternal archetypes. This chapter will first establish *Torchwood*'s claim to cult status by connecting events and characters in its early seasons to many of the cult tropes identified by Eco. Then it will argue that the 'Children of Earth' storyline, which involved a crisis of authority both politically and personally, may well reflect a gradual dismantling of the narrative values and structures that had previously validated *Torchwood*'s cult status, as in the way the 'Children of Earth' turns Cardiff into a remote rather than a central location which reflects this move on another level.[1] Finally, we will dissect the reasons why certain story choices in the arc regarding the crisis of authority were made in order to create a genealogy for *Torchwood*'s cult standing or loss thereof.

According to Eco, *Casablanca* enjoys its envied cult position, because

> [F]orced to improvise a plot, the authors mixed in a little of every-thing, and everything they chose came from a repertoire that had stood the test of time. When only a few of these formulas are used, the result is simply kitsch. But when the repertoire of stock formu-las is used wholesale, then the result is an architecture like Gaudi's Sagrada Familia: the same vertigo, the same stroke of genius.[2]

A close look at *Torchwood* reveals almost as dizzying a set of dra-matic archetypes as in Eco's reading of the classic movie. Where the city in *Casablanca* stood as Eco's Magic Door to safety away from the Nazi march through Europe, the Torchwood Institute, too, is behind a Magic Door, hidden beneath Roald Dahl Plas at the city *centre* of Cardiff; if *Casablanca*'s Rick Blaine and Victor Laszlo both embodied Unhappy Love, Jack Harkness carries on the tradition with aplomb; and loyal, tea-making Ianto is as convincing a Faithful Servant as Sam ever was at the piano. Eco goes on to say:

> When all the archetypes burst out shamelessly, we plumb Homeric profundity. Two clichés make us laugh but a hundred clichés move us because we sense dimly that the clichés are talking among them-selves, celebrating a reunion.[3]

The adulterous triangle Eco identified appears in *Torchwood*, but in the twenty-first century it appears that work has now become the demanding partner, coming between Gwen and Rhys, as well as between Jack and Ianto and perhaps even between Owen and Tosh. *Torchwood* redeploys the trope of Platonic Love/male same-sex camaraderie best represented in TV science fiction by *Star Trek*'s Kirk–Spock–McCoy relationship by making Captain Jack Harkness omnisexual, a manouevre that either changes the trope, or enhances it, depending upon your perspective. Jack and Rhys are connected by same-sex camaraderie through their shared love of Gwen. *Torchwood* seems to study that particular archetype from several new angles. Various episodes go on to evoke other cult terms defined by Eco, such as the Magic Key, with all the alien parapher-nalia in each episode including the resurrection glove that leads to the ultimate Passage out of Death; the Triumph of Purity because

Torchwood is the incorruptible resistance movement of Earth; and the Myth of Sacrifice since all Torchwood team members sacrifice personal fulfillment, and in the case of Owen and Tosh, eventually also sacrifice their physical lives.

Thus the increasing fragility and, finally, also the mortality of the team were given much narrative space, terminating in the deaths of Toshiko and Owen in the closing episode of Series 2, 'Exit Wounds' (2.13). The wastage, in terms of both their sacrifice and the way they had already given up their personal, emotional futures to the Torchwood mission, was, ironically enough, greeted with even more robust and committed fan loyalty toward the characters despite the obvious fact that the actors Naoko Mori and Burn Gorman had wanted to move on to other things.[4] That fictional characters could be sustained by the support they received from their clued-in but committed real-world audience says something about *Torchwood*'s participatory cult audience as well as the dramatic skill and thematic courage that marked this television drama. Notwithstanding the assumptions about the show at that point, however, the 2009 mini-season called 'Children of Earth' moved to deploy the remaining cast in a very different arc from the one that had made the series popular in the United Kingdom and abroad.

Alongside – and potentially connected with – this ambitious and somewhat risky experiment with the *Torchwood* project, 'Children of Earth' is noteworthy for its narrative anomalies – by which we mean the narrative ruptures, glitches, odd choices, fumbles, or simply unlikely assumptions in the text. These anomalies emerge, in particular, from the drama of authority and decision-making that is enacted within both the milieu of government and that of family loyalty and parental rights. The links between the two are implicitly at stake in the earliest scene, preceding the credits for the first episode 'Day One' (3.1), in which a group of young schoolchildren, all between eight and eleven years old, is being transported at night by some kind of uniformed authority to a destination in a remote area in Scotland. The year '1965' appears on the screen and the children on the bus are dressed appropriately. Whatever awaits the children when they are escorted from the bus we do not know, but it is frightening enough that one boy flees, managing (we assume) to escape whatever happened to his classmates. Those children will haunt the story to its conclusion.[5]

The public crisis of authority in 'Children of Earth', or more accurately a crisis of sovereignty, occurs within the context of attempts to meet or manage the challenge represented by the hostile alien invader, a creature known as 456 after the wavelengths on which its transmissions originally appeared. The political, moral and ethical conundrum the alien being delivers, at both the governmental level and in the personal and family context, subjects all institutions to unbearable pressure. As the crisis deepens there appears to be, for example, a takeover of British sovereign authority by the representative of the American government, rendering the British Prime Minister and his cabinet powerless although they continue to embody executive authority vertically within the United Kingdom. The dramatic rendering of this process, however, is marked by unexplained or paradoxical narrative elements involving the political relationships that obtain in the 'Children of Earth' worldview.

These elements are, broadly sketched:

1. the relationship between the United States and the United Kingdom;
2. the relationship between the USA (and implicitly all nation states) and the United Nations (and UNIT, a global military and intelligence agency, an executive arm of the UN Security Council);
3. the implications of the attempted subterfuge that the British government inveigles the 456 into playing along with, ultimately without success.

It is these that this chapter firstly examines. The first element is marked by a conspiratorial perspective, with some historical foundation; the second would appear to be a kind of idealistic vision, with less historical foundation; the third element is an ironic play on modern British political history. It involves a damaging revelation about the British state's credibility, but conveniently made from outside the parameters of human or political relations on any normal scale. As the 456 intones on that significant occasion, 'you have no significance'.

As it unfolds in the narrative, the governing motif in the portrayal of the relationship between Britain and the United States is one of a crude wielding of power and authority. When General Austen Pearce (Colin McFarlane) arrives, he is seen on TV news footage and is described as 'the military representative' of the United States. In the first scene in which he interacts with Prime Minister

Greene (Nicholas Farrell), Pearce wants to deliver to the British leader the 'absolute fury' of the American president, who clearly believes that the British have been doing something in violation of international agreements and protocols in the background to their sudden announcement to other governments that they are hosting a powerful alien life form – an alien diplomatic mission. In later scenes, when the earlier British collaboration with the 456 is finally revealed to him, General Pearce assumes senior executive authority in the British cabinet, seemingly without any objection from other ministers. What his warrant for this assumption of power is exactly, we are not told.

General Pearce – a mere three-star general, it would appear – commands the operations of the British government in a brusque manner designed to conjure up a long cultural and political history of the post-World War Two era and the irreversible decline of British power and global force projection to the advantage of the United States. In many of the key cultural meditations on that history, such as Stanley Kubrick's 1965 film *Dr. Strangelove*, the English character embodies a certain common sense and an antipathy to American prophetic melodrama, as Group Captain Lionel Mandrake, one of Peter Sellers' unforgettable characters, does vis-à-vis the deranged US Air Force general Jack D. Ripper, one of Sterling Hayden's most memorable screen appearances. The mixture of paranoia and, if one were honest, also a touch of admiration was manifested in a different form in the 1980s, as the BBC's remarkable nuclear-doom serial *Edge of Darkness*, written by Troy Kennedy Martin, explored the concept of a US–British relationship in which the UK under Margaret Thatcher had been reduced to a kind of ideological and military colony of the United States. In more recent times, the combative and even hostile relationship between the British security service and the CIA in the TV espionage drama *Spooks* (known as *MI5* in America) suggests a radical divergence of national ideology at the same time that a transatlantic convergence of TV production style was taking place.

Still, the concept that an American military officer would have the diplomatic and political authority to assume unchallenged control of the most sensitive exercise of British government sovereignty is both a deliberately ominous fantasy – rather like a Whitehall version of those urban legends about having your liver removed while

you slept off a drinking session. It is also, of course, a notion rooted in actual historical experience, in particular the tremors – a 'sense of frustration', a 'feeling of resentment' – felt by the British fifty-odd years ago when the maintenance of the country's status as an autonomous nuclear power became more of a fiction than a reality.[6] As the capacity of the United Kingdom to mount a so-called 'independent' nuclear strike force declined throughout the 1960s, the suspicion took root in some circles that the Royal Navy's Polaris and, later, Trident submarines (which replaced the RAF's V-Bomber force as the strategic nuclear platform) were now so locked into the US command structure that the 'independent' British missiles could not be fired without an American say-so first.[7] This appears not to be the case, but certainly many believed – and believe – it to be so.

This experience, while of the nature of a national trauma for the Tory establishment with its nostalgia for empire, had its left-wing equivalent also, we should not doubt. Although the vast majority of anti-nuclear weapons activists were generally opposed to a British nuclear capability on both moral and pragmatic grounds, there was in truth more than one Labour Party stalwart or liberal academic who mourned, if for somewhat different reasons, this degrading of British power, and working-class Labour voters were in any case conservative on defence questions.[8] In the UK, both conservative and left-of-centre suspicions of the USA have tended to echo each other, despite the different ideological spread behind those respective attitudes. That this representation would be taken to somewhat of a caricatured extreme in *Torchwood*, a TV drama that has a strikingly progressive bent in many areas, is not in fact all that surprising.

What is surprising, however, is the narrative embedding of this concept – that of untrammeled and brusquely deployed American power – within, if we understand the narrative of 'Children of Earth', a global arrangement in which the United Nations has a substantial and senior role. Clearly the UN wields an authority to which General Pearce defers at a couple of key moments. That deference may perhaps point only to the hierarchy of institutions that are permitted, presumably on the basis of a treaty of some type, to conduct any contact with an alien species. Nevertheless even that limited remit seems, in the light of declining American support

for or enthusiasm about the UN over the past four decades or so, whimsical to the point of self-delusion. The authors of this chapter suggest emphatically that any arrangement that would give the UN global authority over contacts with alien visitors would not pass the US Senate ratification process, regardless of whether in reality or in science fantasy.

It is noticeable that 'Children of Earth' does not, in fact, clarify the precise chain of command in this relationship – between nation-states and UNIT, represented by the ethnically African but clearly British-educated Colonel Oduya (Charles Abomeli). Our argument is that this is a crucial moment of rupture or hiatus in the narrative, because there is simply no way of squaring the US–British relation-ship with the relationship between either the UK, America, or any-one else and the United Nations, the world body represented by UNIT. Both Britain and the USA are permanent members of the UN Security Council, of course, and the basis for American supremacy in this context – as opposed to the specific relationship between Washington and London – is simply left unexplored.

Apart from the complexities of the transatlantic exchange, how-ever, there is a more definitive statement of the loss of British pres-tige and power in 'Children of Earth' and that is communicated in the 456's chilly bass tones: 'You have no significance'. Unlike the moment in the early 1960s when American Secretary of State Dean Acheson made his famous comment to the effect that Britain 'had lost an empire but failed to find a role', the 456's embarrassingly accurate description of Britain in the early twenty-first century is greeted with relief on the part of the British leadership, rather than indignation. This is, of course, because there is a covert agreement between the government, represented by the painfully loyal senior civil servant John Frobisher (Peter Capaldi), and the alien to keep the earlier event and the fate of the children confidential. The great irony of this moment in the narrative is that, now, the British gov-ernment wants the 456 to declare exactly that truth that so many British governments since the 1960s have tried to evade or obscure. At least, one might say, aliens do not have a partisan electoral agenda.

As the events of 'Children of Earth' keep bringing us back to the secrets of 1965, when Captain Jack Harkness and other officials

handed over twelve children to the 456, so does the imagined political framework of the story point back toward the era when the capability of the United Kingdom to maintain world-power status was finally revealed to be exhausted, and the concession to American authority in strategic policy became more or less unavoidable.[9] It is curious, however, that the leading writer Russell T. Davies reaches into the garden shed of modern British cultural paranoia about the apocalyptic inequalities of the 'special relationship' only to try to balance that with a strand of whimsy regarding the sovereign authority of the United Nations to supervene in a major world crisis. In perhaps the most creatively ironic moment, yet with a kind of contradiction at its heart, an alien being, the voracious and predatory 456, is given the opportunity to advance the one proposition that the series is trying to roll back. With its ambitious narrative, its powerful gestures toward memorable British science fiction movies such as *Village of the Damned* and *Quatermass and the Pit*, and its 'Britannic' worldview, 'Children of Earth' argues against the British fear that 'You have no significance'.[10]

While the British government is represented as relieved at the notion of its own political insignificance, British civilians – especially parents – are asserting their authority in several subplots across the course of 'Children of Earth'. The story of corrupt political power and authority in chaos turns into a story of the myriad ways that authority can be wrenched from – or tenaciously held by – someone as average as a parent. *Torchwood*'s creator and executive producer Russell Davies admitted his own motives as a writer within the dialogue given to Frobisher and government scientific advisor Dekker regarding the aliens' motive:

'Why do the thing with the children?'
 'Because they can. And because they want to scare us,'

Each smaller narrative of a parent–child relationship serves to heighten the drama and build toward Jack Harkness's final dramatic choice, the culmination of the five-hour arc. On the surface that choice appears to follow a narrative structure dating back to both biblical and classical models but, after deeper inspection, we find that it makes one change to the traditional models that may hurt the narrative more than it helps.

Russell T. Davies has discussed the shifts between the first two seasons and 'Children of Earth':

> The modern innovation in *Torchwood* is about taking a high concept idea and dropping it down in the middle of humanity to see how we react. Rather than being about the monster or alien of the week, it's about the human race. Who are we? How do we react? It's about putting society on the knife's edge. We think we're so comfortable in this part of the Hemisphere. We think we're so far away from all the things going on in Libya or Yemen or any places today, even Japan [in the wake of the Tsunami]. We think we're superior intellectually and economically, but given the way the economy could turn by a wrong vote or bad choice, we're all on the same knife's edge. *Torchwood* wants to take dark thoughts like that and examine them at full forensic detail. The older I get the more I realize how close yesterday really is. When I was a kid I thought World War II was years ago, but it was really only 20 years before I was born. Now I realize we're no more clever today than we were during World War II. Everything is so fragile. That's the constant theme of my work.[11]

With Davies' mind so fixed on his connection to WWII, it is perhaps no surprise that Jack's choice echoes the fatal dilemma faced by Jewish parents during the Nazi Holocaust, dramatized in the question posed to Sophie Zowistowska in William Styron's 1979 novel *Sophie's Choice* and later in Alan J. Pakula's 1982 Academy Award-nominated screenplay. When she arrives at Auschwitz, Sophie is forced by a camp guard to choose which of her two young children will live and which will die, making 'Sophie's Choice' an American idiom for a tragic choice between two unbearable options. In 'Children of Earth' these types of dramatic choices revolve around Gwen and Rhys Cooper, John Frobisher, Rhiannon Davies (Ianto's sister) and finally, Jack Harkness himself, the chief protagonist made vulnerable because of the ominous choice he made in a pseudo-parental role forced upon him by governmental authorities over forty years in the past.

Appropriately, the illustrations of the depth and breadth of parental authority, as well as its conflicts, in 'Children of Earth' begin at conception. Gwen discovers her nascent pregnancy while interrogating Clement McDonald, the only adult to fall into the children's chant 'We are coming'. He proves his enhanced sensitivity through

his sense of smell so that when he tells her she is pregnant, Gwen takes him seriously. She races back to the Torchwood Hub to use the ultrasound monitor, discovering that there is a child planted in her womb at the same time that the Torchwood team discover a ticking bomb planted in Jack's stomach, which leaves barely any time for her to deal with the pregnancy. This becomes a dramatic issue when her husband Rhys finds out about the baby and soon after discovers he was not the first to be told. This storyline introduces the inherent issue of pregnancy; once the child is conceived, which of the two parents holds the most authority over its continued existence? It is Gwen's news to impart and when things become desperate with the 456 in 'Day Five' it is her decision whether or not to keep the child. In a moment of desperation she says to Rhys, 'That's what Torchwood does, you see. It ruins your life.' Rhys argues that her life is not ruined, but in fact the pregnancy has made it better, but her response is 'You want to have kids in a world like this, Rhys?' By opening up the threat of abortion, Gwen opens up the question of who holds ultimate parental authority. When Rhys insists, 'You're not getting rid of it', Gwen responds 'Is that right?', which reminds Rhys that as with her work at Torchwood, this child is something over which she exerts complete control and authority.

Meanwhile, midway through 'Day Five' John Frobisher makes the decision Gwen has only threatened. Rather than give his children to the 456, knowing their fate, Frobisher returns home and murders both his daughters and his wife and then commits suicide, illustrating the extent to which parental authority can be, and in this case has been, corrupted. Frobisher makes this final parental decision without consulting his wife, who might have thought that she could live with sacrificing her children in order to save the world. Or she might have held out hope that even if the children were given to the 456 they could be rescued at some later date. Frobisher's action denies her the chance to make either of those possible choices for her children, or for herself, and contrasts the Gwen and Rhys story by making paternal authority more arbitrary and powerful than the maternal side. Though Gwen does not witness Frobisher's act, she does witness several officials and civilians rebelling against the government-enforced evacuation of the children. When approaching the 456, Colonel Oduya of UNIT invokes the possibility of an even higher parental authority, God the Father, when he admits, 'We

have no choice but to initiate your plan, may God help me'. He then expresses his dual role in this story with the words 'Let me ask, not as a representative, but as a father?' In another scene, a local school-teacher calls the soldiers into question when she insists 'I don't care who you are, you haven't got the authority to just march in here'. Later, when told by a soldier to move out of the way of a moving bus, a local mother argues, 'But my boy is in there!', attempting to use her parental authority to trump his military authority. Then Ianto's sister, Rhiannon (Katy Wix), refuses to relinquish the neighborhood children in her care to the soldiers. Instead she and her husband Johnny (Rhodri Lewis) sneak them out the back door and go on the run. Finally, Gwen's old police partner Andy (Tom Price) completely divests himself of his police authority by ripping off his official uniform to join Johnny and other local parents in their fight against the soldiers intent on following orders and taking the children. In the bunker, after witnessing those everyday heroics, Gwen finally tells Rhys she would never abort his child; 'I wouldn't do that to you, sweetheart' in an act that rebalances the parental authority between them. And, as if that verbal promise were not enough, 'Day Five' ends with a time cut to eight months later that visually confirms that Gwen continued the pregnancy. In this gathering, as she and Rhys attempt to talk Jack out of leaving, Gwen Cooper takes the place of Jack's lost daughter and her soon-to-be-born son symbolizes a new child who might perhaps replace Steven.

Steven requires replacing because his character functions narratively as Jack's penance for the sin of complicity that he committed the first time the 456 came to Britain. Yet the character as created keeps the audience from ever being as fully involved in this ultimate sacrifice as it should be, mainly because the relationship between Jack and Steven (Bear McCausland) does not follow a classic narrative arc, even though it appears to and plays for very high stakes in terms of its predecessors in mythology and history. When Abraham chooses to sacrifice his son Isaac, he founds a faith. When Agamemnon sacrifices his daughter Iphigenia, he gives classical Greek drama its mythological beginnings. When Sophie chooses to sacrifice her child, Meryl Streep wins an Academy Award. When Jack sacrifices his *grandson*, the original Wikipedia entry described his daughter Alice (Lucy Cohu) as 'furious' which suggests not only that Wikipedia writers need a wider vocabulary but also that the

mere existence of the character of Alice acts as a block in the emotional relationship between the two participants within the main sacrifice, a closeness of relationship necessary to fuel this ultimate dramatic choice.[12] Yet as the inventor of this *Torchwood* fiction, Davies chose to create that lesser dramatic relationship. *Torchwood* is his world, his creation, and there was no apparent reason not to make Steven Jack's son. Both the characters of Steven and of Alice appear only in 'Children of Earth'; they were not baggage left behind from an earlier episode. When Jack arrives to visit, hoping to use Steven to study the power of the 456 over children, he and Alice discuss why he visits so rarely. The audience is first told, and therefore fairly assumes, that it is because Alice cannot explain to her neighbours why she ages and her father does not. It is later revealed that the minute all the world's children spoke in unison, Alice suspected Jack had to be involved, an involvement she uses to declare, 'Something happens to kids and you want to spend time with him...that's why I want you to stay away, because you're dangerous'.

In our interview with Russell T. Davies, it became clear that his penchant for writing in a rush served as the catalyst for the grandson choice.[13] Since fans had been introduced to Jack a few years earlier in *Doctor Who* and yet had never been introduced to the idea that Jack had children – or wives – Davies felt that 'a son would have had to be sunk deep in Jack's history'. Hence Alice's dead mother existed previous to Jack's introduction on *Doctor Who* and Davies felt that Alice's trepidation at their relationship would cover the fact that Jack had never mentioned her existence. Davies received no questions about creating a grandson for Jack and having created Steven, Davies moved on in accordance with his rash style, as he admitted in *A Writer's Tale: The Final Chapter.*[14]

Despite that practical decision, from a structural standpoint, Davies did not give Jack and Steven a scene alone together to create and illustrate a deeper bond. In fact, because Steven calls him 'Uncle Jack', their relationship proves yet more detached, which weakens the sacrifice. As mentioned earlier, the willing sacrifice of a child is a traditional narrative buried deeply in religion and myth, making the parent a hero for choosing to save humanity at the expense of his or her own happiness. Sacrificing a *grandchild* makes Jack a murderer in the eyes of his child, Alice. We contend

that once that narrative anomaly was chosen, Davies could still have salvaged the power of the storyline by *not* killing Steven. He had in fact planted the seeds for a couple of dramatic exits earlier in the script and then chose never to use them. First, he set up the plot element that Clement was a conduit to the 456 but never gave him the chance to be the one adult-child left who could save the other children. Granted, this would have made a hero of a secondary character rather than of the lead character so it was understandably not Davies' choice. But the second and more intriguing possibility arose when Agent Johnson and her operatives corner Alice and Steven in the alley in 'Day Three'. Urging Alice to relinquish her gun, Johnson (Liz May Bryce) says, 'Are you as immortal as your father? Is the boy? We can put it to the test'. This dialogue, lodged into the audience's memory, would have returned at the moment of Jack's choice, offering the chance that like his grandfather, Steven might have to die to serve as the conduit, but he would indeed rise again. At such a point in the narrative, the terror of Jack's choice would *not* have been softened by this action if Alice asked, 'How did you know?' and Jack responded, 'I didn't'. Her rage at his even taking that chance would be palpable, but mitigated when Steven awoke. As we have it, she hammers on the window as Steven stands placidly in the circle where 'Uncle' Jack places him, ignoring the screams of his more familiar mother, until the connection to the 456 makes the boy drop dead in his place. When we next see Alice after she witnesses Steven's death, she enters one end of the hallway as Jack enters the other. She immediately turns her back on him and exits, illustrating that he has lost her, but Captain Jack Harkness, the star of the show, experiences a loss that is not nearly as dramatic as the terrible loss Alice, the once and potentially future guest character, has experienced. Viewers of 'Day Five' are left with the idea that not only does Jack take the loss of Alice lightly, he feels Ianto's death more deeply than Steven's, yet Ianto was an adult who chose to risk death while Steven had that choice made for him.

The pace of television does not allow for the pauses and reconsiderations of a novelist, and the pace Russell Davies set for himself by writing for two and sometimes three different series at a time certainly did not help. Yet the frantic storytelling style Davies creates kept those who should know better from noticing this narrative curiosity. In the documentary 'Torchwood Declassified' segment

dedicated to 'Children of Earth', director Euros Lyn described Jack's choice of sacrificing Steven inaccurately by saying, 'It's biblical. It's so huge in its emotional stakes here that this kid he loves is the very kid who has to die to save humanity.'[15] Again, we maintain that without a scene or two illustrating a deep relationship between Jack and Steven, the audience did not feel those 'huge emotional stakes'. Lead actor John Barrowman touched on the problem with the choice and with the extraneous character of Alice, 'It is a huge cost to him. That is the death of his grandson and the loss of his daughter *because she won't speak to him anymore* and who knows where it'll go from here'. But 'Won't speak to him anymore' is not a biblical or a classical sacrifice. It's a suburban family tiff.

Furthermore, in 'Torchwood Declassified' Russell Davies mentions, interestingly enough, that his first instinct was not to kill Steven:

> When I actually came to write that script I didn't kill him in the very first draft because it seemed so terrible. And I handed that script in and they just threw it back at me, 'you soft Welshman – of course that child's got to die.' Which I absolutely accepted it. If I'd wanted to fight my corner I could have, but it's right. You have to have a price to pay. You don't save the world in a series like this without there being a terrible, terrible price. And it was terrible, awful to watch but that's the point. It drives Jack away.

We contend that Davies' first instinct to not kill the character was dramatically, thematically and tonally correct, but in another crisis of authority – or perhaps crisis of the author – he let the opinion of the other producers and their lack of understanding of the character interconnections override his instinct, to the detriment of the dramatic resolution. While it is true a 'terrible price' ought to be paid to make the choice the more emotionally difficult, that choice needed to be the death of his child, not his grandchild. Accepting this plot resolution was, we argue, an attempt to have one's apocalyptic cake and eat it too.

Furthermore, even if the whole mini-series was an attempt to darken *Torchwood* and move it out of the romp-in-the-hay-with-aliens reputation it had gained (although it was never that in reality), as the producers discussed in 'Torchwood Declassified', the underlying theme of *Torchwood* had always been the same as *Doctor Who*

– resistance and redemption, the idea that humanity could contain the threat of hostile aliens, not that they would ultimately lose to them. While Steven's sacrifice saves the world, it sabotages any redemptive emotion the story may have had to offer. Coming on the heels of Ianto's useless death in a wild attempt to shoot the 456, it compounds the darkness, and the note of glibness in the final scene between Jack, Gwen, and Rhys emphasises the sense of ethical corners cut. We suggest that Davies tried to prove that his vision could be bleak, so he avoided the more positive theme of human triumph in creating the narrative arc for 'Children of Earth' – but as in the strange mixture of convincing and whimsical narrative elements that define the crisis of sovereign political authority in this drama, the crisis of authority in relation to family is both uncompromising and yet awkwardly engineered.

In 'Children of Earth' the old *Torchwood* is exchanged for something on a new and grander scale but, as we said at the outset, the pressure on the fabric of relationships is considerable. There is, as Matt Hills has noted, an issue of 'conflictual discursive hybridity' in TV science fiction and horror drama as the narratives often have to speak to different audiences simultaneously, causing mixed signals, a constraint that movies are not necessarily subject to.[16] If 'Children of Earth' suffers from that condition by virtue of its televisual location on BBC1, then perhaps the crises of authority that drive the plot also mirror the conflict between a commitment to loyal and passionate viewers – the cult audience – and the creator's and the producers' desire for upward cultural mobility into the larger but more diffuse arena of the national mainstream.

Notes

1. See Matt Hills's discussion of the politics of BBC Wales drama and serial production (essentially the struggle between Cardiff and London) in *Triumph of a Time Lord: Regenerating Doctor Who in the Twenty-First Century* (London and New York, 2010), pp. 46–8.
2. Umberto Eco, *Travels in Hyperreality* (San Diego, CA, 1986), p. 202. The *Sagrada Familia* referenced by Eco is the strange and unforgettable basilica in Barcelona, designed by Antoni Gaudi and still under construction almost a century after the architect's death.
3. Eco: *Travels in Hyperreality*, p. 209.
4. Mourning the death of fictional people might seem to many a somewhat narcissistic exercise, but it testifies to the relationship viewers had

with the programme's leading characters, even if that relationship can generate a certain hostility towards the writers and producers. Indeed, the remarkable memorial wall dedicated to Ianto Jones, established after 'Children of Earth' near the location of the fictional Torchwood entrance on the Cardiff riverfront, confirms this even more strikingly. See Philippe Le Geurn's discussion of the supposedly "hysterical" or "immature" styles of participation of cult audience in 'Toward a Constructivist Approach to Media Cults', in S. Gwenllian-Jones and R.E. Pearson (eds), *Cult Television* (Minneapolis, 2004), pp. 11–12.

5. This and all further references are to the DVD version of *Torchwood: Children of Earth*, BBC Video, 2009.
6. Andrew J. Pierre, *Nuclear Politics: The British Experience with an Independent Strategic Force, 1939–1970* (London, 1972), p. 315.
7. See, for example, the discussion in Tara Callahan and Mark Jansson, 'UK Independence or Dependence', in J. Mackby and P. Cornish (eds), *U.S.–UK Nuclear Cooperation after 50 Years* (Washington DC, 2008).
8. See Richard Moore, *Nuclear Illusion, Nuclear Reality: Britain, the United States, and Nuclear Weapons, 1958–64* (Basingstoke, 2010).
9. A particular historical irony resides in the fact that the full deployment of the British V-Bomber force did not arrive until 1960, at precisely the moment that the shift to intercontinental ballistic missiles with their radically shortened delivery times rendered strategic air forces obsolete.
10. In his study *The Pleasures of Horror* (London and New York, 2005), Matt Hills makes some a brief comments on 'Gothic TV' as a particular iteration of horror stories that television can more easily manage within the constraints of censorship and technology (pp. 123–4). We agree, and suggest that it is a specifically British gothic science fiction tradition that 'Children of Earth' desires to recover and re-deploy – because it is, in fact, a form developed by British television and film over the decades to enable certain kinds of horror to be shown as mainstream programming.
11. Russell T. Davies, interview with Rosanne Welch, Los Angeles, 25 March 2011.
12. The entry has since been edited and the term upgraded to 'enraged', which still reveals a certain tone-deafness. See Wikipedia. Online. Available http://en.wikipedia.org/wiki/Torchwood:_Children_of_Earth (20 November 2011).
13. Russell T. Davies, interview with Rosanne Welch, Los Angeles, 25 March 2011.
14. Russell T. Davies, with Benjamin Cook, *Doctor Who, A Writer's Tale: The Final Chapter: The Definitive Story of the BBC Series* (London, 2010), pp. 32, 45, 49, 70.
15. Included as *Children of Earth Declassified* on the DVD.
16. Hills: *Pleasures of Horror*, p. 128. See also the comments on the mainstream viewer as the 'inauthentic other' of the cult fan in Mark Jancovich and Nathan Hunt, 'The Mainstream, Distinction, and Cult TV', in Gwenllian-Jones and Pearson: *Cult Television*, p. 33.

WALKING CORPSES, REGENERATING DEAD AND ALIEN BODIES: MONSTROUS EMBODIMENT IN *TORCHWOOD*

Stacey Abbott

> Torchwood: outside the government, beyond the police.
> Tracking down alien life on earth; arming the human race
> against the future. The twenty-first century is when every-
> thing changes.

S eason one of *Torchwood* begins with the above statement, outlining the premise for the series and, through the empha- sis upon 'alien life' and 'the future', clearly situating the show within discourses of science fiction (SF). Furthermore, the associa- tion with the science fiction television series *Doctor Who* from which *Torchwood* is a spin-off, also positions *Torchwood* as science fic- tion, albeit earth-based and with a hint of espionage – 'outside the government, beyond the police' – as much *Spooks* as *Doctor Who*. The declaration that the 'twenty-first century is when everything changes' suggests that this series takes place at a pivotal moment in human history which in science fiction terms implies first contact, alien invasion, technological or scientific developments and/or the moment when humanity pushes out into space. Yet *Torchwood's* ori- gins in the *Doctor Who* universe undermine this association, as first

contact is long past with repeated alien encounters having taken place on earth on the parent show, culminating in the destruction of Torchwood One in Canary Wharf by the Daleks and Cybermen in 'Doomsday' (2.13), which preceded the beginning of the spin-off. Furthermore, the Doctor has repeatedly thwarted attempts by alien races to invade or colonise the earth. *Torchwood's* earth-bound Cardiff location also precludes any overt engagement with human-ity's attempts to explore space. So if it is not about first contact, alien invasion or the human exploration of space, what exactly is due to change in the twenty-first century? I would argue that the focus of change on *Torchwood*, from season one through to season four's 'Miracle Day' narrative, is humanity itself and that this change is not presented as utopian progress in the manner that the Doctor often speaks about the evolution of human race but, rather, it is preoc-cupied with anxieties about monstrous embodiment – through the series' focus upon walking corpses, regenerating dead and alien bod-ies. The aim of this chapter, therefore, will be to examine *Torchwood* not primarily as science fiction but as horror, a genre more preoc-cupied with the monstrous body than with utopian or dystopian representations of the future and/or science and technology.

Discussions of *Torchwood* as horror began from the point that the series first aired for, as Matt Hills points out, one of the aims in producing the series was to develop an adult-oriented, niche show distinct from *Doctor Who*. In addition to the inclusion of adult language and an omni-sexuality that permeates much of the first few seasons, '[p]art of *Torchwood's* adult textuality', according to Hills, 'also seems to be premised on including the blood and gore that are visually absent in *Doctor Who*, bringing it very close to TV Horror on occasion'.[1] In this, *Torchwood* is part of a growing tradi-tion within contemporary television, both horror and mainstream, which is increasingly graphic in its depiction of the body in tor-ment. Forensic series like *Bones* regularly put decaying or damaged bodies on graphic display while *True Blood* wallows in the blood and gore of the vampire genre as vampires attack and torture their vic-tims (as well as each other), and where vampires explode in a wave of blood and tissue when they are staked.

Torchwood similarly wallows in visual excess. Many of its epi-sodes focus upon violent human crimes in graphic and disturbing detail, often featuring some form of alien intervention, including

the murder narrative in 'Everything Changes' (1.1) in which the victims are murdered by a human but with an alien knife, and the rape at the centre of 'Ghost Machine' (1.3) which Torchwood member Owen Harper is able to subjectively experience – all the pain and fear – through a form of alien technology. The crimes in 'Everything Changes' are presented after the fact but with the clinical precision of forensic drama, while 'Ghost Machine' emphasizes the horror of the experience of violent crime. Other episodes focus upon carnage of all-too human criminals such as the cannibalism in 'Countrycide' (1.6) or the humans carving up a sentient alien for profit in 'Meat' (2.4). Similarly, in 'They Keep Killing Suzie' (1.8), the team investigates a series of brutal murders in which the word 'Torchwood' is written on the walls in the victim's blood, while season four is filled with images of living bodies in physical trauma or various stages of decay. All of these episodes exploit the graphic depiction of blood, gore and violence to generate horror.

Alongside these human crimes are more supernatural or alien attacks upon humanity in the form of weevils (aliens who live in the sewers) who rip out the throats of their victims with their teeth ('Everything Changes'); an alien who absorbs men's life energy during sex ('Day One' (1.2)); spectres who suck the tears and souls out of the living, leaving catatonic husks of life ('From Out of the Rain' 2.10); and the aliens, the 456, who breath poisonous gas and screech and spew green bile (in 'Children of Earth'). Whether the perpetrators are alien or human, this series is replete with images of horror and the body in torment. Even the main set of seasons one, two and three, The Hub, is coded through the *mise en scène* of horror with its subterranean decaying brick-lined tunnels and prison cells; its vault-like doorways, gates and barriers; jars filled with disembodied hands and heads; and Frankenstein-style scientific equipment. Initially broadcast on niche channel BBC3, *Torchwood*'s graphic display of bodily horror signalled a trend in British television, paving the way for subsequent series such as *Being Human* and *The Fades*. These shows are more informed by the conventions of the horror genre and are increasingly graphic in their depiction of werewolf transformation, vampire attacks and a form of zombie cannibalism. But where these series overtly present themselves as horror through their supernatural content, *Torchwood*'s emphasis upon alien intervention blurs the line between science fiction and horror.

It is, however, precisely this blurring of the line that highlights the intrusion of horror within this science fiction series. Daniel J. Rawcliffe argues that *Torchwood*'s generic leaning is rooted in the traditions of Gothic, embedded within 'notions of the uncanny, transgression and excess', while also describing Captain Jack Harkness as a Byronic hero and Gwen Cooper as a Gothic heroine.[2] Similarly Susan J. Wolf and Courtney Huse Wika have argued that the series is infused with notions of the 'uncanny' manifesting itself 'whenever the boundaries between familiar/unfamiliar, known/known, human/monstrous is violated'.[3] *Torchwood* is of course based upon the premise that Cardiff is built over a rift in space and time through which aliens, monsters and humans from other time periods and dimensions are regularly deposited. The rift is therefore the metaphysical embodiment of the uncanny through which all temporal and spatial lines are blurred. Furthermore, as Wolf and Wika argue, to 'effectively police the Rift and protect the ordinary citizens from the horrors of the unknown' the members of Torchwood 'must willingly invoke the uncanny'.[4] But nowhere is the presence of horror more apparent than through the representation of Torchwood's leader, Captain Jack Harkness.

Jack – less Doctor, more Angel

In an interview about *Doctor* Who, show runner Stephen Moffat claims that 'children will always need a hero who fights monsters but never becomes one'.[5] Captain Jack Harkness is, however, the reverse of Moffat's Doctor. He is a hero fighting monsters while struggling with becoming one, making him a troubling hero in a TV series more preoccupied with unsettling than reassuring its audience. In this manner, Jack is less like the Doctor and more like another TV monster, walking a fine line between good and evil, humanity and monstrosity – the vampire with a soul, Angel. Elsewhere Lorna Jowett and I have argued that Captain Jack is 'part of a growing tradition in which the seemingly oppositional notions of heroism and monstrosity are problematised by focusing on the monstrous body of the hero'.[6] Series such as *Angel, Supernatural, True Blood* and *The Vampire Diaries* repeatedly present their heroes as more frightening and potentially more dangerous than the monsters from which they are supposedly trying to protect humanity.

Jack repeatedly refers to the Doctor as his mentor and role model, suggesting that it was his encounter with the doctor and his companion Rose in season one of *Doctor Who* that transformed him physically and emotionally. Rose's absorption of the power of the TARDIS not only brought Jack back to life after he had been killed in battle with the Daleks, but also made him immortal ('Parting of the Ways' (1.13)). His encounters with the Doctor and Rose also encouraged him to abandon his life as a self-absorbed conman and put him on the path to being a hero. Despite Jack's desire to emulate the Doctor, however, the series' presentation of Jack bears much stronger association with Angel. Both heroes operate in a morally ambiguous universe where it is often difficult to distinguish between right or wrong. Angel attempts to help the helpless on a case-by-case basis but must accept that he cannot save everyone ('City Of' (1.1)) or that easy fixes, like letting two vampires murder a group of evil lawyers, actually lead to his own moral corruption ('Reunion' (2.10)). Jack must make difficult, sometimes question-able, decisions like destroying Ianto's girlfriend, now a cyberwoman ('Cyberwoman' (1.4)), because it serves the greater good, or allow-ing his own grandson to be destroyed in order to save the rest of the children of earth – a pragmatic if unheroic decision ('Day 5' (3.5)).

Jack also visually emulates Angel. While Angel is the guardian of Los Angeles, often presented standing above the city overlooking his territory ('City Of'), Jack is presented in 'Everything Changes' as similarly standing above Cardiff, guardian of his human charges. His iconic military coat bears within it echoes of Angel's distinctive black trench coat – with numerous references in both shows to the significance of the coat. Furthermore, Jack, like Angel, cannot die. Or more to the point, he cannot stay dead. He dies repeatedly but comes back to life each time, making him even more of a revenant than the vampire, Angel. While his inability to stay dead initially appears wondrous – he is able to save Gwen's life when he unex-pectedly comes back to life at the end of 'Everything Changes' – it is increasingly presented as a monstrous fate, forcing Jack to confront the emptiness of the afterlife as well as an eternity of isolation as he watches his loved ones age and die (a fact re-enacted frequently on *Torchwood*). Furthermore, Jack, like Angel, is increasingly pre-sented as tormented by his questionable past, both before and after joining Torchwood. While Angel seeks atonement for his years as a

marauding soul-less vampire, season two of *Torchwood* reveals that the root of Jack's guilt lies in a childhood trauma in which he failed to protect his brother from alien invaders. It is this desire for atonement, and in Jack's case his failure to protect his brother, that leads both 'men' to take on the role of humanity's protector.

Their desire for atonement also means that both characters suffer extreme physical punishment as part of this process. Angel is repeatedly staked, stabbed, cut open, pummelled and shot on *Buffy the Vampire Slayer* and *Angel* while Jack suffers repeated violent deaths: he is shot, stabbed, electrocuted, thrown off a building, buried alive in the earth, buried alive in cement, poisoned and even blown up. More significantly, Angel and Jack frequently suffer intensive bouts of torture. Lorna Jowett points out that on *Buffy* romantic hero Angel 'is displayed semi-naked at least as often in scenes of wounding and torture as in "bedroom" scenes', a trend that continues on *Angel* with even greater emphasis upon his bodily suffering in episodes such as 'In the Dark' (1.3), 'The Ring' (1.16) and 'The Trial' (2.9).[7] Jack is similarly made to endure great suffering when he is tortured by two nineteenth-century Torchwood agents trying to ascertain what he is, why he can't die and how to control him in 'Fragments' (2.12). The parallel between Angel and Jack is self-consciously put on display when Jack is later tortured in 'Exit Wounds' (2.13) by fellow time traveller Captain John Hart, played by actor James Marsters, best known for playing the vampire Spike on *Buffy* and *Angel*. This bit of intertextual casting is emphasised by the fact that Marsters' Captain John fulfils a similarly antagonistic and yet homosocial relationship with Jack as Spike does with Angel.[8] In *Torchwood*, however, the implied homosexual undercurrents that permeate the Angel–Spike relationship are made literal when Jack and John exchange kisses and punches in their first meeting in 'Kiss Kiss Bang Bang' (2.1) and later when John tells Jack that he loves him ('Exit Wounds'). This declaration of love notably takes place during a scene in which John has tied Jack up by his wrists and repeatedly inflicts bursts of electricity upon him. This deliberately calls to mind the *Buffy* episode 'What's My Line Part 2' (2.10) as Spike watches his girlfriend Drusilla similarly tie up Angel and torture him with holy water, and the *Angel* episode 'In the Dark' when Angel is once again captured by Spike and this time is tortured by a specialist as Spike watches from the sidelines. All three torture scenes conflate torture and sex through allusions to sado-masochism.

More importantly, the significance of the parallels between both shows and characters is that both heroes are presented as monstrous *because* of their physical suffering and their ability to withstand such torment. These series highlight the monstrous body of the hero. As I've argued elsewhere, Angel's suffering allows the series to

> emphasiz[e] the physical frailty of the human body while, through Angel's immortality, demonstrating the uncanniness of a body able to absorb and transcend these attacks to his being. Angel's position as a hero is therefore both challenged by the level of his suffering and reinforced by his ability to withstand it.[9]

On *Torchwood*, Angel's suffering is multiplied in Jack. Where Angel suffers for three months in a coffin beneath the ocean, put there by his son Connor ('Deep Down' (4.1)), Jack is buried alive for 2000 years by his brother Gray ('Exit Wounds'); where Angel eventually reconciles with his son and earns Connor's forgiveness and understanding ('Origin' (5.18)), Jack is denied his absolution by Gray who refuses to forgive him, leaving Jack no choice but to lock him away for eternity ('Exit Wounds'). In 'The Trial', Angel is tortured to prove his worthiness to save another's soul, his willingness for self-sacrifice standing as evidence of his position as a champion. In contrast in 'Immortal Sins' (4.7), in one of the most bloodthirsty scenes within contemporary TV horror, Jack is tied up in a 1927 butcher's meat locker and repeatedly murdered by a community who see his revival as both the work of the devil and God. Shot in hallucinatory fashion, with a soft focus, handheld camera, and repeated fades to black each time Jack dies, the sequence is both impressionistic and graphically realistic, conveying both the nightmarish quality and brutality of the experience. The scene suggests a religious frenzy as Jack returns to life only to find more people surrounding him, urging each other to witness his death and resuscitation. They attack him violently with guns and butcher knives, collecting his blood and crossing themselves every time he is restored to life. Previously in *Torchwood*, Jack had been presented as a Christ-like martyr, sacrificing himself to save the world. Here again, Jack is presented as the object of a strange form of 'worship' and later his lover Angelo saves him and washes the blood off his feet in a deliberately Christ-like moment. But this is undermined by the fact that he has been

reduced to spectacle, like a living freak-show, rather than champion or saviour. Furthermore, before his rescue the final observers are three businessmen who negotiate to buy his body, and his immortality, for financial gain, also presenting Jack's monstrous body as commodity. Despite the Christian allusions, in this torture scene the monster has lost its mysticism and been absorbed into modern consumer culture, as suggested by Fred Botting:

> Monsters take their place in a corporate and consumerist world already used to technological innovation, products of corporate technoscience, genetically modified, patented creations of research and development departments. Their lives are routine and uninteresting new version of service sector drones existing with few prospects on the lowest ladder of the western economic hierarchy.[10]

Despite Jack's good looks, he is repeatedly presented on *Torchwood* as monstrous because he, like the vampire, crosses lines between life and death, past, present and future, human and 'other'. As the Doctor explains to Jack in 'Utopia' (*Doctor Who* (3.11)), 'It's not easy, even just looking at you Jack, "cause you're wrong"'. But he is 'wrong' in a world where the blurring of boundaries has become increasingly commonplace, showing us that his 'monstrosity' is ours.

Monstrous 'others': lost in time and the undying dead

On *Torchwood* Jack is, therefore, not the only one who is 'wrong'. The show is replete with monstrous bodies that cross physical or social boundaries, questioning what it means to be human in the modern age. Noël Carroll argues that horror emerges where we are confronted by notions of impurity, i.e. the 'categorically interstitial, contradictory … , incomplete, and/or formless'.[11] *Torchwood* similarly taps into these anxieties by exploring the horror of bodies that undermine distinct boundaries, whether that is between human and alien, human and technology, or life and death, but also demonstrating how often boundaries are blurred, for as Botting explains, 'monsters no longer render norms visible [by contrast], they are the norm'.[12] The series explores how humanity is evolving and questions the existence of boundaries to our humanity. For instance, in 'Sleeper' (2.20) Torchwood uncovers a woman who is in reality an

alien sleeper agent, collecting data about the earth while living a human life as cover. With human memories and identity built into her programming, she is not even aware that she is not human and is therefore a perfect alien/human hybrid. Her alien identity is only revealed under intense physical probing by Torchwood's alien technology when a hybrid form of organic and mechanical control panel appears on her arm through which she can access her programming and her data collection. Her memories are human but her body is a hybrid, and the episode's obvious terrorist analogy highlights anxieties about the monstrous hidden within the familiar. In 'Reset' (2.6), Jack's friend and former *Doctor Who* companion Martha Jones is injected with alien larvae that causes an alien to incubate in her abdomen while Torchwood second in command Gwen Cooper is, in a later episode, impregnated by the bite of an alien shapeshifter ('Something Borrowed' (2.9)). In both of these cases, the lines between human and alien are blurred within the human body, while notions of motherhood and disease become problematically interconnected. In both cases, motherhood is presented as highly medicalised, primarily through Owen's attempts to use alien technology – a singularity scalpel able to remove an object from within the body without surgery – to abort both 'pregnancies'.

The merging of horror and science fiction through the series' preoccupation with time travel also allows for a specifically science fiction approach to Carroll's understanding of the 'categorically interstitial', in this case, the boundaries of time. The notion of time travel, particularly when people are randomly pulled through time, presents bodies as out of time. In 'Captain Jack Harkness' (1.12) the Japanese Toshiko Sato finds herself in Cardiff during World War II when the country was at war with Japan. In 'Out of Time' (1.10) a man from the 1940s finds himself in the twenty-first century, coming face to face with his son, now in a rest home suffering from Alzheimer's. His inability to adjust to the future and deal with the reality that he will outlive his son, leads to his committing suicide. In 'To The Last Man' (2.3) a World War I soldier suffering from shellshock is pulled out of his time in order to be frozen in the Torchwood facilities, resuscitated for one day every year to ensure his good health, before he is eventually called upon to return to the past in order to seal a breach in time. Offered a glimpse of a bright future, Tommy is eventually sent back in time where he will

be executed for cowardice. These narratives highlight the fragility of time and our place within it.[13]

While the series emphasises the emotional price of time travel, it also drives home the dangers of splintering time. In 'End of Days' (1.13) Roman soldiers turn up in Cardiff, violently confused and disorientated, and murder passers-by trying to help, while Black Death victims thrust into the modern day risk unleashing the plague upon an unsuspecting city. In 'Exit Wounds' the Rift unleashes aliens and scythe-toting monks upon the city, while in 'From Out of the Rain' a troupe of carnival performers, captured on film before the decline of travelling sideshows, escape from the film back into the real world. Fred Botting argues that in contemporary gothic 'horror no longer returns upon the present from a past to reveal guilty secrets, mythic energies or spectral powers: it has undergone a temporal shift, projected into and returning from a terroristic, terminating and machinic future'.[14] In *Torchwood*, horror, in post-modern fashion, emerges from both the past and present, highlighting monstrous implications of time co-existing along the rift. Where the *Doctor Who* episode 'The Wedding of River Song' (6.13) is a whimsical alternate universe narrative in which all time is happening at once and Roman centurions populate London alongside pterodactyls, and Winston Churchill is Emperor of the Roman Empire while talking to the Doctor about downloads, *Torchwood* presents this overlap of space and time as a monstrous tear in space in which people are violently ripped out of time and thrust somewhere new. It is less where they come from that matters but rather the horror of being lost and the randomness of the universe.

This is best exemplified in 'Adrift' (2.11) in which Gwen discovers that the rift goes both ways, stealing people away as often as it brings people or aliens through. Attempting to track a missing teenager, Gwen follows Jack to an old bunker concealed on an island outpost, where it is revealed that Torchwood cares for those who were randomly caught in the rift only to be returned years later, emotionally and physically damaged forever. It is there that she finds Jonah, the boy she has been looking for, lost for over forty years (although he was returned to Cardiff a mere few months after his disappearance), burned and traumatised by all that he witnessed in the far reaches of space. His experiences have left him damaged in ways that Gwen cannot imagine, which become evident when

he begins his 'downswing', manifested in a primal scream that lasts for twenty hours of every day. The image of Jonah sitting on the edge of his bed screaming calls to mind the haunting image of Edvard Munch's expressionist painting *The Scream*, both capturing the alienating horror of the individual lost in an unfeeling universe.

The cynicism of 'Adrift', in which Gwen has to accept that there are some mysteries best left unsolved and some truths left unspoken, is a distinguishing feature of *Torchwood*'s position as TV horror that is further presented through the show's unique representation of death and the afterlife. As Matt Hills has argued, '*Torchwood* is preoccupied with a materialist, atheistic stance in which there is no life after death; there is just blackness, an everlasting nothingness'.[15] This experience of death is repeatedly articulated by Jack but reasserted by others. For instance, in a break from other examples of telefantasy, the show replaces ghosts or spirits (a regular feature of other TV Horror series such as *The X-Files, Angel* and *Supernatural*) with the undying dead, people who have died but who refuse (or are not allowed) to stay dead. Unlike Jack who comes back to life each time he dies, as evidenced by the large intake of breath that usually marks his return, these undying dead are neither alive nor dead but liminally existing between the two. In the episodes 'Everything Changes' and 'They Keep Killing Suzie', the Torchwood team uses an alien 'resurrection gauntlet' (aka the 'risen mitten' as coined by Ianto Jones) in order to bring the recently deceased back to life. In scenes reminiscent of the American television series *Pushing Daisies,* this narrative trope is used as a technique to undercover how the victims were murdered. Lorna Jowett and I have argued that on *Pushing Daisies* the abject body on display is 'superficially "justified" by the weekly investigation' but 'their main function is as a spectacle of corporeal excess' as the bodies are increasingly bizarre and grotesque as the series continued.[16]

On *Torchwood*, it is not how they died that is disturbing but the irreconcilability of the dead opening their eyes and talking. The fact that they are still dead is reinforced by the *mise en scène*. In 'Everything Changes', a murder victim is briefly brought back while his body still lies at the crime scene, surrounded by forensic equipment and the blood spatter from his murder, while in 'They Keep Killing Suzie' the murder victim is revived while his body lies in the morgue. In 'They Keep Killing Suzie' and 'Dead Man Walking' (2.7)

Torchwood members Suzie Costello and Owen Harper are each restored to life through the use of the resurrection gauntlet. Unlike the other victims, Suzie and Owen do not fall back into death again after two minutes but rather stay animated although not quite alive. Suzie, it is eventually revealed, draws the life force from Gwen, who used the gauntlet to bring her back, gradually taking her place as Gwen slowly dies. Owen is initially animated by Death itself, becoming a gateway for Death to manifest in the real world. Once Death is defeated, however, Owen remains animated by the residual energy from the experience. Both Suzie and Owen exist at the boundary between life and death, a boundary that Jack crosses repeatedly, and serve as a reminder of the tenuousness of our grasp upon life.

Their liminal status is emphasised by visible reminders of their corpse-like status. Julia Kristeva argues that the corpse is the most abject object of all for it is the self made waste,[17] and *Torchwood* uses these two characters to confront the audience with this reality, providing what Matt Hills refers to as a 'secular' view of death.[18] Suzie is first presented as lump of flesh, unable to stand or walk and propped up in a wheelchair, still bearing the bullets holes from where she shot herself in the head. She is forced to wear a head scarf to conceal the gaping wound at the back of her head. Owen wakes up on the morgue table to find an open bullet hole in his chest, no heart beat and no bodily functions. He cannot sleep, eat, or 'shag' as he laments, and his attempts to console himself by drinking to excess make him realise that he can no longer digest food or liquid. He must force the liquid out of his system by standing on his head and allowing it to pour back down his throat and out his mouth in a shower of abject liquid. In fact, while Suzie is able to heal by continuing to absorb Gwen's life energy, gradually emerging from the wheelchair fully fit, Owen is a repeated reminder of the abject status of the corpse. He experiences the flatulence common when a body decomposes; he can no longer heal any injuries, accidently slicing his hand with a scalpel because he cannot feel any pain, and then later deliberately breaks his finger to call attention to the fact that he 'is broken' ('A Day in the Death' (2.8)).

The episode 'A Day in the Death' in particular emphasises Owen's alienation from those around him, the same but now different, and this inability to connect with his friends; the living and the dead do not mix easily. While Jack's condition provides him

with never-ending life, Owen represents never-ending death. In a sequence reminiscent of Jonah's 'primal howl' in 'Adrift', Owen runs and leaps into Cardiff Bay, silently screaming beneath the water. While Jonah's scream expressed his inability to shield himself from the horrors of the universe, emotionally and physically exposed to all sensations, Owen's scream is testament to his inability to feel anything, numb to everything around him. Owen's undying dead is the corollary to Jonah's pained existence, both representing the monstrous embodiment of contemporary life. While the ending of 'A Day in the Death' provides a glimmer of hope, with Owen choosing to go on with his new form of life or undeath, the show's cynical world view reasserts itself at the end of the season when Owen dies once again in a nuclear meltdown. His final death is darker and more disturbing because he had chosen life.

This preoccupation with a materialist understanding of life and death comes to its climatic conclusion in season four, 'Miracle Day', when all of humanity becomes the undying dead, like Owen. In seasons one and two, Torchwood's protection of the earth was handled, much like Angel's, on an individual basis, one alien at a time. Season three, 'Children of Earth', however, began to put *Torchwood* on a global platform (both diegetically and extra-diegetically) as it confronts the 456, aliens who want to take away one-third of the planet's children. Similarly, 'Miracle Day' goes global as it marks the point when *all* of humanity stops dying. While this may not be the moment that Jack was referring to in his season one opening monologue, it is definitely a moment when 'everything changes'.

In both series, the global nature of the threat means that the monsters that Torchwood must confront are virtually intangible. The aliens in 'Children of Earth', orbiting outside the earth's atmosphere, are never seen except for one emissary concealed behind a cloud of poisonous gas, while the families of 'Miracle Day' who conceived of the 'miracle' are shown to be impossible to trace in a global economy, hidden behind layers of corporations and governments. Without an external villain – or 'other' – to blame, both series expose the growing monstrosity of humanity itself. In 'Children of Earth' it is a government willing to co-operate with the aliens and sacrifice its children, while in 'Miracle Day' it is the altered human condition that is presented as horrific.

The new-found human immortality is initially perceived as wondrous – although the fact that the first beneficiary of this new

human condition is a convicted paedophile and murderer about to be executed for his crimes is a sign that this is perhaps not the result of divine intervention. Gradually, however, the cold hard reality sinks in: if no one dies but the population continues to grow, resources will run out, people will starve and human civilisation will be decimated. This series, more than any, is therefore preoccupied with the monstrous human body that is changing, this time because of earthly rather than alien intervention, exposing violent repercussions. The parallels with contemporary anxieties about increasing human longevity in the light of decreasing natural and economic resources are obvious. Furthermore, the realisation that the 'miracle' – a fundamental rewriting of the human condition – is more like an 'apocalypse' is demonstrated by the image of a body in pieces on a morgue table, burned beyond recognition, with its spinal cord severed, and yet still alive, moving, potentially thinking and feeling ('The New World' (4.1)). Later it is discovered that while the body cannot die, it will continue to age, turning life into a living slow process of dying ('Rendition' (4.2)). 'Miracle Day' therefore raises questions about what it means to be dead or alive in a new world order, enabling governments, who in contrast to the calculating government leaders in 'Children of Earth' are notably invisible, to draw up seemingly arbitrary categories of life and new death. If horror is, according to Carroll and Kristeva, generally focused upon the blurring of borders and boundaries, in 'Miracle Day' horror itself is reversed, along with the natural order of life and death, where it is the attempt to impose a strict, unrelenting division between life and death that is so frightening.

It is notable, almost typical of *Torchwood,* that the climax of 'Miracle Day' and the triumph for Jack and Gwen is the return of death to the world, marked by the simultaneous demise of all of those forced to hover on the precipice of life and death, like, as Gwen explains, 'one last breath'. Each season has ended with death; the finale to season one includes the death of Rhys, Gwen's fiancé, and Jack (although both are restored); season two concludes with the passing of Owen and Toshiko; and season three concludes with the meaningless death of Ianto, and supposed meaningful death of Jack's grandson, sacrificed to save the world. 'Miracle Day' tops them all with the restoration of death itself, offering a bittersweet take on the 'restoration of normality' that so often characterises the horror genre. 'Miracle Day' questions how much we should try to

intervene in our own humanity, and shows us a sinister interpretation of what happens when 'everything changes'. That does not mean that *Torchwood* is necessarily an advocate for stasis. The concluding image of CIA agent Rex Matheson, having transfused Jack's blood into his body, now bursting back to life after being shot, suggests that things do change, even if the implications are unclear. *Torchwood* simply reminds us that change always comes at a price.

Notes

1. Matt Hills, '*Torchwood*', in D. Lavery (ed), *The Essential Cult TV Reader* (Lexington, 2010), p. 278.
2. Daniel J. Rawcliffe, 'Transgressive Torch Bearers: Who Carries the Confines of Gothic Aesthetics', in A. Ireland (ed), *Illuminating Torchwood: Essays on Narrative, Character and Sexuality in the BBC Series* (Jefferson, NC, 2009), p. 102.
3. Susan J. Wolfe and Courtney Huse Wika, 'Policing the Rift: The Monstrous and the Uncanny', in Ireland: *Illuminating Torchwood*, p.31.
4. Wolfe and Wika: 'Policing the Rift', p. 31.
5. Steven Moffat quoted by Nick Setchfield, 'The First Eleven', *SFX*, May 2010, p. 59.
6. Lorna Jowett and Stacey Abbott, *TV Horror: Investigating the Dark Side of the Small Screen* (London, 2013).
7. Lorna Jowett, *Sex and the Slayer: A Gender Studies Primer for the Buffy Fan* (Middletown, Connecticut, 2005), p. 157.
8. See my discussion of Angel, Spike, and the buddy genre in Stacey Abbott, *Angel* (Detroit, 2009).
9. Abbott: *Angel*, p. 61.
10. Fred Botting, *Limits of Horror: Technology, Bodies, Gothic* (Manchester and New York, 2008), p. 159.
11. Noël Carroll, *The Philosophy of Horror: or Paradoxes of the Heart* (New York and London, 1990), p. 34.
12. Botting: *Limits of Horror*, p. 12.
13. See also Rebecca Williams, 'Cannibals in the Brecon Beacons: *Torchwood*, Place and Television Horror', *Critical Studies in Television* 6/2 (2011), pp. 61–73.
14. Botting: *Limits of Horror*, p. 176.
15. Hills: '*Torchwood*', p. 277.
16. Jowett and Abbott: *TV Horror*.
17. Julia Kristeva, *Powers of Horror: An Essay on Abjection*, trans. Leon S. Roudiez (New York, 1982), p. 3.
18. Hills: '*Torchwood*', p. 277.

Part III

TORCHWOOD, PLACE AND LOCATION

Part III

TORCHWOOD, PLACE AND
LOCATION

'WHEN YOU SEE CARDIFF ON FILM, IT LOOKS LIKE LA' (JOHN BARROWMAN): SPACE, GENRE, AND REALISM IN *TORCHWOOD*

Stephen Lacey

What does it mean to say that a city is 'represented' in a television drama? And why might the answer to this question be important? Certainly, Cardiff has a powerful onscreen presence throughout the first two series of *Torchwood*, and for much of the third. A great deal of critical and popular commentary on the programme has also acknowledged that the city, and the nation of which it is the capital, is more than simply a backdrop to the series, convenient because of its production location. Unlike *Torchwood*'s close cousin *Doctor Who*, which since its reincarnation in 2005 by BBC Cymru Wales has also been filmed in and around the city, *Torchwood* allows Cardiff to 'be itself'. In *Doctor Who*, Cardiff and Wales frequently stand in for anywhere in the universe, though most often Cardiff represents London as a 'default setting'. As Brett Mills has noted, the programme 'proudly announces to its Welsh viewers that it is "made in Wales by BBC Wales" before every episode [yet] requires its audience to assume that stories are set in London unless told otherwise'.[1] *Torchwood* demands no such re-readings of the distinctive topography of the city.

Considering the implications of Cardiff 'being itself' for *Torchwood,* and the complex ways in which the city is portrayed, are among the main concerns of this chapter especially where such meanings are negotiated by Welsh audiences. The questions that frame this investigation are the two that began the chapter, one of four questions that underpinned research commissioned by the BBC Trust and Audience Council Wales (ACW) into the representation of Cardiff and Wales in high-profile TV drama made by BBC Cymru Wales in 2009–2010, research in which this author participated. The project and its subsequent report,[2] which included audience research, a survey and discussion of press coverage of both programmes and textual analysis, will be drawn on throughout the analysis that follows.[3]

'One of the biggest stars in *Torchwood*'

Torchwood can be and has been framed in different ways, notably in terms of its relationship to genre, initially – though not exclusively – science fiction; indeed, *Torchwood* ranges freely and playfully across different genres for different purposes, and this is a large part of its innovative appeal. It is an aspect of its status as 'cult television', the subject of other chapters in this book. Certainly, *Torchwood* is cult in the terms outlined by Matt Hills,[4] containing a hyperdiegetic, engrossing narrative space, in which resolution is endlessly postponed; which invites, and is the repository for, the absorbed attention of its viewers/fans; and which achieves coherence through the agency of an auteur (in this case, Russell T. Davies). Notably, with the exception of Hills,[5] the study of cult television rarely pays sustained attention to the 'reality' of the real locations in which programmes are set. The programme also has one foot firmly rooted in a form of television realism that refuses to be compromised by its connection to genre and the fantastic. Realism here may be equated with verisimilitude of the everyday, plausibility in general location and specific setting that extends into language and characterisation. It is also realism defined by its representation of 'the contemporary'.[6] For Russell T. Davies, *Torchwood's* visual and aural realism is related to a realism of representation and theme: *Torchwood* is about 'us now ... western people in twenty-first century cities' with stories that are

'out there in the real world. We go to clubland, the country... we meet really ordinary people whose lives are becoming extraordinary'. This means that *Torchwood* is '*really* set in Cardiff. The real laws of physics apply. If they [the characters] are shot, they will be hurt. They go home, they have tea. They once went to school, they have lovers'.[7] Unlike *Doctor Who*, *Torchwood* was conceived as a post-watershed drama, in which 'dark' and 'edgy' subject matter, often associated with realism, would be permissible.

However, what is the Cardiff that *Torchwood* is 'really set in'? And how can it 'be itself'? Of course, no city, and no location, can be itself in a simple sense, yielding up its identity to the camera's gaze, nor is Cardiff an object of investigation, as it might be if it were the location of a social realist drama or documentary. Yet it is clearly *present* in different ways, for different audiences at different times. Cardiff City Council was not slow to see the benefits of such presence, linking the city's attractions directly to the appeal of the series:

> The city of Cardiff is undoubtedly one of the biggest stars of the BBC series *Torchwood*.
>
> The exciting drama shows how photogenic and cinematic Cardiff really is, with its tall towers, imposing structures and totally unique architecture.
>
> Showcasing some of the city's most striking and impressive landmarks, *Torchwood* allows the TV viewing public to see Cardiff in all its glory.[8]

The web page concluded with a reference to a comment made by Menna Richards, then BBC Cymru Wales' Controller, that *Torchwood* is Russell T. Davies' 'love letter to Cardiff'. The audience research conducted for the BBC Trust/ACW demonstrated that Welsh viewers (albeit only one segment of the wider, diverse international audience for both *Doctor Who* and *Torchwood*) took a particular pleasure in seeing familiar locations represented on screen. This engagement has produced the 'location spotting' of places used by both programmes, which has been fed by online sites dedicated to placing each fictional location in its real-world setting.[9] Witnessing filming, indeed, adds to the viewing pleasure, but often in ways that are not simply those of the 'cult tourist'. As Matt Hills has noted, location spotting is common for cult audiences – producing a 'cult

geography' – which seeks to 'extend the productivity of his or her relationship with the original text, reinscribing this attachment within a different domain (that of physical space)'.[10] However, the engagement of local audiences is in some ways different from that of cult viewers, or indeed non-Welsh fans, since their knowledge of Cardiff is normally not a mediated one: that is, it is not only based on its presence in *Torchwood* but also on personal experience, and in this way connects viewers' investment in a television programme to their everyday social experience. As *Screening the Nation* put it:

> Celebrity- and film-spotting, although exceptional events, are one way in which television is made integral to the rituals of everyday life. Many focus group members from Cardiff and South Wales recounted experiences of seeing filming in action and many more explained how they were conscious of it going on even if they did not personally witness the shoot. In this way, programmes like *Doctor Who* and *Torchwood* were seen by many viewers to have helped put Cardiff 'on the map' in ways that audiences appreciated both for its familiarity and for the perceived visibility it gave to the city across the UK and internationally.[11]

It is Cardiff Bay, specifically Roald Dahl Plas, which frames the Wales Millennium Centre and the Senedd (the centre of the devolved Welsh parliament) and is home to the Torchwood Hub, which is most in evidence in *Torchwood*. In a collision of the discourses of tourism and television drama, the Bay is an iconic point of reference for Cardiff's sense of itself as a European, postmodern city and for *Torchwood* as a series. The Bay is one of several city locations that give the series its specificity, another being the Wales Millennium Stadium, the national sporting arena. Both are known to viewers beyond Cardiff, and probably beyond Wales (though perhaps not outside the UK prior to the programme). Other repeated locations, such as the Altolusso apartments, atop of which Captain Jack (John Barrowman) frequently stands, are recognisable to a local audience, but not far beyond it. Most of the locations that *Torchwood* uses 'stand in' for generic urban landscapes that are narratively linked to the city, and carry the cachet of the familiar for Cardiff and Welsh audiences, but can be read as 'Cardiff' by those without privileged knowledge: bars, streets, car parks, the motorway/ dual-carriage-way network, Gwen's flat (which adds the comfort of the domestic

in contrast to the dangerous, public spaces in which much of the action occurs).

It is important to emphasise that such readings are products of the narrative; these urban environments are 'Cardiff' because the narratives construct them as such, rather than because they are recognisable to viewers (even Welsh viewers). There are traps for the unwary: the streets of the housing estate, in which Ianto's family live in Series 3, 'Children of Earth', are in Newport, a city eleven miles to the east of Cardiff; and several of the limited number of scenes set in Wales in Series 4, 'Miracle Day', were filmed in Swansea. Additionally, there are several locations used from beyond Cardiff, and which are signalled as such.[12] However, the further the series moves from Cardiff into the rest of Wales, the less likely it is for locations to retain their specific identity.

One of the main reasons, of course, why Cardiff cannot 'be itself' is because real-world spaces are transformed into fictional places via genre. Both Linnie Blake[13] and Daniel J. Rawcliffe[14] have explored the way that *Torchwood* exemplifies a particular kind of postmodern Gothic television, with consequences for the way that Cardiff is represented. For Rawcliffe, 'Cardiff is marked as a liminal Gothic environment – that is, a space populated by myriad examples of hybrid figures ... all of which share a close relation to the uncanny'.[15] Noting that Cardiff is 'a highly gothic location', Blake argues that the city 'is nothing less than a grotesque urban body repeatedly penetrated by the fantastic spectres of other times and places'.[16] Similarly, Rebecca Williams has argued that *Torchwood*'s representation of place can be usefully analysed in relation to different conceptions of televisual horror (a particular example is 1:6, 'Countrycide', which concerns strange disappearances in the countryside around Cardiff – in reality, the Brecon Beacons –attributable to a community of cannibals).[17]

Cardiff is also transformed by the specific visual grammar of the way it is filmed, which links its representation to that of other cities and to a trend towards the 'Americanisation' of British television drama (to which we will return). As noted above, it is the (post) modern spaces of Cardiff that provide most of *Torchwood*'s urban imagery, rather than its Edwardian residential streets and shopping arcades. These are often filmed in a way that both identifies and spectacularises them. *Torchwood* makes extensive use of aerial

photography, including tracking shots of Cardiff, filmed both during the day and at night. There is, for example, a repeated aerial shot of the city, which became the opening establishing shot of each episode of Series 1 and 2, in which the camera swoops in from the Bristol Channel (the estuary on which Cardiff is located) across the Bay and framing the location of the Hub. This strategy draws attention to the shape of the city, its symmetry, with its distinctive local features, the Wales Millennium Centre and Senedd, foregrounded but placed against the generic features of the contemporary, post-modern landscape – sleek tower blocks, a developed waterfront, a busy, jagged skyline, dazzlingly illuminated at night. The ubiquity of such urban imagery and the familiarity of the shot render it likely that for most viewers Cardiff's specific identity will be subsumed into its generic one, and rendered anonymous in the process.

This is not a wholly negative reading, however, as the press coverage and local audience response to *Torchwood* indicates. On the one hand, no matter how familiar viewers might be with Cardiff, aerial photography offers a view of the city that is not normally available and there is a pleasure in seeing a familiar place rendered, spectacularly, in an unfamiliar way. On the other hand, the internationalising of the city is often embraced because it places Cardiff on a bigger stage, especially in a context where there have been few representations of the city on networked UK, let alone international, television screens. Indeed, the findings of the BBC Trust/ACW project audience research indicated that a 'virtuous circle' existed in which the discourses of tourism, news reporting and viewer appreciation overlapped. As one respondent to the online questionnaire put it:

> Not many programmes are filmed in Cardiff (especially that then get aired in England) and so in terms of merely highlighting the city that's positive. *Torchwood* in particular emphasises its setting in Cardiff (and makes it look pretty!) and presents Cardiff as lively and exciting.[18]

Visit Cardiff, the official visitor's website for Cardiff, at one stage headlined its web pages on *Torchwood* with the approving quote from John Barrowman that provides this chapter with its tag line:

> When you see Cardiff on film, it looks like LA – it looks amazing. I think a lot of people are going to want to come here, not just

because of *Torchwood* but because it's such a great place – it's buzzing every single day and it's beautiful.[19]

Barrowman's comment gives the internationalising of Cardiff a specific resonance, relating representations of the city not to cities in the generality but to a specific city, Los Angeles, that is familiar through its ubiquity in American television and Hollywood cinema. The reference is, therefore, as much to other television as it is to a known tourist destination. Cardiff-as-Los-Angeles is a way of noting a form of 'Americanisation' of UK television drama alluded to earlier. In this context, Americanisation is shorthand for the ways in which (some) British drama series have absorbed modes of narrative and character construction and shooting style associated with high-profile US drama. *Spooks* and *Life on Mars* are relevant examples, if only because they are also clearly British/English in their orientation as well and show that the phenomenon is a complex one. Julie Gardner commented on the process during a symposium on *Life on Mars* held at the Cardiff School of Creative and Cultural Industries in 2007. Noting the specific contribution of Kudos, the independent production company responsible for developing both *Spooks* and *Life on Mars*, Gardner equated what she identified as a new, bold and much-needed manner of storytelling with the influence of American drama series:

> [O]ne of the things they did, they brought really robust entertainment – very well written, very bold, very clear storytelling – to series. I think the other thing, that's not just Kudos, I'm speaking in very broad industry terms, I think at that point, shall we say seven years ago [c.2001], I think that show [*Spooks*] really made series TV in the UK exciting again ... I think they made TV series start to feel sexy, start to feel quite American, in the good ways that kind of pace the wit of the storytelling, the clear definition of a genre, and I think at that point we needed that.[20]

Torchwood films Cardiff in ways that are similar to the use of urban establishing shots in US series such as *CSI* in its different guises. For example, the aerial shots noted already are repeated throughout each episode in Series 1 and 2: in 'Everything Changes' (1.1), the shot of the city at night is used three times, and in 'Day One' (1.2), it is used twice. This pattern is repeated in relation to the sister shot of

the city in daylight and from 'Day One' onwards, this shot becomes part of the credit sequence. These shots are paralleled by sequences that are set on the road network – largely generic and anonymous – mostly at night (four in each episode). Such sequences are not only about establishing place and genre, but are also components of the 'punctuation' of the episode, separating one part of the narrative from another, signalling a change of focus, of location or of mood or indicating the passage of time. Similar use is made of the recurrent shot of Jack Harkness/John Barrowman on the roof of the Altolusso apartment block. In representing cityscapes in this way, *Torchwood* is borrowing from US television drama, in which there is a similar use of the urban environment to break up the narrative (often placed in relation to the ad breaks). *CSI: Miami*, for example, punctuates its stories with shots of the sun-drenched coast and waterfronts of the city, whilst the originator of the franchise, *CSI*, makes similar use of the recognisable iconography of Las Vegas, shot mostly at night. Indeed, episode one of *Torchwood,* 'Everything Changes', makes an ironic reference to this connection, when PC Andy Davidson (Tom Price), en route to breaking up a pub brawl with Gwen Cooper (Eve Myles), muses, in an oft-quoted moment, on the possibility that *CSI* could locate itself in Cardiff: '[C]an you imagine it?' he observes, '*CSI Cardiff* – I'd like to see that: they'd be measuring the velocity of a kebab'.

Hearing Welshness: aural discourses and characterisation

So far, this discussion has drawn attention to the visual elements of the programme, following one of the dominant practices of screen analysis, which is to privilege the visual over the aural. In *Torchwood*, the visual and aural do not always follow the same path, even though they wear the same generic clothing. What characters *say* – or rather how they say it – is one of the main ways that the Welshness of *Torchwood* is made evident. Accent and speech idiom, in television drama as in life, connote geographical and social identity, and within the broad conventions of verisimilitude stand in synecdochically for a region and class. There is nothing formulaic or inevitable about what accents signify, and for most viewers

beyond Wales the accents will connote 'Wales' rather than 'south-east Wales', let alone 'Cardiff'. (Very rarely is the Welsh language heard in the series.) For locals, with privileged knowledge, accents and idiom are read in more specific ways. One of the complaints of some focus group members interviewed during the 'Screening the Nation' project was that the accents were not specific enough: 'even in Cardiff no-one seems to have a Cardiff accent'[21], as one respondent put it. Interviewees from north Wales complained that Rhys (Gwen Cooper's boyfriend and then husband, played by Kai Owen) 'was from the north originally too but that doesn't come across. There's no one northern, it is a southern thing'.[22]

It is not possible to discuss voice and accent independently of character, and it is in the characters that populate the narrative of *Torchwood* that much of the specific identity of the series is established. In Series 1 and 2, characters may be divided into three types: the main protagonists (the *Torchwood* team); other recurring characters who come from beyond the team yet are important to the series identity and appear frequently in it (for example, Rhys and PC Andy Davidson); and characters who are brought into each episode to populate particular storylines. The distinction between the first two of these became blurred in Series 3, with Rhys becoming a de facto member of the team. The schema was abandoned altogether in Series 4, where a new set of characters came into the programme.

The initial Torchwood team is self-consciously cosmopolitan, led by an American, Jack Harkness; with an English medic, Owen Harper (Burn Gorman); and a Japanese computer expert, Toshiko Sato (Naoko Mori). The original group also included Suzie Costello (Indira Varma), who is killed off early in Series 1 and is played by an English actor of Indian descent. The team is completed by two characters who are clearly Welsh, Ianto Jones (Gareth David-Lloyd) and Gwen Cooper. The latter, of course, enacts the role of audience representative, providing the most consistent access to the world beyond the Hub through her relationship with other recurring series characters such as Rhys and Andy, and her role in accessing local knowledge when required to further the plot. Indeed, the very first episode, 'Everything Changes', introduces Torchwood to us through the narrative device of using the arrival of a new member of the team as a means of providing essential background

information for the audience: as Torchwood is revealed to Gwen, it is revealed to the audience as well, and she becomes the viewer's point of access to the series' narrative conceits. In Series 4, this role is filled by Rex Matheson (Mekhi Phifer), who, with Esther Drummond (Alexa Havins), leads the audience, many of whom are assumed to be new to the series, into Torchwood's secrets; the refrain, 'what is Torchwood?' echoes through the opening of both the first and last series.

Gwen is constructed as local to Cardiff by the narrative.[23] In this, she is aligned with the key non-*Torchwood* series characters, who are Cardiffians/Welsh – as distinct from characters who simply appear in more than one episode, such as Captain John Hart (James Marsters) – and the changing cast of characters central to each episode are also largely Welsh, although the continuous narrative arc in Series 3 and the partial relocation to London problematise this group. In this way, and with the caveat that specific identity is sometimes difficult to read with certainty, Cardiff and its citizens, and Wales and the Welsh more generally, provide the narrative core of Series 1 to 3, providing a range of types and individuals that are signalled as Welsh, and frequently Cardiffian. Sometimes, as in Series 3, characters also connote, metonymically, a politics and a set of ethical values as well (to which we will return).

London versus Cardiff: old and new enmities and 'Children of Earth'

The Cardiff that is represented in *Torchwood* is caught in the perpetual present of the series' narrative, which looks outward to the extravagance of the universe, but rarely looks back to the history of the city itself. However, the legacy of Cardiff's industrial past, as well as its position in contemporary post-devolutionary politics, is relevant both to certain undercurrents in some of *Torchwood*'s narrative twists and turns and to the political and cultural context in which the series emerged, and which it has in turn affected. Cardiff was made the capital city in 1955 in a belated recognition of its importance to the industrial wealth of both Wales and the UK as a whole and of the legitimacy of Welsh demands for greater status and autonomy. Cardiff docks, which embraced far more than

the Bay area as portrayed in *Torchwood*, grew as a conduit for coal and steel from the industrial heartlands of south Wales, initially by canal and then by rail from the 1850s onwards. By 1913, Cardiff was exporting 10.5 million tons of coal per year, making it the biggest coal port in the world. This was the apex of its industrial importance, as it was for the heavy industries of the UK as a whole. After the First World War, the industries of South Wales declined, suffering particularly hard from the depression of the 1920s and 1930s. By 1958 Cardiff exported just 2 million tons of coal per year, and ceased altogether in the 1960s.[24]

The decline of the docks turned into redevelopment in the 1980s, and the Cardiff Bay Development Corporation was established in 1987 with a brief to modernise the Bay area. It is important to raise one's eyes beyond Cardiff and the Bay at this point: the period 1980 to 1997 saw other kinds of transformation, further stages in Wales' long march towards a postmodern and postcolonial identity. These were connected to the struggle to re-establish Welsh as an official national language, which produced the Welsh language channel S4C (Sianel Pedwar Cymru) in 1982 and The Welsh Language Act of 1993, which obliged all public bodies to treat the English and Welsh languages as equal for official purposes. Most importantly, the 1997 Referendum resulted in a narrow vote in favour of political devolution (it had been decisively rejected in 1979), and the National Assembly for Wales was founded in 1999.

The Bay, now home to the Assembly Government, generates some of the dominant imagery of the 'new' Wales (often seen in *Torchwood*), although how the 'old' Wales is viewed remains a moot point. Arguing against the tendency within postcolonial discourse, and by extension postmodernism as well, to reject the past (even if one could confidently locate the point where Wales ceased to be a 'colonised' or 'industrial' nation), Aaron and Williams note that it is not a question of 'old Wales bad, new Wales good' but rather that postcolonial discourse 'embraces concepts such as ambivalence (the mix of attraction and repulsion that may characterise relationships between Imperial power and colony) and hybridity (the creation of "transcultural" forms in the contact zone between the two) that raise many awkward questions for Wales and the people of Wales'.[25] There are two 'awkward questions' that are relevant here, and both are political as well as representational: the first concerns

the relationship between past and present, between the old and the new Wales, with the Bay as an area of contestation; the second is about Wales' relationship to England, which is also being asked in the other devolved nations of the UK, especially Scotland. Both questions are relevant to *Torchwood* and the conjuncture in which it was produced; indeed, they are particularly relevant to the BBC as an institution, especially the second.

The BBC's recent history enacts the tension between London/England and Cardiff/Wales. Responsibility for broadcasting was not devolved to the Welsh Assembly, but remains with the Westminster Parliament, which means that the BBC in London ultimately determines the policy and finances for BBC Cymru Wales (and soon for S4C as well). A belated awareness of its historical neglect of the nations and regions of the UK has led the Corporation to commit to spending 50 per cent of its production budget for network television outside London by 2016. Cardiff has been developed as a base for drama, of which *Doctor Who*, *Torchwood* and the highly successful *Sherlock* are pertinent examples. However, this commitment was made in a context where the BBC's investment in English-language programmes for viewers in Wales was reduced by 11 per cent per year in the period 2004–2009, and where the recession has led to a general contraction of budgets that risks undermining any benefit to the production sector in Wales.[26] The BBC has invested heavily in new drama studios located in Roath Basin, a former dockland area within view of the Senedd, which is also the location of a new centre that aims to act as a focus for the development of Wales' digital industries. In an attempt to acknowledge – and construct – a continuity between past and present, the development has been called Porth Teigr, which recalls Tiger Bay, an historic name for the area and home to the multi-ethnic working class who had once supported and lived off the docks.

Series 3 of *Torchwood*, 'Children of Earth', also represents the tension between London/England and Cardiff/Wales and, obliquely, between a past and present. In doing so, it makes visible questions of social class, hitherto concealed within the series. 'Children of Earth' also radically altered *Torchwood*'s established narrative structure. Stretched across five consecutive nights in July 2009 instead of appearing as thirteen separate episodes, the series was conceived as a television 'event' with a single narrative arc (hence the series

title). As Russell T. Davies noted, it was conceived as 'bigger, darker, bolder'[27] than its predecessors, was the first series to run without Owen Harper and Toshiko Sato, and included the death of Ianto Jones. For the first time, much of the action was set outside Wales, mostly in London.

The narrative explores an act of secrecy and deception committed by the British government in the 1960s which has appalling consequences in the present. A deal was struck with aliens, known as the 456, who were allowed to abduct a group of children for their own use, and who return in 2009. This time, however, they want one in ten children from across the world: the alternative is the annihilation of the human race. The series is a form of 'holocaust narrative', imagining a global catastrophe of unimaginable suffering and exploring guilt, responsibility, appeasement and resistance. It also implicates Jack, who was complicit in the betrayal of the initial group of children, and who is required to sacrifice his own grandson in the dénouement of episode five.

The narrative of 'Children of Earth' is structured in terms of a binary opposition between Cardiff/Wales and London/England, in which the latter (with the connivance of other governments) is an agent of deceit and betrayal. Personified by the oleaginous UK Prime Minister (Nicholas Farrell), the UK government is willing to compromise with the aliens and organise, by subterfuge, the abduction of the children (with the destruction of the Torchwood Hub in 'Day Two' (3.2) and the attempted elimination of the team as a necessary pre-condition). This opposition is not only the expected one between good and evil often required by genre, but also uses the socio-geography of the cities/countries synecdochically to represent a set of values and attitudes, and eventually actions. London, the home of government and of the alien presence, is the source of betrayal; Cardiff, in contrast, is the source of resistance. Also, this resistance is associated with a part of Cardiff that has not been in evidence before, a post-war, working-class housing estate. Class is made an issue, since the Government's plan is to target schools that will provide the children for abduction, which, it is suggested by the Prime Minister, would be an opportunity to get rid of 'undesirables' and protect the children of the middle classes.

The viewer is taken into the estate via a plot line that focuses on Ianto's sister Rhiannon (Katy Wix) and her husband Johnny (Rhodri

Lewis), who live there and run an informal crèche. In a climactic moment which has strong echoes of the rounding-up of Jews from pre-War European cities, the army is sent to collect the targeted children, who are spirited away by Gwen and Rhiannon (although they are eventually tracked down). Johnny and a group of hastily assembled locals actively resist, and although they are eventually defeated, their actions are represented as necessary and heroic, offering the only example in the series of concerted opposition to government actions. Cardiff here, and Welshness with it, is linked to the traditional working-class values of solidarity and collective action (even though it is one more narrative of heroic defeat, with which the history of working-class politics and art is littered). Whilst this connection is not made explicitly political (any more than the echoes of the holocaust are), it is one way in which *Torchwood* uses genre to create resonances beyond the immediate concerns of the narrative.

Conclusion: coming from 'somewhere'

Torchwood appears at a significant moment in post-war Welsh history, and plays a part in debates about not only the representation of Cardiff but also what 'Welshness' means in contemporary Wales. The 'Screening the Nation' audience research suggests that audiences, in responding to the heterogeneous identities on display across the series, are willing to embrace a wide range of representations of the national, whilst acknowledging that representation is not a simple matter. *Torchwood* was also seen as in some ways anomalous in a context where many viewers are concerned that the BBC, and the media generally, are London-centric. As the report puts it:

> Good quality programmes garner audience appreciation when they succeed in representing Wales in a way that is credible (within the limits of the specific genre), well-produced, and avoiding simplistic, stereotypical images. However, there is a widespread view that the BBC, together with other broadcasters, does not consistently live up to this expectation, with television fiction remaining a London-centric phenomenon producing too many stereotypical images of Wales that lack conviction and appeal.[28]

The criticism is one to which the BBC is increasingly sensitive. In a speech in Cardiff in 2010, Jana Bennett, the BBC Director of Vision, acknowledged that the BBC had too often mistakenly assumed that representing the specific social and geographical identity of a location would be unpopular. Her message to commissioners was blunt:

> I want them to get the message out loud and clear that we want fewer programmes from 'nowhere' in particular, and more from and about 'Somewhere'. That way we will get both the quality and the authenticity that audiences tell us they want.[29]

Given that she was speaking in Cardiff, it is no surprise that she singled out *Torchwood* and Russell T. Davies for praise:

> [w]e know that one of the things which made it [*Torchwood*] such a success was Russell T Davies's decision to set it here in Wales, in this city, which in the end helped to define the show. He didn't see setting his science fiction drama in this city as an impediment to scale, ambition, risk taking – quite the reverse.[30]

As a BBC executive, Bennett's comments are made with an acute awareness of audiences, who are also licence-fee payers, and the BBC Charter. It was a moment where what it 'means' to represent Cardiff, and other locations beyond the metropolitan belt, was made visible in broadcasting policy. Whether this has lasting impact remains to be seen.

Notes

1. Brett Mills, 'My House Was On *Torchwood*: Media, Place and Identity', *International Journal of Cultural Studies* 11/4 (2008), pp. 379–99, p. 383.
2. See Steve Blandford, Stephen Lacey, Ruth McElroy and Rebecca Williams, *Screening the Nation: Landmark Television in Wales*, BBC Trust and Audience Council Wales, 2010. Online. Available http://culture.research.glam. ac.uk/news/en/2010/mar/15/screening-nation-wales-and-landmark-television-rep (1 January 2012).
3. The research was conducted after Series 1 and 2 had been transmitted, although the textual analysis took account of Series 3. This chapter will consider, for the most part, these three series, although some observations will be made on Series 4.

4. Matt Hills, *Fan Cultures* (London, 2002); see especially chapter 6.
5. Matt Hills, '*Doctor Who* Discovers ... Cardiff: Investigating Trans-Generational Audiences and Trans-National Fans of the BBC Wales Production', *Cyfrwng: Media Wales Journal* 3 (2006), pp. 56–74.
6. Raymond Williams, 'A Defence of Realism', in *What I Came to Say* (London, 1994). Williams argues that representing contemporary life and issues is one of the defining characteristics of realist drama, historically speaking.
7. Russell T. Davies, 'Interviews', *Torchwood: The Complete Series One and Two*, Bonus Features (BBC Worldwide, 2008).
8. Cardiff Council website. Online. Available http://www.cardiff.gov.uk/content.asp?nav=2868,2969&parent_directory_id=2865&id=4024(15 August 2010. Page unavailable as of 1 March 2012).
9. See http://www.doctorwholocations.net/ and its sister site www.torchwoodlocations.net . The BBC participated as well, encouraging viewers to post their encounters with film crews on its own site: http://www.bbc.co.uk/wales/southeast/sites/doctorwho/pages/sightings.shtml
10. Hills: *Fan Cultures*, p. 149.
11. Blandford et al.: *Screening the Nation*, p. 28.
12. These include Merthyr Tydfil, whose Old Town Hall provides the external shots of the Ritz Cinema in 'Captain Jack Harkness', 1:12 (the interior shots are of the Westgate Hotel, Newport); Flat Holm island ('Adrift', 2:11); and the Brecon Beacons ('Countrycide' (1.6)).
13. Linnie Blake, '"You Guys and Your Cute Little Categories": *Torchwood*, The Space-Time Rift and Cardiff's Postmodern, Postcolonial and (avowedly) Pansexual Gothic', *The Irish Journal of Gothic and Horror Studies* 9 (2009). Online. Available http://irishgothichorrorjournal.homestead.co./Torchwood.html (4 October 2011).
14. Daniel Rawcliffe, 'Transgressive Torch Bearers: Who Carries the Confines of the Gothic Aesthetics', in A. Ireland (ed), *Illuminating Torchwood: Essays on Narrative, Character and Sexuality in the BBC Series* (Jefferson, North Carolina, 2010).
15. Rawcliffe: 'Transgressive Torch Bearers', p. 102.
16. Blake: 'You guys and your cute little categories', pp. 1–2.
17. Rebecca Williams, 'Cannibals in the Brecon Beacons: *Torchwood*, Place and Television Horror', *Critical Studies in Television* 6/2 (2011), pp. 61–73.
18. Blandford et al.: *Screening the Nation*, p. 41
19. Visit Cardiff. Online. Available http://www.visitcardiff.com/Torchwood.html (7 December 2009. This page has since been amended to remove the quotation (16 January 2012)).
20. Julie Gardner and Claire Parker, 'Julie Gardner and Claire Parker: In Conversation', in S. Lacey and R. McElroy (eds), *Life on Mars: from Manchester to New York* (Cardiff, 2012), p. 193.
21. Blandford et al.: *Screening the Nation*, p. 31
22. Ibid.
23. The actor herself comes from Ystradgynlais in Powys, a former mining town some forty miles to the northwest of Cardiff, on the edge of the Brecon Beacons.

24. A good sense of what Cardiff Bay looked like in the 1960s and 1970s before it was redeveloped is conveyed in John Briggs' photographic record, *Before the Deluge* (Bridgend, 2002); a full account of the economic significance of Cardiff docks can be found in M.J. Daunton, *Coal Metropolis: Cardiff 1870–1914* (Leicester, 1977).
25. Jane Aaron and Chris Williams (eds), *Postcolonial Wales* (Cardiff, 2005), p. xvi.
26. OFCOM. The Communications Market in Wales: TV and Audio Content. Online. Available http://stakeholders.ofcom.org.uk/binaries/research/cmr/753567/Wales-tv.pdf (27 August 2010).
27. Russell T. Davies, 'DVD extras', in *Torchwood: Children of Earth*, Bonus Features, (BBC Worldwide, 2009).
28. Blandford et al.: *Screening the Nation*, p. 24.
29. Jana Bennett, 'Putting Programmes on the Map' (Speech given to Cardiff & Co, 2010). Online. Available http://investincardiff.com/assets/pdf/Jana%20Bennett%20Portrayal%20Speech%20-%20final.pdf (14 February 2012).
30. Bennett: 'Putting Programmes on the Map'.

TONIGHT'S THE NIGHT WITH… CAPTAIN JACK! *TORCHWOOD*'S JOHN BARROWMAN AS CELEBRITY/SUBCULTURAL CELEBRITY/LOCALEBRITY

Rebecca Williams

He's a time traveller, a Desperate Housewife killer and a light entertainment TV presenter. John Barrowman's got his finger in so many pies, he could be a taster at Greggs.[1]

Torchwood's biggest mystery is how it transforms John Barrowman from a cheesy talent and chat show lightweight into a bona fide action hero. He should stick to the acting.[2]

As any fan of *Torchwood* or its parent show *Doctor Who* knows, the enigmatic character of Captain Jack Harkness is played by John Barrowman, an actor, singer and general television personality. This chapter explores Barrowman as a celebrity, seeking to contribute to contemporary debates around television stardom, particularly in relation to the tension between mainstream and cult celebrity. It offers a new means of understanding television celebrity through consideration of how personalities can cross between factual and fictional TV genres. It also argues that notions of televisual

celebrity are often resolutely wedded to specific locations, considering how place and space impact upon audience encounters with TV stars. Barrowman's roles in cult shows such as *Torchwood* indicate that he functions as a form of 'subcultural celebrity', that is, 'mediated figures who are treated as famous only by and for their fan audiences'.[3] However, his appearances on primetime Saturday night entertainment shows such as *Tonight's The Night, Any Dream Will Do* and *Strictly Come Dancing* complicate how we read his star persona and limit his construction as a subcultural celebrity since, as the quotes that open this chapter indicate, there is often difficulty in addressing celebrities who move between different genres and modes of performance. As noted, the chapter also explores the relationship between celebrity, genre, and place and space in relation to contemporary stardom. Given *Torchwood*'s status as a production based in Cardiff (until its fourth series 'Miracle Day'), and Barrowman's often very visible status as a resident of South Wales, I draw on the concept of the 'localebrity', a 'hybrid of the reality television celebrity and the local personality or "character"',[4] to discuss how Barrowman's status as a 'local character' can be explored.

Theorising television celebrity

There remains a 'well caught distinction' between the film star and the television performer.[5] As Su Holme

> Television's rhetoric of familiarity and intimacy, the size of the screen, the perpetual presence of its everyday flow, and its domestic context of reception all mitigated against the construction of a star, instead producing the "personality effect".[6]

This is linked to the emphasis in early star studies on 'authenticity' and the relationship between on-screen and off-screen star personae.[7] The ability to act was seen as a mark of the star's talent and as 'an achievement, that has worked towards establishing the hierarchical dichotomy with television fame and performance'.[8] Similarly, Ellis argues the TV performer was a 'known and familiar person, rather than a paradoxical figure, both ordinary and extraordinary' and, therefore, TV performers could not be seen as stars in the same way as cinematic actors.[9]

However, Murray has argued that the crossover appeal of teen stars such as Sarah Michelle Gellar of *Buffy the Vampire Slayer* and their ability to work in both television and cinema blurs such boundaries.[10] Other work has considered TV personalities who are often reality television stars, such as Jade Goody, or presenters, such as Jamie Oliver or Steve Irwin.[11] This has led to a theoretical distinction between 'stars' and 'personalities' – although the intertextual circulation of television fame may use each term interchangeably – whereby the former term might relate to actors in fictional programming, and the latter presenters in factual programming'.[12] However, this distinction between television stars (those who appear in fiction) and personalities (those who appear in factual shows) does not always hold up since, as this chapter argues, figures such as John Barrowman are able to occupy both roles.[13] This is linked to the fact that contemporary television has witnessed increased hybridisation and crossover between factual and fictional forms more broadly in genres such as reality television and documentary.

Work on cult TV stardom has also proliferated, with particular attention paid to the interplay between characters and stars. Pearson argues that 'cult television may equate or entangle actor and character even more than other television fictions.... With cult television stars, the fictional figure overlaps the star's general image'.[14] Likewise, Gwenllian-Jones concludes that 'cult television series and cult films favour characters over stars and the primacy of character-as-star over performer-as-star greatly reduces the effectiveness of the performer's star text upon that of the character'.[15] However, for some fans both characters and actors are the subject of fascination and 'celebrity and character are treated as a complex semiotic interaction, as fans playfully negotiate lines between the two'.[16]

Central to more recent work is the concept of the subcultural celebrity. Focusing upon his role as Captain Jack Harkness in *Torchwood*, this part examines how John Barrowman can be partially read as a typical cult celebrity who works to blur character and star persona and who is accessible to fans via social events such as conventions and signings. Certain stars 'have usually been treated as culturally ubiquitous. Stars/celebrities are hence assumed to constitute a mass-mediated and shared currency within contemporary consumer cultures.'[17] However, attempts have been made

to understand cult stardom through the notion of the 'subcultural celebrity' who, in contrast to culturally ubiquitous figures such as Madonna, Marilyn Monroe or Lady Gaga, are 'mediated figures who are treated as famous only by and for their fan audiences'.[18] Matt Hills notes that subcultural celebrities are likely to

> have embodied, social interactions with their fans through conventions and so on, and also via the internet and that, in contrast to the notion of 'closeness through distance' engendered by culturally ubiquitous celebrities, this can be seen as 'distance through closeness'.[19]

Therefore, existing binaries 'based on "mediated" and one-way interaction versus "embodied" and two-way social interaction are at least partly blurred by the phenomenon of subcultural celebrity'.[20] One is far more likely to get to meet subcultural celebrities such as Barrowman than more culturally ubiquitous stars who remain out of reach. Indeed Barrowman can in many ways be considered a relatively typical cult star, given his appearances and contact with fans and the ways in which he blurs the distinction between his own 'celebrity and character'.[21]

Access and contact

Since his first appearance on *Doctor Who* in 2005, John Barrowman has been generally accessible to cult audiences through a variety of means. He has appeared at a range of conventions such as Gallifrey (2006), Collectormania London (2009), San Diego Comic-Con (2008, 2009) and Torchsong Chicago (2009) and has also taken part in countless book signings for his autobiographies and albums and, with Eve Myles and Gareth David-Lloyd, for the DVD release of 'Children of Earth' in 2009. Such accessibility is crucial to establishing and maintaining closeness with fans since 'fan festivals and conventions render professionals unusually available to fans. This fan–celebrity social proximity, however ritualized and reflexively monitored it may be, allows fans to feel close to [stars].'[22]

Whilst some cult fans focus on characters, for others it is the actors themselves who are the objects of fandom since '[S]ome [fans] are deeply interested in the actors and spend most of their

time discussing and speculating about their lives.'[23] Whilst the types of 'Q&A', signing or convention discussed above may allow fans to 'get close' to Barrowman, I want here to consider how such interest in both the character of Jack Harkness and the actor who plays him are maintained and marshalled, with particular emphasis on how Barrowman is positioned as both similar to, and different from, Captain Jack. This is crucial since 'managing perceived intimacy requires actors to delicately balance their real persona with that of their character when interacting with the public.'[24]

Cult celebrities are similar to the more traditional type of TV star in that characters can often become inextricably linked to those who play them. As Ellis noted,

> [T]he television performer appears in subsidiary forms of circulation (newspapers, magazines) mostly during the time that the series of performances is being broadcast. The result is a drastic reduction in the distance between the circulated image and the performance. The two become very much entangled, so that the performer's image is equated with that of the fictional role.[25]

In many ways, Barrowman creates and maintains such 'entanglement' with Captain Jack. He often explicitly likens himself to the role, in one interview answering a question about why people respond to Captains Jack's openness and enjoyment of life:

> In a way, and I'm not, you know, stroking my own ego here, but that's a lot like John Barrowman. And anybody who you might talk to who knows me, knows that I love life, I love to have fun, I'm very open, I don't mince my words, I say what I feel, and, you know, that's just the way I am. I put a lot of my own personality into Jack.... So maybe that's why they like him.[26]

In a 2011 interview with the official *Doctor Who Magazine*, Barrowman reiterated this Jack–John fusion, noting that 'about 75 per cent of it is the wonderful writing, and then maybe 25 per cent because of personality. I put a lot of my own personality into Jack ... There's a lot of Jack in John, and a lot of John in Jack.'[27]

Perhaps the most obvious overlap is Barrowman's status as a happily married gay man and the 'omnisexuality' of Harkness which has been much commented on.[28] Whilst Barrowman himself identifies

as gay, he is often playfully flirtatious with both genders and frequently performs in a fairly risqué manner. For instance, in one controversial incident in 2008, he was forced to apologise 'for exposing his genitals during a live BBC Radio 1 broadcast'.[29] Putting aside the apparent incongruity of having to apologise for flashing on a radio show (a non-visual medium), such events work to cement the entwining of Barrowman's own playful persona with the openness and sexual frankness of Captain Jack. However, it also underscores the diversity in Barrowman's multiple forms of celebrity; his behaviour here is quite different from how he performs when presenting family entertainment shows, as I will discuss below. The next part examines how similarity with, and difference from, the character of Captain Jack are mobilised in the construction of Barrowman as a mainstream figure with the BBC's Saturday night family schedule. In keeping with the focus on mainstream/cult dynamics, his judging slots on Andrew Lloyd-Webber's musical talent shows and his own variety show *Tonight's The Night* will be considered in light of the balance performed between the subcultural cult celebrity of *Torchwood* and the mainstream renown associated with these Saturday night shows.

Mr Saturday Night: John Barrowman as mainstream celebrity

Whilst Barrowman's role as Captain Jack in *Doctor Who* and *Torchwood* may be the key point of interest for cult fans of the shows, his celebrity status is also inflected by his role as a television host and personality. This part focuses on his Saturday night television programme *Tonight's The Night,* although he has also appeared on Andrew Lloyd Webber's musical talent shows *Any Dream Will Do, How Do You Solve A Problem Like Maria?* and *I'd Do Anything.* He has also appeared on ITV's *Dancing on Ice* in 2006, BBC1's *Strictly Come Dancing* in 2010, presented sections of BBC fundraising telethon *Children in Need* in 2009 and 2010 and the children's show *Animals at Work* for CBBC, and been a guest on game shows such as *All Star Family Fortunes* or *Scream If You Know The Answer.*[30] Such appearances across a breadth of genres mean that '[The] personality and the actor ... may oscillate from one position to another.

The actor may perform as a celebrity when they [sic]guest on a game show, whereas the celebrity may act in a dramatic fiction.'[31] The Lloyd Webber shows allow Barrowman to draw on his experience in musical theatre, having appeared in musical productions such as *La Cage Aux Follies, The Phantom of the Opera* and *Miss Saigon*. His own show *Tonight's The Night* is also linked to his broader musical recording career which has seen him release albums of show tunes, pop songs and some original music such as the Gary Barlow-penned 'What About Us?' in 2008. It is, therefore, *Tonight's The Night* that demonstrates most clearly the multiple forms of performance in which Barrowman engages. Indeed, even when presenting the show as 'himself' he is performing a role as 'John Barrowman' since 'performance... is fundamental to the celebrity of the television personality'.[32]

The Saturday night show typically opens with Barrowman performing a rendition of the Black Eyed Peas' 'I Gotta Feeling' and he also closes the show with a song. There are opportunities for him to sing with, or serenade, members of the audience and this is interspersed with pre-recorded moments where Barrowman surprises 'deserving' members of the public. The programme thus draws on a long tradition of British Saturday night light entertainment such as *Surprise Surprise* and *Beadle's About*. Karen Lury argues that the characteristics of light entertainment are 'the promise of escapism, "harmless" entertainment, slightly bawdy but not malevolent humour, a little bit of glitter and excitement, community and participation'.[33] This draws on a long lineage which has roots in cabaret, music hall and seaside acts.[34] *Tonight's The Night* fits perfectly into Lury's criteria, encouraging audience participation, offering 'glitter' via the often glamorous styling of Barrowman and his dancers, and, as discussed below, some risqué but family-friendly comedy.[35]

In *Ordinary Television,* Bonner discusses the role of television presenters and their use of 'direct address... to establish and maintain an intimacy between programme and audience'.[36] In *Tonight's The Night* it is Barrowman's role to provide this intimacy, to mediate between the viewer and the show and to perform the function of anchoring the on-screen events. Here, Barrowman's appeal is quite different from his cult persona since his appearances must fall in line with the traditional mainstream 'mass family viewership'

of Saturday night TV.[37] Thus whilst he may maintain a jokey or cheeky guise (e.g. in a segment where he poses as a camp Scottish air steward to surprise a member of the public) he must avoid the more potentially controversial aspects of his performance (such as the radio flashing incident mentioned above). There is a slightly risqué tone to some of the features but this is always subsumed into 'family entertainment'. A similar move has taken place with the popular TV presenter Graham Norton who maintains a distinction between his own highly risqué late-night *Graham Norton Show* where he 'draws on his sexuality for a performance laced with innuendo and explicit gags about sex' and his Saturday night presenting duties where 'the mobilisation of his sexuality ... is more akin to fairy godmother'.[38] The scheduling of *Tonight's The Night* and the talent shows on which Barrowman has appeared as a judge mean that some aspects of his star persona must be subsumed into more acceptable camp comedy for the mainstream primetime audience since 'scheduling... works as an important process for differentiating the televisual image of personalities'.[39]

Matt Hills has discussed how Barrowman's dual appeal impacted the screening of 'Miracle Day' in the UK, with particular reference to the removal of sex scenes from the third episode, 'Dead of Night' (4.3). Hills suggests that this removal of sexual content works to 'create a branding firewall' between Barrowman and Captain Jack and that 'a clear semiotic divide has to be established between the two as far as BBC brand management goes'.[40] He argues that this was especially pertinent since *Tonight's The Night's* second series was on air at the same time as *Torchwood* and that the BBC tried to avoid leading 'viewers from *Tonight's The Night* to *Torchwood*'.[41] Thus 'differences in television personality as not simply motivated by genre but also affected and constructed by the nature of the schedule and what certain time slots allow or prohibit'.[42] However, there *are* references made to *Torchwood* in *Tonight's The Night* when their airings coincide. In the fifth show of 2011, Barrowman opens with the following comment:

> You all know how this show works: Along with my trusty team I travel here, there and everywhere hunting down people with big plans. And when I find them, I eliminate them [audience laughter]. Oh no no no, sorry, that's *Torchwood*. Ha!

Here, then, Barrowman's role as both 'genial, playful, and family-friendly'[43] and his playing of Captain Jack are invoked, leaving the audience in no doubt as to the fact that he is also a star in *Torchwood*. Even before the airing of 'Miracle Day', *Tonight's the Night* allowed Barrowman to negotiate the line between himself and Captain Jack. The clearest example of this was when one competition winner starred as an alien in a short *Doctor Who* sketch that was written by Russell T. Davies and starred David Tennant as the Doctor and Barrowman as Jack. This part of the show begins with Barrowman on stage announcing that the quest for the new alien has taken him 'From Gallifrey to Gateshead'. After briefly explaining the concept of the competition, Barrowman announces 'Be afraid. Very afraid' and the shot cuts from the studio to the Tardis. Barrowman is then seen as Captain Jack, dressed in his recognisable military uniform, making the jump from Barrowman-as-host to Barrowman-as-Jack visually clear. The scene is playful and comic, playing on the joke that Barrowman-as-himself (the apparently 'real' John Barrowman) can often be found acting out scenes in the Tardis set when the cast and crew are not around. The scene is followed by Barrowman standing onstage with the fan, Tim, who won the competition, and discussing the experience. In this episode of *Tonight's The Night,* the fluidity with which Barrowman crosses between his role as the host of the show and his fictional persona of Captain Jack emphasises his position as both a subcultural celebrity and a mainstream television personality. He can, here, perform as both 'himself' and as the character he plays, highlighting the performance of both aspects of his star persona without threatening to 'collapse' one into the other or to become inextricably 'entangled, so that the performer's image is equated with that of the fictional role'.[44] Indeed, at the very moment when he might be most clearly seen as 'Captain Jack', this is revealed to be a trick for the audience. In this sketch he is, despite first appearances, 'Barrowman-playing-Barrowman' rather than 'Barrowman-playing-Jack'.

Indeed, it is in many ways precisely his playing of the role of Captain Jack that allows such fluidity to occur, given the playful blurring of character and actor at work in fantasy shows in comparison to more serious genres such as crime drama. The genres of science fiction/fantasy and light entertainment allow for Barrowman's subsequent appearance as a personality who embodies 'ordinariness,

authenticity, intimacy and the continuity between on/off-screen self',[45] as well as continuity between the performed self and the fictional role of Captain Jack.

'*Torchwood* star holds garage sale!' – John Barrowman as 'localebrity'

I have so far argued that the example of John Barrrowman allows us to destabilise some of the existing theoretical categories that have been used to consider television stardom and that these categories tend to map onto distinctions between cult texts (the subcultural celebrity) and the mainstream (television personalities). However, I want here to consider the final boundary which his star persona blurs; the tension between national and local celebrity. Many TV performers are 'widely, if not universally, recognized within the nation, though unknown outside'.[46] Another apparent distinction between traditional film stars and television personalities, then, is that the former cross international boundaries and achieve global fame, whilst the majority of television performers remain grounded within specific nations. This final part considers how the notion of the 'localebrity' can help us to consider how stardom operates in relation to place and space. Barrowman functions not only as a national (i.e. 'British') celebrity via his Saturday night appearances and an international cult star via the figure of Captain Jack, but also as a highly localised and geographically rooted figure within South Wales.[47] Such arguments have broader purchase in our understandings of celebrity within the era of TVIII, especially with regard to performance and celebrity selves.

Sociologist Kerry O. Ferris has called for more academic inquiry into local celebrity, arguing that 'At the local level, celebrity may be defined in a more limited way – people who are well-known in smaller, more circumscribed worlds, but who are not necessarily household names like the Hollywood stars'.[48] McElroy and Williams developed the concept of the '"localebrity", a hybrid of the reality television celebrity and the local personality or "character" that better enables us to examine the cultural and theoretical specificity of local/national celebrity'.[49] As this quote makes clear, this was initially coined to understand the appeal of participants in local reality

television such as BBC Wales' *Coal House* and *Coal House at War* which aired only within Wales and were not screened nationally. McElroy and Williams note that

> the contradictions and liminality of figures such as participants in *Coal House* position them as ambiguous celebrities who are both within and outside the media world and who we suggest can be approached as 'localebrities' who both embody and complicate traditional notions of celebrity.[50]

I suggest here that, whilst John Barrowman does not fit all the criteria established for the localebrity as defined in the *Coal House* study (e.g. that localebrity functions primarily in a national context with a limited national media), other aspects of this idea can be usefully employed to understand how his celebrity functions within a local context.

As discussed above, Barrowman maintains a proximity to fans via conventions and other official events. However, his position as a resident of Sully (a small South Wales village, approximately five miles outside Wales' capital city Cardiff), in which he is often present at local community events, necessitates a way of understanding this which the notion of subcultural celebrity alone cannot fully account for. For example, in the summer of 2010 he held a garage sale at his home, an event which made it into the local news. Barrowman commented that 'I'm having a garage sale like any other citizen of South Wales!' and 'I'm just a regular citizen holding a normal garage sale to clear out a load of old junk and raise money for charity'. A neighbour also noted, 'It's nice to see he's part of the community'.[51] Such comments work to emphasise Barrowman's 'normality' and regularity, positioning him as 'like everyone else' and engaging in everyday activity. His comment that he is like 'any other citizen of South Wales' also positions him as a local figure, as someone who belongs in the local area. This contributes to the notion that he functions here as a 'localebrity'; as someone who views himself, and is viewed by others as, part of the local community and is geographically rooted. Similarly, in June 2009 he opened the local school fête, an event that came about purely because of his availability and residency in Sully. The organiser explains that 'I've seen him in Sully a few times so thought I'd be

cheeky and put a note through his front door. I was quite shocked when his agent called saying he'd be delighted to get involved!'[52] As with the example of the garage sale, this story suggests a closeness and accessibility for local people who are able to directly contact him and ask for participation.

He has also, variously, attended an open garden in his home town of Sully and charity events at the local Ty Hafan children's hospice. [53] Again, there is a reference to Wales in the press reporting of this event with Barrowman commenting that 'I thought it would be good to get involved with it and the community, and that it is how all this started.... People in South Wales are very generous!'[54] There is a sense here that celebrity endorses or grants value to place, functioning as a marker of virtue and according status to both the location of South Wales itself and the people who inhabit it. The ability to grant value to certain places has been explored in work on the use of locations in television drama production. In discussion of the impact of place branding and cultural value of production in Cardiff, Ruth McElroy has argued that

> Television enjoys a privileged relationship to citizens' identities being capable of bringing images and stories into the most intimate of places: our homes. But television also has the potential not only to represent place, but also to imbue it with values that have both economic and cultural worth.[55]

Whilst this refers to the ways in which marketing and tourism can function alongside mediated representations, comments like those made by Barrowman can also function to imbue South Wales with cultural worth. Since celebrity continues to function as a marker of status and as a position to which to aspire, the association with and the endorsement of place and people can act as an indicator of value. Encountering Barrowman at such localised events is quite different from meeting him at an officially scheduled signing or convention. Instead, certain 'Celebrity encounters on a local scale speak to a very particular sense of place and of belonging',[56] suggesting that celebrity in contemporary mediated culture is often highly localised and fluid.

Whilst Barrowman's home village and local standing may not be widely known to the mainstream audience who view his

Saturday night television shows, such knowledge is possessed by local residents and some more geographically distant *Torchwood* fans, especially given the proximity to the site of Roald Dahl Plas and 'the Hub' or Torchwood Tower in Cardiff Bay. Much academic attention has focused on the link between *Torchwood*, its diegetic Cardiff setting and its 'Welshness'.[57] Furthermore, '*Torchwood*'s use of Cardiff is likely to have different meanings for those who live in or have "local knowledge" ...of the place, just as the same is the case for any media text using a "real world" location'.[58] If such local knowledge is important in terms of reading and responding to the show, it is also key to understanding John Barrowman's local celebrity status. Thus, whilst his reputation as an international cult television star and a domestic television performer means that he is not, as is the typical localebrity, 'known *only* to those within a very specific geographical national or local area... [within the local area he is] known to a wider range of people than those who know them personally and may have some name recognition in local gossip or talk'.[59]

. Again, such terms do not easily map onto our understandings of how Barrowman's stardom is mobilised. As discussed above, encounters with the star at signings or events does fit into Hills and Williams' definition of how the subcultural celebrity performs a very specific role at such functions: 'The "persona" that fans encounter at conventions and personal appearances is thus a hybridized actor/character performance of identity, an embodied self-performance that remains related to character/actor blurrings in secondary texts'.[60] However, how is this performed when Barrowman appears at more localised occasions such as school fêtes, or at his own garage sale? Here, rather than appearing at events and meeting fans as part of the publicity surrounding his roles in *Doctor Who* or *Torchwood*, he is appearing and performing as 'John Barrowman' himself. As Bennett notes, 'The notion of performance is helpful insofar as it enables us to understand that the celebrity "self" is always a mediated construct'.[61] Whilst this is not to suggest that those who encounter him in such circumstances have any more access to the 'real' person than those who meet him at conventions, it seems likely that the entwining of the star and character that often occurs within cult subcultural celebrity encounters is not occurring

here in the same way. Indeed, here Barrowman clearly straddles the categories of cult subcultural celebrity and localebrity:

> While some audiences of large-scale U.K. or U.S. shows may meet celebrities through conventions, signings, and so on, this is neither typical nor everyday. What distinguishes the localebrity encounter then is both their random nature (engendered by the very specific locality and intimacy of their location) and their intimate, small scale.[62]

He is, then, both accessible via signings, conventions or other staged events but can also be encountered randomly, a possibility generated by his very locality and intimacy within South Wales. Such examples are important to how we understand celebrity theory, contemporary media and the self through the ways in which celebrity is performed and maintained in a range of social and geographical settings and how encounters between the public with television figures are influenced by this.

Conclusion

Television celebrities who move across a range of different genres are often hard to conceptualise, and challenge the diverse schemas used by theorists of celebrity culture. Pre-existing categories are limited in their capacity to account for those whose fame operates across a variety of genres and who assume quite different personae in each of their spheres of performance. This chapter has interrogated existing ways of understanding cult/mainstream television celebrity and argued that conceptualisations of mainstream versus subcultural celebrity do not always neatly map onto figures within the contemporary hybrid TV landscape. The example of John Barrowman suggests that existing binary oppositions such as TV star/personality, fiction/fact, subcultural/mainstream, ordinary/extraordinary and national/local do not always hold and that some stars can move between mainstream and subcultural celebrity based on their appearances across a range of texts. Barrowman is relatively unique in the way in which he straddles numerous media (television, music and live performance), types of television performance (as an

actor in a fictional series and a presenter) and the border between a cult and mainstream personality. Finally, it is important to consider the impact of place and locality when considering cult/mainstream celebrity since the concept of the 'localebrity' complicates how we read celebrity in specific local contexts. Indeed, 'many of the interactional dynamics associated with celebrity also operate at the regional, local and hyper-local levels'.[63] Whilst Barrowman can be read as a national or international 'star', his presence in the locality of South Wales offers different opportunities to encounter him and to experience a different mode of interaction. The possibility of such informal and accidental meetings, and Barrowman's own continued assertions that he is a resident of South Wales, add another dimension to the cult/mainstream binary that often characterises discussions of contemporary celebrity.

Notes

1. Paul English, 'Tonight's the Night for Scots Jack of All Trades John Barrowman', *Daily Record* 17 July 2010. Online. Available http://www.dailyrecord.co.uk/showbiz/celebrity-interviews/2010/07/17/tonight-s-the-night-for-scots-jack-of-all-trades-john-barrowman-86908–22419278/ (13 May 2011). Greggs is the largest chain of bakeries in the UK, with nearly 1,500 stores across the country.
2. Keith Watson, '*Torchwood* Turns John Barrowman from Chat Show Lightweight to TV Hero', *Metro* (2010) Online. Available http://www.metro.co.uk/tv/reviews/869317-torchwood-turns-john-barrowman-from-chat-show-lightweight-to-tv-hero#ixzz1TPFnC0LL (28 July 2011).
3. Matt Hills, 'Recognition in the Eyes of the Relevant Beholder: Representing "Subcultural Celebrity" and Cult TV Fans', *Mediactive* 2 (2003), pp. 59–73, p. 61.
4. Ruth McElroy, and Rebecca Williams, 'Remembering Ourselves, Viewing the Others: Historical Reality Television and Celebrity in the Small Nation', *Television and New Media* 12/3 (2011), pp. 187–206, p. 197.
5. Graeme Turner, *Understanding Celebrity* (London, 2004), p. 15.
6. Su Holmes, '"All You've Got to Worry About is the Task, Having a Cup of Tea, and Doing a Bit of Sunbathing": Approaching Celebrity in *Big Brother*', in S. Holmes and D. Jermyn (eds), *Understanding Reality Television* (London, 2004), p. 116.
7. Richard Dyer, *Stars 2nd revised edition* (London, 1998).
8. James Bennett and Su Holmes, 'The "Place" of Television in Celebrity Studies', *Celebrity Studies* 1/1 (2010), pp. 65–80, p. 72.
9. John Ellis, *Visible Fictions: Cinema, Television, Video* (London, 1992), p. 106. See also John Langer, 'TV's Personality System', *Media, Culture and Society* 3/4 (1981), pp. 351–65, p. 355.

10. Susan Murray, '"I Know What You Did Last Summer": Sarah Michelle Gellar and Crossover Teen Stardom' in E. Levine and L. Parks (eds), *Undead TV: Essays on Buffy the Vampire Slayer* (Durham and London, 2007), p. 53.

11. James Bennett, *Television Personalities: Stardom and the Small Screen* (London, 2010).

12. Bennett and Holmes: 'The "Place" of Television in Celebrity Studies', p. 68.

13. See also Deborah Jermyn, 'Bringing Out the * in You: SJP, Carrie Bradshaw and the Evolution of Television Stardom', in S. Holmes and S. Redmond (eds), *Framing Celebrity: New Directions in Celebrity Culture* (London, 2006), p. 74.

14. Roberta Pearson, '"Bright Particular Star": Patrick Stewart, Jean-Luc Picard, and Cult Television', in S. Gwenllian-Jones and R.E. Pearson (eds), *Cult Television* (Minneapolis, 2004), p. 62.

15. Gwenllian-Jones, Sara, 'Starring Lucy Lawless?', *Continuum: Journal of Media and Cultural Studies* 14/1 (2000), pp. 9–22, p. 16.

16. Hills: 'Recognition in the Eyes of the Relevant Beholder', p. 61.

17. Ibid., p. 59.

18. Ibid., p. 69.

19. Matt Hills, 'Subcultural Celebrity', in S. Abbott (ed), *The Cult TV Book* (London, 2010) p. 236.

20. Ibid.

21. Hills: 'Recognition in the Eyes of the Relevant Beholder', p. 61.

22. Matt Hills and Rebecca Williams, '"It's All My Interpretation": Reading Spike through the "Subcultural Celebrity" of James Marsters', *European Journal of Cultural Studies* 8/3 (2005), pp. 345–65, p. 352.

23. S. Elizabeth Bird, *The Audience in Everyday Life: Living in a Media World* (London, 2003), p. 77.

24. C. Lee Harrington and Denise Bielby, *Soap Fans: Pursuing Pleasure and Making Meaning in Everyday Life* (Philadelphia, 1995), p. 62.

25. Ellis: *Visible Fictions*, p. 106.

26. Locksley Hall, 'Interview with *Doctor Who's* John Barrowman'. *After Elton.com*. Online. Available http://www.afterelton.com/archive/elton/people/2006/5/intbarrowman.html (1 July 2011).

27. John Barrowman, quoted in Benjamin Cook, 'Alive and Kicking', *Doctor Who Magazine*, 437, 2011, p. 19.

28. Lee Barron, 'Out in Space: Masculinity, Sexuality, and the Science Fiction Heroics of Captain Jack', in A. Ireland (ed), *Illuminating Torchwood: Essays on Narrative, Character and Sexuality in the BBC Series* (Jefferson, North Carolina, 2010).

29. BBC. 'Barrowman Sorry for Radio Flash.' *BBC Online*, 1 December 2008. Online. Available http://news.bbc.co.uk/1/hi/entertainment/7759215.stm (2 June 2011).

30. Discussion of Barrowman's appearance in 2010 in the US comedy/drama *Desperate Housewives* is beyond the scope of this chapter. Whilst this role may well complicate further his status as a cult/mainstream star or celebrity, brevity demands a focus on his dramatic acting in cult TV roles only.

31. Karen Lury, 'Television Performance: Being, Acting and "Corpsing"', *New Formations* 26 (1995), pp. 114–31, p. 117.

32. Bennett: *Television Personalities*, p. 118.

33. Karen Lury, *Interpreting Television* (London, 2005), p. 176.

34. Frances Bonner, *Ordinary Television* (London, 2003) pp. 18–19.

35. The same can be said of Barrowman's annual appearances in Christmas pantomimes in the UK where there is often a balance between humour aimed at the child audience (e.g. visual gags, comedy pratfalls) and more risqué jokes that are aimed at the adult contingent.

36. Bonner: *Ordinary Television*, p. 68.

37. Bennett: *Television Personalities*, p. 103.

38. Ibid., p. 122.

39. Ibid.

40. Matt Hills, '*Torchwood Miracle Day*, Episode Three: Tonight's The Night?', *Antenna Blog*, 29 July 2011. Online. Available http://blog.commarts. wisc.edu/2011/07/29/torchwood-miracle-day-episode-three-tonights-the-night/

41. Hills: '*Torchwood Miracle Day*, Episode Three: Tonight's The Night?'

42. Bennett: *Television Personalities*, p. 122.

43. Ibid.

44. Ellis: *Visible Fictions*, p. 106.

45. Bennett and Holmes: 'The "Place" of Television in Celebrity Studies', p. 69.

46. Bonner: *Ordinary Television*, p. 72.

47. Debates over Barrowman's nationality are contentious given that he was born in Scotland, raised in the United States and has a predominantly American accent, but that he lapses into a Scottish accent when with his Scottish family.

48. Kerry O. Ferris, 'The Next Big Thing: Local Celebrity', *Sociology* 47 (2010), pp. 392–5, p. 393.

49. McElroy and Williams: 'Remembering Ourselves, Viewing the Others', p. 197.

50. Ibid., p. 190.

51. No Author. 'Torchwood Star John Barrowman Holds Garage Sale,' *Oh No They Didn't*. 22 August 2010. Online. Available http://ohnothey-didnt.livejournal.com/50222426.html (1 February 2012).

52. No Author. 'Torchwood Star to Open Summer Fete', *Penarth Times*. Online. Available http://www.penarthtimes.co.uk/news/latestnews/4468862.Torchwood_star_to_open_summer_fete/ (3 June 2011).

53. *Penarth Times*. 'Sully Garden Attracts the Crowds – and TV Star John Barrowman', *Penarth Times*. Online. Available http://www.penarth-times.co.uk/news/4555955.Sully_garden_attracts_the_crowds and_TV_star_John_Barrowman_/ (3 June 2011).

54. Sharon Harris, 'TV Star John Barrowman Takes Time Out at Ty Hafan Children's Hospice', *Barry & District News*. Online. Available http://www.barryanddistrictnews.co.uk/news/4876102.TV_star_John_Barrowman_takes_time_out_at_Ty_Hafan_Children_s_Hospice/ (4 June 2011).

55. Ruth McElroy, '"Putting the Landmark Back into Television": Producing Place and Cultural Value in Cardiff', *Place-Branding and Public Diplomacy* 7/3 (2011), pp. 175–84, p. 182.
56. McElroy and Williams: 'Remembering Ourselves, Viewing the Others', p. 188.
57. See Rebecca Williams, 'Cannibals in the Brecon Beacons: *Torchwood,* Place and Television Horror', *Critical Studies in Television* 6/2 (2011), pp. 61–73.
58. Brett Mills, 'My House was on *Torchwood*! Media, Place and Identity', *International Journal of Cultural Studies* 11/4 (2008), pp. 379–99, p. 380.
59. McElroy and Williams: 'Remembering Ourselves, Viewing the Others', pp. 11–12, my emphasis.
60. Hills and Williams: 'It's all my interpretation', p 352.
61. Bennett: *Television Personalities,* p. 119.
62. McElroy and Williams: 'Remembering Ourselves, Viewing the Others', p. 202.
63. Ferris: 'The Next Big Thing', p. 393.

Part IV

TORCHWOOD'S RECEPTION AND AUDIENCES

LOVE CAPTAIN JACK OR HATE HIM: HOW *TORCHWOOD* HAS POLARISED THE *DOCTOR WHO* FANDOM

Lindsay Bryde

roadly speaking, a fandom is a community of fans who come together to share their love of a certain television series or sports team. In particular, fans of science fiction have been at the forefront of this community mentality, dating back to Hugo Gernsback's *Modern Electrics* magazine in the 1900s.[1] As much as a fandom loves its subject of interest, the fans are also often compelled to revolt when they feel they have been wronged. This has been the case with the fandom of cult classic *Doctor Who* (*Who* for short) and the fandom of its sister show *Torchwood*. Ironically one of their central points of connection and disconnection is the same man, Captain Jack Harkness, played by actor John Barrowman. There have been controversies and debates strictly in the *Who* universe, relating to the rotating door of actors playing the titular hero and the evolution of his companions from friends to love interests, Yet, these debates appear to intersect when identifying the division of opinion regarding what Jack has brought to the show(s) and how the creator of each series, Russell T. Davies, has seemingly toyed with the fandom at every turn.

Since 2010, *Who* has officially been the longest running science fiction television series to air;[2] this is an accumulation of its original run of episodes from between 1963 and 1989 and the current incarnation airing since 2005. The show remains on air because it has expanded its fandom from the original fans, those who have also embraced the new series, and others who are only now discovering the world of *Who*. Journalist and long-standing *Who* fan Deborah Stanish lamented about the trepidation that she shared with fans when the new original episodes began to air:

> What I discovered was that fandom was giddy. After years of being consigned to the periphery, clinging to life in the form of books and audio plays, when even the die-hard fan had given up hope of ever seeing their show come back to life, watching it blaze forth on their television screens filled them with euphoria. Sure, there was grumbling in some corners about characterization and accusations of 'sexing up the Tardis,' but for the most part the joy of having their fandom regenerate created good will to spare. It was into this fannish environment that I dipped my toes in.[3]

In order to have this type of longevity, the series must be tapping into a distinct and distinctly large audience that has continued to follow the exploits of the protagonist (anti)hero, the Doctor. It has been argued that

> There's a good case for regeneration being the most important aspect of *Who*. How many other fictional dramas have managed to maintain the same central character so cleverly for over 40 years? The concept has also been combined with the show's other trademark element – time travel – to bring about a number of adventures in which two or more of the Doctor's incarnations have met.[4]

The show made the star of the series the character rather than any particular actor. The entire point of the Doctor is that he is a man who could take any shape, any form, and still be on the hunt for different adventures that audiences are invited to join. Lynne M. Thomas crystallises this point in her essay 'Marrying into the Tardis Tribe' when she explains how, 'David Tennant has become *my* Doctor. His interpretation of the Doctor hits my brain in such a way that my instinctual reaction is '*that* is the person I'd travel through

time and space with, oh yes.'[5] Each Doctor will take viewers on their own unique journey, through their lens. While he always retains some basic attributes, his personality shifts with each new form, allowing each actor to make his own stamp on the now iconic role. This characteristic has left the show open to innovation while still providing the same contract to audiences: go on an adventure through time with a man who loves this thrill as much as you do.

There have been other shows that explore the premise of travelling throughout outer space, exploring territories that can only exist in our mind's eye (*Star Trek* being a prime example). It's true that *Doctor Who* does visit alien worlds in a similar fashion. Yet it also explores our own known society and world in exactly the same manner as more fantastical landscapes. Indeed,

> It's fair to say that *Doctor Who*'s enormous success is due in part to the Tardis's ability to flit back and forth through time. While Buck Rogers (the weapon of choice of BBC's competitor against the Doctor in the early 1980s) had to be content visiting worlds separated merely in space, the Doctor can be anywhere at any time. Over the years, he has dropped in on the Aztecs, seen the dawn of life on Earth and skipped forward 5 billion years to watch our planet's destruction at the hands of the aging and expanding Sun.[6]

Thanks to the Doctor being an alien himself, he is examining our culture through the same lens of discovery and judgement, allowing us to view our own history through that lens. It's an escapist function that allows those of us in the fandom to experience and re-envision our past, present, and future. We are able to consider whether the possible futures are realistic, or a matter of fantasy that needs to be re-written. Also, those interested in history are able to enjoy the blending of fact and fiction. When we see the episode 'The Unicorn and the Wasp' (4.7), we are able to see an Agatha Christie caper with Christie herself as one of the characters in the story. This allows for some basis in reality whilst engaging in a fantasy scenario.

The new series began to rock the boat for many fans as it were (though Tardis may be more apt), before Captain Jack stepped on board. One fan, Jennifer Steele, noted in an essay: '"I know Russell T. Davies has taken a lot of flak for all the relationships on *Doctor Who*," ... [e]xplaining that before Davies rebooted the franchise, the

character of the Doctor had been largely asexual since the 1960s.'[7] The reboot opened with the audience being introduced to Rose Tyler (Billie Piper), a young British girl who gets thrown into the world of the newly minted Ninth Doctor (Christopher Eccleston) in the first episode 'Rose' (1.1). From there the audience is introduced to each new fantastical element, a primer on the rules of time travel and the Doctor through Rose's naiveté. Some fans balked when it was suggested that Rose could be a potential love interest because they considered the Doctor as more of a man of science than a sexual being (unless you speak to those involved with writing and reading fan fiction). Kate Orman, a fan and author of official *Who* tie-in fiction, explains this struggle by examining how,

> Some of this stemmed from the comfort gay fans took from being able to watch a hero who never got the girl, and didn't care; if he wasn't explicitly gay, at least he wasn't explicitly straight, and the lack of romance in the show was refuge from the media message of compulsory heterosexuality.... For the most part, though, the resistance was simply a sort of playground squeamishness in which violence and horror were fine but girl germs weren't.[8]

On a subconscious level, it does make sense why the Doctor would be represented as seeking a companion for his journeys since 'According to Angela Carter, an occupational psychologist at the University of Sheffield, humans – and presumably Time Lords too – crave companionship for good reason. People are social animals and get depressed if they don't have other people around them, she says'.[9] Some viewers identify their own need for companionship and see why the Doctor would have people accompanying him on the journey. Furthermore, the distancing from a sexual relationship being depicted on the show allowed for the series to be family fare. It also created a contrived significance whenever it was suggested that the Doctor could fall in love; what kind of person would that take? To take a man who has lived an asexual life for centuries (with over forty years being depicted on-screen), and give him the hope of love and companionship of a different sort: that's a lot of pressure, driven even more to the fore with the introduction of River Song (Alex Kingston) in Series 4 and her relationship with Doctors Ten (David Tennant) and Eleven (Matt Smith). She was a woman crafted

to slowly be integrated into the Doctor's life, an equal enigma of adventure, philosophy, and romance. They may get to be together, but even their union in 'The Wedding of River Song' occurs only to divide them. They get married to restore the timeline, and she must then go to prison for the crime. We are given her, to have her taken away, and find her all over again.

Doctor Who and the fandom have certainly made leaps of acceptance regarding the Doctor's female companions. Another companion has been another matter altogether, and not just because of his gender or preferences; 'One of Davies' most daring moves was the introduction of the show's first (overtly) non-heterosexual companion. Captain Jack Harkness is a conman and time traveler from the fifty-first century – where everyone, himself included, is bisexual.'[10] Captain Jack was introduced in the World War II period piece 'The Empty Child' (1.9) as a cavalier time agent whom Rose encounters. His blatant sexuality and bawdy sense of humour appealed to her, in contrast to the dour Ninth Doctor. It was not revealed until Jack's second episode 'The Doctor Dances' (1.10) that Jack was bisexual, when he flirts with a guard rather than Rose. It was a changing of the guard for fans who had grown accustomed to repressed sexual desires being the norm for the show's varying humans, aliens, and robots. It was noted that

> Davies has Captain Jack flirt brazenly with the Doctor, culminating in the series' first gay kiss as the two say their farewells in 'The Parting of the Ways.' It was a brave move for what's still a prime-time children's show. It certainly couldn't have been done back when the series first launched in 1963, and probably couldn't have even happened 10 years ago.[11]

The great irony of this speculation is that the most controversial part was not that Jack was gay, but that Jack was kissing the Doctor. The show never made it a secret that there was a gay audience, but it was brought to the forefront when Davies took over the new series.[12] Jack kissing the Doctor was a sign of love and respect, similar to the kiss that he gave to Rose mere seconds before. Yet, some fans did not see it that way. They saw the Doctor kissing someone, engaging in a potentially sexual act; an act of treason to some sects of the fandom, those who would rather see the Doctor as completely asexual rather than straddling any type of boundaries.

For other fans, though, Jack was a popular character and:

> Barely a week after Jack was first introduced in *Doctor Who* an
> on-line community devoted to him (named 'galactic_conman')
> appeared on the Live Journal site. The first post to the community
> was made on the 28 May 2005, and linked to a piece of fan fiction
> by taraljc entitled *Odd Man Out* which features The Doctor, Rose
> and Jack. At that point Jack had only featured in two episodes of
> *Doctor Who,* yet almost overnight he had achieved cult status to
> the point in which fans 'borrowed' his character to write their own
> pieces of fiction about him.[13]

Captain Jack is under a mask of mystery, even years after his intro-
duction. His cryptic references to moments from his past give fans
a glimpse of all the possible adventures they could have seen, could
have experienced with him. Costumer, cosplayer, and *Who* fan
Johanna Mead explains fans' reactions and responses to the char-
acter at conventions:

> Jack Harkness is an outwardly confident, internally vulnerable and
> complex character with a past of doing pretty much as – or who –
> he pleased, and nothing too dire in the way of consequences (unless
> you want to count the paperwork at Torchwood as some sort of
> punishment detail). Who *wouldn't* want to be Jack, at least for a
> little while? Crossplay isn't my thing – I'd rather flatter my curves
> than flatten them – but the popularity amongst female cosplayers
> makes sense to me.[14]

A number of his allusions are more sexually explicit or dangerous
than what is broached by other companions; it allows for those
interested in exploring that avenue to do so off-screen. Even with
every new episode, there is a story being left untold that can be
acted out or embodied by cosplayers like Mead.

The BBC understood the growing appeal of Jack to fans and the
more adult situations he could open up, and contracted Davies to
create the spin-off *Torchwood;* a series for Jack to be the main char-
acter and catalyst of the series. The reaction was immediate:

> When the spin-off TV series *Torchwood* was officially announced fans
> immediately flocked to variations on the *Torchwood* domain name to
> search for clues and previews. One such address, torchwood.org.uk
> greeted the user with the warning: 'Torchwood: Access Denied!' –

the very same message that greeted the character Mickey in the episode 'School Reunion' (29 April 2006), indicating that the site would eventually be updated with official information.[15]

Before they even knew what the show would entail, fans were envisioning what this proposed show could involve, what it could signify. The dedication of the fans was pronounced from the beginning: 'Fans "opened" the fictional universe before the show had even aired, fans piecing together through magazine interviews and other means what the Torchwood universe might be like, using this information in their fan fiction.'[16]

Torchwood essentially served its purpose, to draw in viewers. It was a series created so that it could appeal to fans of *Who* and could reach an older demographic that may have not been enticed into watching the sister series because of the notion that it is strictly for children (see Garner in this book). However, one of the main areas of mystery was what the show would be about, beyond the presence of Jack:

> *Torchwood* takes a relatively minor and marginalized character (Captain Jack Harkness) from what is essentially a family show (*Doctor Who*) and places him in an 'adult' reworking. Themes which were relatively glossed over in *Doctor Who*, i.e. Jack's sexuality, are more fully explored in *Torchwood*.[17]

However, it was not only Jack's sexuality that was explored throughout the series, but that of each regular cast member. Before the first season was complete, each character had engaged in at least two sexual relationships, and been intimate with other characters of the same and opposite gender. Where it was controversial for the Doctor to kiss someone goodbye or have romantic feelings for his companions, Jack and company explored every physical and emotional relationship they could think to pursue.

A point of contention between those who strictly consider themselves 'Woodies' (a term for *Torchwood* fans that Barrowman coined) or '*Who*-vians' involves what should be considered canonical, and which characters are allowed to cross over between the two series. Academic Neil Perryman articulated this dilemma:

> Another controversial aspect to *Torchwood* is that the show actively explores narrative mysteries introduced in the parent show, even

though a large proportion of the audience who would like to explore the answers to many of these questions are actively forbidden from watching this programme (assuming, of course, they have responsible parents who would police their television viewing).[18]

Torchwood deals with adult themes that, due to its post-watershed hour, can be depicted and/or explicitly stated. A central problem is that it also takes aliens and characters from *Who* that children recognise and (potentially tune in to), seeing them in contexts that may not be appropriate. A prime example of this is *Torchwood*'s fourth episode 'Cyberwoman' (1.4) surrounding the classic *Who* villain, The Cybermen. The episode featured a woman turned into a new Cybermen-human hybrid, wearing a revealing peek-a-boo variation of the solid metal suit that *Who* fans recognised as The Cybermen's calling card. It was a warning to fans of *Who* that while some names and faces are familiar, there is always going to be a twist and a flair that marks it as distinctly *Torchwood* (whether the fans like it or not).

Given that Jack originated on *Who*, it's not unfathomable to consider him returning to the parent series. According to Barrowman, Jack did not return for the second series of *Who* because the writers and producers of the show did not want an additional strong male presence while David Tennant was initially crafting his take of the Doctor.[19] It is debatable whether his return in *Who*'s third series wreaked any havoc to the narrative flow, as:

> [T]he two series do successfully dovetail for those members of the audience who are free to traverse the transmedia landscape. Captain Jack walks off the set of the first season of *Torchwood* and into the third season TARDIS of *Doctor Who*, and then back again into the narrative flow of *Torchwood* season two, and, despite some fans' fears to the contrary, the two programmes never actively contradict each other (even if seamlessly connecting the two shows together does require a leap of faith).[20]

The leap of faith was not regarding the timing of Jack's travels through time but in remembering what information is revealed on each series and how it is carried through to the other. While Jack's absence on *Torchwood* was dealt with admirably, the writers seemed to have retconned one of the plot reveals from his stint on *Who*. It has not been addressed on *Torchwood*, as of 'Miracle

Day', that Jack is also the Face of Boe, a significant character from Davies' tenure as head writer of *Who*. A revelation in that series' finale left Martha and the Doctor staring agape as Jack walked away from them at Roald Dahl Plas, minds boggled that Jack's immortality would lead his body to morph into that of the Doctor's 'other' immortal friend. Yet, despite all of the complications *Torchwood* has recognised about Jack's immortality – what it means for the world if people cannot die, what it is like to watch his lovers keep dying, how it affects Jack physically – it is never inferred that his fate could lead to him becoming known as The Face of Boe. While strictly *Torchwood* fans are not missing anything, those who watch both shows are left to wait for Jack's return to *Who*, which seems a dimmer hope with each new Doctor that arrives and Barrowman's latest interviews stating that he is unsure about returning.[21]

Another actor who originally appeared on *Who* to step inside the Hub was Freema Agyeman as companion Dr. Martha Jones, in the episodes 'Reset' (2.6) and 'Dead Man Walking' (2.7). Her camaraderie with Jack had been established on *Who* and it made narrative sense for the character to make her way from London to Cardiff, Wales. The surprises were in her personal dynamics with each Torchwood team member, and the line the writers drew between what she was allowed to be depicted doing, versus other characters. Martha and Ianto could discuss the burgeoning sexual relationship between him and Captain Jack, but Martha never outright said anything sexually explicit. All of her questions were cut off by Ianto answering them for her. They found a way to have a crossover without it forcing a *Who* character into something inappropriate for the character or going against the set canon.

It was another matter in Series 4 of *Who*, when it was announced that the final two episodes would feature a crossover not just by Jack, but also Torchwood team members Ianto and Gwen. Their presence can be boiled down to a 'make-cute' between their characters and others in the *Who*-verse (the conceit of the episode being that they are bringing back every companion, showing how far the Doctor's positive reach has been). One reviewer of the crossover episode 'The Stolen Earth' (4.12) noted,

> *Torchwood* in *Doctor Who* is a crossover that should never have happened. As a base for adult viewing, the ensemble series was

intended to be a completely separate entity to the mother series and deal with more adult issues. Sadly the spin-off series was toned down in its second year (and according to reports will be continued in season three), but the silver lining to that decision is this episode. *Torchwood* has now reached the point where complete crossovers are possible.[22]

By Series 2 *Torchwood* was more focused on action stories than on being risqué, and altogether ceased producing episodes that featured *Who* villains (arguably one Cyberwoman was bad enough); it had become its own series with its own mythology. 'The Stolen Earth' does not surround the team and only vaguely broaches any storylines that were occurring on *Torchwood*, one such reference being to the relationship between Jack and Ianto (a fan favourite that was dubbed Janto). There is also a joke about the adult content between Captain Jack and Sarah Jane Smith (former companion and star of *Who*'s other spin-off, *The Sarah Jane Adventures*, the late Elisabeth Sladen):

> Captain Jack: I've been following your work. Nice job with the Slitheen.
> Sarah Jane Smith: Yeah, well I've been staying away from your lot. Too many guns.

The lines are dealing with a central distinction between *Who*, *The Sarah Jane Adventures* and *Torchwood*. They are all part of the same roots, the same mythology and universe, but should not co-exist completely. Captain Jack and Sarah Jane can admire each other's work, but admit their methods would never mesh. Sarah Jane represents the classic series, initially intended for children and family viewing; her similarly suited spin-off can bring in classic *Who* villains such as the Slitheen because it attracts the same demographic. Jack represents the older skewing *Who* audience that wished to explore the darker natures of science fiction popularised by other series/fandoms. It's only two lines of an hour-long episode, but it quickly sets at play the stakes of all three series and what it signifies that all of these characters can come together for the audience to watch. When the Doctor needs them, his companions will all come together despite their differences; this is how the Doctor can be a rallying point to all the fan(dom)s.

Russell T. Davies is not afraid to break the mould of *Who* or *Torchwood*, which has upset fans significantly in the past. What may have been his two largest contractual breaks with *Torchwood* fans occurred in back-to-back episodes when Captain Jack killed his own grandson to save the planet, and when Ianto Jones died at the end of Series 3, 'Children of Earth'. A startling realisation for one reviewer of this series was that:

> [I]n the end, though it's all resolved, it's certainly not 'Happily ever after,' and it comes at the cost of a brutally killed child. In the *Brothers Karamazov*, Dostoyevsky asks the question, 'If the Millennium comes at the cost of even a single dead child, is it worth having?' Dostoyevsky clearly thought 'No,' but we have a similar question here, where the answer is guardedly 'yes,' as Torchwood tells it.[23]

Jack uses his grandson's life force to eradicate the series' villain in order to save the targeted children of the planet from potential enslavement. It was a stark and darkly seismic shift from the light-hearted soldier that we were introduced to four years earlier in the child-friendly *Who*, one that was rationalised by the same reviewer as 'Jack's giving 12 kids to the 456 in '65 is compared to a sacrifice of virgins to the gods, in exchange for peace. Though they don't overtly say so, his sacrifice of his grandson at the end is essentially a penance – a personal punishment – for his callous sacrifice of the innocents 44 years before.'[24] Jack's grandson – who had never been seen or mentioned until 'Day One' (4.1) – was a character who acted as collateral damage to further the mythology of Jack. His purpose was to die, to be the deus ex machina when killing the heinous 456. The fact that he was an innocent child does offer a disconcerting question to fans regarding what lengths their hero will go to in saving the world. Yet, it could still be considered odd that the potential controversy of this plot point was overshadowed in the long run due to the other major death of the season. Some elements of the fandom can forgive killing off children when faced with killing off a fan favourite/series regular/half of the central series' couple.

Ianto's death acted as a rallying point for many supporters; he was the popular Teaboy, half of the couple nicknamed Janto, loved by Jack and many fans. Where *Torchwood*'s brazen sexuality, twisting of the mythology, and annoyance over Jack's questionable ethics

could create ire and confusion,[25] Ianto was not necessarily a part of that. His character functioned to save the Earth and make dry quips that mocked everyone else's frivolous notions. Many fans were out-raged regardless of the *Who* and *Torchwood* division; they liked Ianto, and proceeded to stage protests and create petitions demanding his return, including the website aptly titled 'Save Ianto Jones'.[26] This outcry fell on deaf ears; Davies never backed down and he simplified the matter in interviews and tried to give it a context:

> It's not particularly a backlash. What's *actually* happening is, well, nothing really to be honest. It's a few people posting online and getting fans upset. Which is marvelous. It just goes to prove how much they love the character and the actor. People often say, 'Fans have got their knives out!' They haven't got any knives. I haven't been stabbed. Nothing's happened. It's simply a few people typ-ing. I'm *glad* they're typing because they're that involved. But if you can't handle drama you shouldn't watch it.[27]

Davies' glib remarks are true. The fans were outraged, saddened, but unable to stop or change what he had done as a writer. He even remarked that some fans could tune out and recommended *Supernatural* as a new show to become addicted to.[28] Davies is indicating that fans may be holding a larger grudge than neces-sary considering the series is a work of fiction, and if they felt so offended, then they are capable of not returning to the show when the new series begins. He is not forcing the fans to watch the series; they are willing participants in their choice to tune in and see what happens next.

Two years later, the character of Ianto is still dead, a footnote in the history of the series. There was a total of five minutes directly referencing his life and death when the fourth series, 'Miracle Day', aired in summer of 2011. There is, of course, the chance that had Ianto lived, then the plotline would have been considered more unsatisfactory than Ianto's death, but fans will never know. Instead there will be ongoing campaigns and groups; the site 'Save Ianto Jones' is still running, and points to a memorial for the fallen hero that fans can visit.

> There is a shrine in Mermaid Quay, a tiny alcove in Roald Dahl Plas that had a scene shot there between Jack and Ianto in the episode

'2.11' of season two, that is still maintained two years after being created. It is a memoriam for those that miss their beloved Ianto.[29]

Now fans can not only watch the show or read this essay to lament Ianto's passing; devout fans can schedule their next vacation in locations where the show films and add it to their own *Who*/*Torchwood* site-seeing tour.

A final matter that should be addressed when considering the division of the *Who* fandom over *Torchwood* and Captain Jack Harkness is the role of Jack's portrayer, John Barrowman. Barrowman is an affable actor, a triple threat who had previously performed in theatre, television, and a few minor film roles. While he spent half his childhood living in America, which resulted in his American accent, he was born and spent part of his childhood in Scotland. This is critical to understanding Barrowman's role because it means that he grew up watching *Who*. In his autobiography, *Anything Goes*, he discusses his initial auditions for the show, pointing out that part of the time was spent reminiscing about the original series, that, 'it was the Doctor I enjoyed the most.... I loved them all. Jon Pertwee, Tom Baker, and Peter Davison ruled my Sunday evenings. I'd avoid homework, imagine eating Jelly Babies and let myself be carried off to other galaxies.'[30] There have been other actors who grew up watching the show and ended up getting to be a part of the universe (primarily the Tenth Doctor's David Tennant),[31] but none has been quite as vocal as Barrowman. He embraces the fandom because he is a part of it. The man keeps a Dalek in the foyer of his house, and shares that fact openly via pictures on his website.[32] That should not really come as much of a surprise. Barrowman shares everything and anything about himself; some would argue to the point of excess.

John Barrowman has crafted a rather daunting persona for himself as an everyman who has no limits. Barrowman's media presence, particularly in the United Kingdom, is rather high (see also Williams in this book). A concert reviewer began an account of Barrowman's 2010 tour by first explaining how the public may know him, before describing the concert itself:

John Barrowman. Who? Well, more *Torchwood* really. And most of Saturday night BBC primetime. And, yes, the odd adventure with

the good Doctor himself. If you haven't heard of Barrowman, then you will certainly know his clean cut, all American apple pie smile. Unless you've come from Alpha Centauri that is.[33]

The review actually offers a scant critique of Barrowman's stage show or vocal ability as a singer but notes how Barrowman offers a peek into his personal and professional lives for fans throughout the evening. He appeals to *Who* fans by wearing Captain Jack's 'hero coat', and singing a parody song of the musical *Wicked*'s 'The Wizard and I' re-entitled 'The Doctor and I', a song that chronicles Jack's journeys through time with The Doctor rather than Elphaba's search for scientific innovation with the Wizard of Oz. The emphasis of the review is that love him or hate him, his repertoire relies strictly on the fact that unless you like Barrowman the person, the persona recognisable from a number of television programmes, then you will not care about Barrowman the musician.[34] Another reviewer, Michael Deacon, similarly commented that 'I didn't think it was possible to show more John Barrowman. He's on television more often than the weather forecast.'[35] Deacon is rather frank in his description of Barrowman's stage show: 'For sufferers of seasickness who yearn to discover what the entertainment is like on a cruise ship, a Barrowman gig is the ideal opportunity.'[36] Deacon comments that even with this less-than-stellar recount of his musicianship, Barrowman's devotees continued to applaud and cheer their hero's non-musical antics. They are there regardless of the quality of the music to commune with the star they love from television and with those who also hold him in high esteem.[37] Barrowman's entertainment career as a whole is, therefore, intrinsically linked to the fandom surrounding *Who* and *Torchwood*.

There is an investment to joining a fandom, deciding what you will spend your time enjoying. There are any number of television shows, movies, bands, teams of various sports; communities that become as familiar as those in your actual neighbourhood. It's about connection and sharing of ideas. When it comes to *Who* and *Torchwood*, the fandoms are complicated because of how equally connected and distanced they remain from each other. *Who*'s new incarnation can be viewed as controversial due to its steps towards sexualising the Doctor, and the introduction of Barrowman's hypersexual Jack. In making *Torchwood* unique and distinct from its sister

show, it has intrinsically alienated some of the core audience because it does not hold the same time-travelling and child-friendly appeal that *Who* idealises. It will never be clear what *Who* would have been like if it had not launched with the early breakout of Captain Jack and his portrayer. For better or worse, Davies and Barrowman introduced a character and subsequent series that has turned heads and never apologised for the decisions made for either. Instead, the fans have been asked to take it or leave it, and if they stay, then to talk about it. Have fun, kids; wear your bow ties, your hero coats, collect your action figures and buy more books of essays about the series. That's the real heart of the fandom, the appreciation of it rather than the debate. None of the academics would be presenting their arguments for or against the series if it did not hold a special place in many fans' hearts.

Notes

1. Eric S. Rabkin, 'Science Fiction and Future of Criticism', *PMLA* 119 (2004), pp. 457–73, p. 458.
2. 'Guinness World Records. Longest Running Science Fiction TV Series'. *Guinness World Records*. 30 June 2010. Online. Available http://www.guinnessworldrecords.com/world-records/4000/longest-running-science-fiction-tv-series (30 October 2011).
3. Deborah Stanish, 'My Fandom Regenerates', in L.M. Thomas and T. O'Shea (eds), *Chicks Dig Time Lords* (New York, 2010), p. 32.
4. Paul Parsons, *The Science of Doctor Who* (Baltimore, 2010), p. 43.
5. Lynne M. Thomas, 'Marrying into the Tardis Tribe', in Thomas and O'Shea: *Chicks Dig Time Lords*, p. 85.
6. See Parsons: *The Science of Doctor Who*, pp. 28–9.
7. Ibid.
8. Kate Orman, 'If I Can't Squee, I Don't Want to be Part of Your Revolution', in Thomas and O'Shea: *Chicks Dig Time Lords*, p. 150.
9. Ann Hovel, '*Torchwood: Miracle Day* Steeped in Fandom, Libido and Relationships'. *CNN*. 8 July 2011. Online. Available http://articles.cnn.com/2011–07–08/entertainment/torchwood.miracle.day_1_gwen-cooper-ianto-jones-jack-harkness/2?_s=PM:SHOWBIZ (1 September 2011).
10. Parsons: *The Science of Doctor Who*, pp. 56–7.
11. Ibid., p. 58.
12. Ibid.
13. Jodie Corney, 'Fanning the Flames: How the "Queer Space" of the Internet and the Writing of Fan Fiction Enhances the Fictional Universe of Torchwood'. *Hack Writers*. 2007. Online. Available http://www.hack-writers.com/Torchwood.htm (30 July 2011).

14. Johanna Mead, 'Costuming: More Productive than Drugs, But Just as Expensive', in Thomas and O'Shea: *Chicks Dig Time Lords*, p. 59.
15. Neil Perryman, '*Doctor Who* and the Convergence of Media: A Case Study in "Transmedia Storytelling"', *Convergence: The International Journal of Research into New Media Technologies* 14/1 (2008), pp. 21–39, p. 30.
16. See Corney; 'Fanning the Flames'.
17. Ibid.
18. Perryman: 'Doctor Who and the Convergence of Media', p. 35.
19. John Barrowman and Carol E. Barrowman, *Anything Goes* (London, 2008), pp. 231–2.
20. Perryman: 'Doctor Who and the Convergence of Media', p. 36.
21. Jethro Nededog. 'Barrowman Would Return for *Doctor Who*'s 50th Anniversary Episode (Video)'. *Hollywood Reporter*. 7 June 2011. Online. Available http://www.hollywoodreporter.com/live-feed/comic-con-2011-torchwoods-john-214466 (28 January 2012).
22. Alan Stanley Blair, 'Review: Doctor Who – "The Stolen Earth"', *Airlock Alpha*. 30 June 2008. Online. Available http://www.airlockalpha.com/node/5169 (30 October 2011).
23. No author. 'Episode Review: Torchwood: Children of Earth, Day 5'. *The Republibot*. 24 July 2009. Online. Available http://www.republibot.com/content/episode-review-torchwood-%E2%80%9Cchildren-earth-day-5-%E2%80%9D-season-3-episode-5?page=0,2 Web (14 February 2012).
24. See 'Episode Review: Torchwood: Children of Earth, Day 5'.
25. Will Brooker, 'TV Review: *Torchwood: Miracle Day*', *Times Higher Education*. 11 August 2011. Online. Available http://www.timeshigher-education.co.uk/story.asp?storycode=417112 (14 February 2012).
26. 'Save Ianto Jones'. Online. Available http://www.saveianto.com/ (10 October 2011).
27. Michael Ausiello, '*Torchwood* Boss to Angry Fans: Go Watch *Supernatural*', *Entertainment Weekly*, 24 July 2009. Online. Available http://insidetv.ew.com/2009/07/24/backlash-shmacklash-thats-torchwood-creator-russell-t-davies-reaction-to-the-outcry-over-the-death-of-gareth-david-lloyds/ (10 September 2011).
28. See Ausiello: '*Torchwood* boss to angry fans'.
29. See 'Save Ianto Jones'.
30. Barrowman and Barrowman: *Anything Goes*, p. 16.
31. Thomas: 'Marrying into the Tardis Tribe', p. 85.
32. 'John Barrowman: The Official Site'. John Barrowman. 1 January 2012. Online. Available http://www.johnbarrowman.com/ (26 January 2012).
33. No author, 'Review: John Barrowman, The Playhouse'. *The Scotsman*. 2 November 2010. Online. Available http://www.scotsman.com/news/review-john-barrowman-the-playhouse-1-1311578# (14 February 2012).
34. See 'Review: John Barrowman, The Playhouse'.
35. Michael Deacon, 'John Barrowman: Slick, Sickly, and Hard to Avoid'. *The Telegraph*.15 April 2008. Online. Available http://www.telegraph.co.uk/culture/culturereviews/3672640/John-Barrowman-Slick-sickly-and-difficult-to-avoid.html (18 February 2012).
36. See Deacon: 'John Barrowman: Slick, Sickly, and Hard to Avoid'.
37. Ibid.

QUAINT LITTLE CATEGORIES: GENDER AND SEXUALITY IN *TORCHWOOD* AND ITS IMPORTANCE TO THE FANDOM

Jeannette Vermeulen

I'm talking about understanding – or at least feeling like I understand – every artistic decision, every impulse, the soul of both the work and its creator. 'This is me,' I wanted to say when I read Tyler's rich, sad, lovely novel. 'I'm not a character, I'm nothing like the author, I haven't had the experiences she writes about. But even so, this is what I feel like, inside. This is what I would sound like, if ever I were to find a voice.'

Nick Hornby, *31 Songs*[1]

They don't even know what it means to be a fan, y'know? To truly love some silly little piece of music, or some band, so much that it hurts.

Almost Famous[2]

We're all fans of something. Whether it's a television show, a sports team, a musical or film, a band or an artist, it all boils down to one thing – connection. Some part of you, for reasons you may not even fully understand, connects to that

external source in such a visceral way that it has the potential to challenge your view of the world. Such a reaction is critical to the concept of 'cult' because it is in recognising that element, and discovering that others have had similar responses, that a cult following is essentially established. As Jes Battis remarks, 'fans are known to be "cult" once they truly admit to loving a program'[3] and John Tulloch notes that 'a unified interpretive position is what makes fans a cultural unit, an interpretive community'.[4] In order to engender such a strong response, a cult object can often be understood to be transgressive, a risky undertaking that stands in contrast to 'mainstream' ideals. How then does *Torchwood* fit into this mould?

The show occupies a rather unique space within popular culture as it is a television show that doesn't allow its characters to adhere to convention, particularly with regard to gender and sexuality. All of the show's characters, from original team members like Owen (Burn Gorman) and Toshiko (Naoko Mori), to newer season four characters like Rex (Mekhi Phifer), take a very relaxed approach to sex and, in a sense, challenge preconceived notions of gender roles. For example, one of the first introductions to Owen's character in 'Everything Changes' (1.1) sees him attempt to pick up a woman, and when she turns out to have a boyfriend, Owen picks him up as well. Granted, it is done with the help of alien technology but the fact that Owen doesn't hesitate to take that step illustrates the more relaxed attitude his character, and the show in general, has towards sex. It can thus be said that issues that may be problematic in other shows or contexts are neutralised and normalised. While discussing the foundation of the modern world view, Richard Tarnas highlighted the importance of science as

> no traditional authority now dogmatically defined the cultural out-
> look, nor was such an authority needed, for every individual pos-
> sessed within himself the means for attaining certain knowledge
> and that this opened the way to envision and establish a new form
> of society, based on self-evident principles of individual livery and
> rationality.[5]

Torchwood actively embraces this sentiment as the team's expo-
sure to alien life and technology frees its members from main-
stream constraints and beliefs. In effect, there are no limitations

in *Torchwood* because the main characters are given authority to disregard those boundaries. This opens up the show to viewer identification and connection from the start as it is an open space with room to develop. This chapter aims to examine how that space is established and how it inspired a cult fandom.

The idea of cult television is hardly a new one and has been covered extensively in this collection and other writing, with fandom often being highlighted as a defining element of any cult television show. Television can be considered a relationship, one to which an entire field of study has been applied through parasocial interaction and relationship development theory: 'Audiences form an intimacy with television that they do not have with other visual mediums, not because television comes into their homes but because television comes into their heads. And stays there.'[6] A viewer is encouraged to form a relationship with a character, a show relies on the viewer's investment, and so it's a completely rational response when viewers react strongly to situations portrayed on the screen. Intense relationships are especially common when it comes to cult shows because they rely so strongly on an internal system of understanding. These are often formed by the fans themselves through their interaction with the show, whether it be through discussion with other fans or creating their own work such as fan art or fan fiction, and appeals directly to a somewhat niche, marginalised audience. Consider for example Margaret Morse's discussion of television as distraction, a system 'organized in a way which allows for "liquidity", the exchange of values between different ontological levels and otherwise incommensurable facets of life, for example... among the economic, societal, and symbolic realms of our culture'.[7] That is in essence, then, the basis of television fandom. Science fiction in particular has a long history of establishing cult followings and, by extension, strong fandoms. Its use dates back to the 1930s and it gained particular popularity in reference to the media fandom of *Star Trek* in the 1970s. It's worth noting that the concept of fandom as referred to in this chapter draws upon the general understanding as outlined by Henry Jenkins:

> Fandom is a cultural community, one which shares a common mode of reception, a common set of critical categories and practices, a tradition of aesthetic production, a set of social norms and

> expectations. I look upon fans as possessing certain knowledge and competency in the area of popular culture that is different from that possessed by academic critics and from that possessed by the 'normal' or average television viewer.[8]

In this regard, fandom is not merely the enjoyment of something. There are a great number of issues at play including the positioning of the individual, self and identity. There is the issue of self-reflection and projection, 'as fans are fascinated by extensions of themselves, which they do not recognize as such'.[9]

The two concepts appear inextricably linked as a show's cult status hinges on the actions of its fan base. As the quotes that open this chapter suggest, it's about relatability and notions of authorship. The power of the show lies in the viewers' interaction with it and how they express their involvement. That is to say, 'fans are consumers who also produce, readers who also write, and spectators who also participate.'[10] They are completely invested in their chosen fandom and immerse themselves entirely in the show, following it through various media forms; in the case of *Torchwood*, this means official material such as tie-in novels, audiobooks, radio plays and comic books, as well as unofficial forms such as fan fiction and various fan websites. This intertextual framework plays a key role in shaping cult fandom as it leads to the creation of a subculture manifesting online, with its own language, traditions and internal factions who support particular characters or relationships above others. The cult then 'serves to build consensus in an interpretive community committed to difference' and it in turn alters the personal culture of those viewers 'ready to seek ... membership in a new *systeme*, ready to belong to it, to learn its language and customs, by committing their imaginaries to time-slotted new televisual experience'.[11]

As a spin-off show, *Torchwood* automatically enters more of a niche space. Spin-offs branch off from an existing show with an existing mythology, and seek to appeal to a particular type of viewer already existing within the original audience. In the case of *Torchwood*, the show was pitched to be edgier, sexier and darker than its parent *Doctor Who,* and so in that sense it was already positioned towards a specific audience. In essence, the show originally presents five very different individuals living on the fringe of society.

The very nature of a secret organisation means that they're always somewhat apart, even when they are dealing directly with others. This in itself is an easily relatable scenario, as many people often feel like they're not quite clicking with the rest of the world, never quite fitting in. On screen, Team Torchwood embodies that situation and in a sense glorifies it. Gwen is meant to restore a human connection, but there was always a bridge too far between the team and normal life. Once the extraordinary is experienced, the ordinary holds no appeal. However the characters are still human and they deal with these extraordinary events in a very human way. It starts with Jack – brash, bold, and larger than life from the very first moment he appeared in *Doctor Who*. While apparent immortality roughed his edges a bit, it only made him more interesting as the more flawed and conflicted characters are, the more potential they have. There is unlimited possibility for viewers to become involved in this character because he has the uncanny ability to be many different things all at once. Since it is aimed at an adult audience, the show's very inception places it within a specific frame of reference. It's not pitched to appeal to the 'mainstream' and so it inherently lends itself to cult status, one that is more transgressive and continually pushes the boundaries of television conventions. *Torchwood* has done this consistently throughout its run both superficially, by constantly changing its narrative structure as it morphed from a monster-of-the-week type show to a mini-series format, and thematically as it challenged societal perceptions, especially with regard to gender and sexuality. This ties in with Jes Battis' observation that:

> Often, 'transgression' on television becomes coded specifically as the (unexpected) representation of racial and sexual minorities on screen, which Judith Butler locates as the battle between the 'universal' audience and the 'foreclosed' particular subject who 'makes a claim' for universality.[12]

Consider, for example, Jack's introductory monologue within the first five minutes of the show: 'Contraceptives in the rain.... Still, at least I won't get pregnant. Never doing that again.' Motherhood has long been seen as a defining characteristic of femininity, a key element of what it is to be female. This exchange immediately subverts that perception by tying the concept to a character who

appears very much masculine. While the effect is mostly comic, it's indicative of the stance the show takes towards normative social conventions. Its use so early in the show further suggests that *Torchwood* never initially intended to appeal to a mainstream audience that's comfortable in its view of the world, but was instead targeting those who were open to pushing the boundaries of what is considered 'normal'. Jack continues to be the main subversive element of the show, a walking contradiction of tradition as embodied in his uniform and progressive attitudes, best showcased through his shameless flirting and many anecdotes. He is essentially a new type of hero, one who fits Miranda J. Banks' notion of a hero and martyr who:

> ...at the same time can be unabashedly emotional and decidedly masculine, [and] offers himself up each week for physical as well as emotional torture. And because of his alien status, which allows him to spontaneously heal himself, this suffering hero can return each episode anew.[13]

While Jack's attitude and behaviour can be perhaps be dismissed by his obvious Otherness, 'a strangeness that is difficult to locate',[14] the subversion of gender roles is also evident in the character of Gwen. She acts as an identifier for the audience, their 'way into' this strange new world, and she is a strong example of a modern, liberal woman who is not afraid to speak her mind or follow her instincts. Her de facto relationship with Rhys is similarly modern as they're both portrayed to be quite independent and often Rhys is shown completing tasks traditionally considered 'women's work' such as cooking or doing the laundry. There is a suggestion that it's her newfound involvement with Torchwood that plays a role in this emancipation. For example, in 'Ghost Machine' (1.3) Rhys calls her for instructions on how to use the washing machine, suggesting that this is a task she was more likely to perform but no longer has time for. This lays the groundwork for a growing tension in their relationship that's explored throughout the series, as Gwen's work keeps her from home and the secrecy required alienates her from Rhys. But by discovering this extraordinary world in her everyday life, she has discovered more possibilities for herself that extend beyond that of what society necessarily affords her. Interestingly, the show itself acknowledges that breakdown of such

long-standing barriers can be problematic and lead to discontent; Gwen responds to the uncertainty this brings by having an affair with Owen. That's not to say that the breakdown of societal conventions and expectations is necessarily destructive, merely that there is a learning curve to be weathered as individuals find a new way to position themselves within the world. The show's characters do this by very much identifying themselves as Torchwood, 'outside the government, beyond the police', and the show's fans do this as well by identifying themselves as part of a fandom, or indeed particular factions of that fandom.

This continues throughout the show's run as other characters are presented to challenge preconceived ideas of gender roles. Diane, for example, dispels the notion of a repressed 1950s female identity in the episode 'Out of Time' (1.10) in which she also highlights Owen's modern masculinity by referencing his beauty products. Owen's response that 'real men can moisturise too, you know' is that of someone who is comfortable with his masculinity. This recalls Judith Butler's notion that there isn't an 'implicitly heterosexual framework for the description of gender, gender identity and sexuality' but that gender is rather enacted, to be embodied fully through action rather than societal prescriptions.[15] It's especially curious when you consider that the episode following 'Out of Time' is the testosterone-heavy 'Combat' (1.11), an episode that draws on *Fight Club* themes of dissatisfaction with masculinity and modern society. The conflict presented seems to further suggest that 'what is called gender identity is a performative accomplishment compelled by social sanction and taboo'.[16] This is also embodied by Toshiko, who finds her view of her identity challenged when she becomes sexually involved with the alien Mary in 'Greeks Bearing Gifts' (1.7):

> Tosh: So. I'm shagging a woman and an alien.
> Mary: Which is worse?
> Tosh: Well I know which one my parents would say.

The exchange shows that she is very aware of social sanction and, as this is presumably a first for Tosh, she undergoes a crisis in terms of her positioning within the team and the world. This is mirrored by the alienation she experiences thanks to the telepathic necklace Mary gives her, reminiscent of the technique whereby horror fiction

writers 'utilized metaphor as a means to address larger social issues – issues that . . . would not have had the same philosophical impact on the audience without the underlying metaphor'.[17]

The Tosh–Mary relationship also highlights how the show's treatment of gender ties in with its fluid treatment of sexuality. Many television shows tackling the topic, while considered progressive, are still positioned within a narrative space that relies on familiar conventions. *Will & Grace,* for example, relied on comedic conventions such as equating gayness with a lack of masculinity.[18] *Torchwood,* however, took sexuality out of the safe and familiar popular culture conventions and for all intents and purposes made it a non-issue. It never shied away from its themes, but it also never attributed any preconceived notions to its representations. It is all in the subtleties and is presented from the get-go. In 'Day One' there is a scene in which the team members are sitting in the boardroom, discussing Jack's sexuality to which Ianto merely says 'And I don't care'. In the same episode Jack makes the remark from which this chapter takes its name, replying 'you people and your quaint little categories' when Owen questions why Gwen is kissing Carys when she has a boyfriend. This episode then essentially captures what I argue the show stands for, namely embracing freedom and difference, and sets up the egalitarian notion of dispensing with the need to neatly label people. Jack actively embodies this in that he doesn't shy away from sexuality but rather embraces it in all its forms, gleefully indulging in innuendo and openly flirting with men, women and aliens alike. This is reinforced by the appearance of John Hart in the second season episode 'Kiss Kiss, Bang Bang' (2.1) as he brings the same sort of fifty-first century sensibility to the show that Jack consistently exhibits, and so eschews boundaries and so-called normative society's expectations.

As already mentioned, Tosh had a chance to explore her sexuality while both Owen and Gwen had brief encounters with members of the same sex. Ianto, after nearly dying in his quest to save his girlfriend, begins a relationship with Jack, which perfectly encapsulates the fluidity of sexuality in the show. It's presented as something malleable and open to individual interpretation. Again this recalls Butler's theory of performative gender, as sexuality is similarly not presented as 'a stable identity or locus agency from which various acts proceed' and that the body is 'a continual and incessant

materializing of possibilities'.[19] Indeed I would argue that *Torchwood* is all about possibilities, both on the macro level of the great unknown of the universe as well as on a micro level of personal identity formation through challenging notions of gender, sexuality, ethnicity and spirituality. Being a member of the Torchwood team takes the characters away from normative society, which allows them to examine the existing societal boundaries and ultimately find them pointless.

As such, the fluid sexuality of characters is never really raised as an issue in the first two seasons; it is simply there; everyone accepts it and carries on. It's truly only directly addressed for the first time in the season three arc, 'Children of Earth', when Ianto is somewhat forced under the microscope – first, in a conversation with his sister and brother-in-law and then later through an exchange with the character of Clement who says he can 'smell' that Ianto is 'queer'. For a show that was generally very *laissez-faire* about sexuality, it was an interesting change of pace and one that highlighted the difference between the world *Torchwood* represented on-screen and the reality of life. It showed that the norms within the Hub differed from the world outside it, so while within Torchwood itself there may not be judgements on these issues, the outside world still categorised and liked to define things. This seemed to suggest that no matter how removed you thought you were from everyday life, societal constraints still had a way of creeping up on you. This disparity with reality continued in the fourth season, 'Miracle Day', along with added emphasis on the cultural differences that came from displacing Gwen and Jack to the USA. In this season, sexuality was again more highlighted than in the first two seasons, mostly in the form of Rex's discomfort with Jack's easy sexuality and Jack teasing him about it. It's worth mentioning, however, that 'Miracle Day' takes a rather transgressive step in intercutting a heterosexual sex scene with a homosexual one in the episode 'Dead of Night' (4.3), thereby continuing the show's habit of levelling sexuality onto one plane. Jack's one-night stand with a bartender is juxtaposed with Rex and Vera acting on the sexual tension that characterised their relationship from the start of the season, and so the intercut scene portrays a very modern stance on sex and relationships, one which recalls the show's very first episode. It is interesting to note that this sex scene caused some tension as the BBC decided to cut it down,

trimming approximately ten seconds from the original version that first aired in the United States. This resulted in a number of complaints from fans who thought it prejudicial and contrary to what the show stood for. *Torchwood* should, after all, be all-inclusive and not prescriptive over what is or isn't appropriate, especially when it comes to gender and sexuality. In a way, fans of the show expect the boundaries of these issues to be pushed. Merri Lisa Johnson notes, 'riddled with stereotypes as media culture admittedly is, television can also provide rare insight into alternative ways of living in the world.'[20] I'd suggest that this rare insight is what forms the main appeal of this show for many viewers, and when it is challenged, fans react strongly against it.

The impact of *Torchwood*'s portrayal of gender and sexuality on the fandom and its role in forming fans' investment in the show is perhaps best exemplified through the fandom's reaction to the death of characters since '[t]he key rationale is that television drama must reflect to some degree the lived reality of emotions or the audience would not watch'.[21] Character deaths are a necessary evil of certain types of shows, adding gravity and importance to a situation, and a show like *Torchwood* needs that to remain credible. After all, as Cawelti argues, a story cannot be 'incredible to the point that it cannot generate some temporary suspension of disbelief'.[22] To remain believable, it must maintain a balance with the risks being taken, and Owen's first death perfectly reflects that. However, across season two and 'Children of Earth', *Torchwood* lost three of its lead characters in the space of five episodes. Owen, Tosh and Ianto skirted the shadows and were arguably the more marginalised of the team with Jack occupying a very particular space as somewhat otherworldly and Gwen being still closely associated with the norm. The three were subsequently characters much of the fandom was more invested in because that feeling of being overlooked and misunderstood is a powerful conduit for someone sitting at home. There is a sense of 'blankness' to the characters, with so much left unsaid and so much to be teased out, that it gives fans a huge amount to engage with, and nothing is better for investment than the opportunity to explore. The fans come to know the characters in their own terms and so feel very close to them. More telling perhaps, viewers *project*; they begin to find themselves in the characters, they become 'personal totems, aspects of oneself with which

one wishes to engage and think through...'.[23] They come to see the show and the action through the eyes of their favourite character, interpreting things from that point of view. Through the character, the viewer can be the person he or she wants to be. It's absolutely devastating then when those characters die, because in a sense the audience members are those characters, and they have become so invested that the characters' deaths may feel like a direct violation of themselves.

Essentially character death threatens the viewers' connection to the show and jeopardises their continued engagement with it. The character death trend in *Torchwood* continued into 'Miracle Day' with two major characters, Vera and Esther, dying across the series arc. Fans can become reluctant to become involved in a show where this continually happens; after all, why become entrenched in a show and attached to characters if they aren't going to be around for more than a few episodes? As argued earlier, fandom encompasses a wide variety of issues of identity and reflection. As a result, it has the capacity to 'carry meaning that articulates fans' identity and their objective and subjective position within society'.[24] Following character deaths, fans are often unable to locate themselves, and what they loved, within the space and are unable to reconcile their position in society with the show as they had before. For lack of a better term, the special tie they have to it is severed. This is best seen by examining Ianto's death in 'Children of Earth'. After the deaths of Owen and Tosh, many fans felt that Ianto was the remaining fringe character, and this bond was given time to grow in the intervening time between seasons two and three. There was a strong reaction to his death that has been well documented,[25] and it brings into play a number of issues to which the character's death serves as a catalyst, such as changes made to the format, the destruction of the Hub and the relocation of much of the action to London, along with the way Ianto died in context with Tosh and Owen's deaths and what was promoted to be a stronger Jack and Ianto relationship in the third season. As mentioned previously, 'Children of Earth' took a more complex stance on sexuality than previous seasons of the show. Ianto was in particular singled out for this, with his sexuality repeatedly spotlighted while Jack remained relatively free from scrutiny. Fan and Livejournal user blush_violently commented on the change while also encapsulating

the power the show has to open viewers' eyes to new ways of living in the world:

> I was shocked at all the references and questions regarding Ianto's sexuality (Gayboy, taking it up the ass, queer, etc). When I first started watching the show I was a little uncomfortable with the idea of the Janto ship. The message I eventually got was that sexuality and orientation wasn't an issue. It was what it was. That acceptence [*sic*] eventually became what I loved about the ship. Yeah, so when COE started labeling Ianto – not what Jack and Ianto are to each other – I just found it upsetting.[26]

During promotion for the season, fans were often told they'd be very happy with the treatment of the Jack and Ianto relationship in the season. While it was addressed, it wasn't represented in the same way the Gwen and Rhys relationship was addressed throughout the show – the pair were often seen on dates, at home, and having discussions and arguments, when the Jack and Ianto relationship was mostly confined to innuendo and references to off-screen activities, such as the date Ianto's sister mentions in 'Children of Earth'. This left many feeling disappointed with the ultimate outcome of season three, as noted by Livejournal user flohkatie:

> You know what makes it so hard for me to accept this outcome of CoE is, although it is the final consequence for a relationship with an immortal (how strange that sounds), that the writers deprived us of how they got there. The all of a sudden deep love of Jack for Ianto that ends up with Jack's destruction, I actually wanted to see that happen on screen but no, we just jump to the end. And that is for some unsatisfying viewing, I really would have liked to bawl my eyes out, if we had ever seen some deep mutual affection, some coup-ly stuff, whatever, besides the death scene. Than it [*sic*] might have been cathartic, but it wasn't. And what annoys me just as much is that it maybe ages before we ever get to see anything like that again.[27]

For all its progressive attitudes, the show essentially gave viewers a hollow Jack and Ianto relationship where a lot was left up to inference and interpretation, and it even took away some of the information given about Ianto as a character by having his sister lash out at Gwen in 'Day Five' (3.5) when she revealed he'd lied about his

father. Though well executed, the third series became a destruction of everything many fans identified with, from the physical Hub and the SUV, through to Ianto and the team itself. As Petra Witowski, known on Livejournal as user rallyemadartep, noted after the airing of 'Children of Earth':

> Frobisher was brilliant, the entire thing was brilliant – but it should have been a stand-alone sci-fi drama. That would have blown me away. Setting it into Torchwood has made me a wreck, destroyed my favourite UK/sci-fi show and also killed off one of the best gay relationships on tv... I would not be able to invest in another season, because you have to invest in the characters – and considering they killed off 60% of the cast within 3 episodes, who's willing to re-invest in new characters?[28]

Many comments online at fan communities, such as Livejournal, highlight a common thread among fans where many noted that they would have been fine with the series, and the character death itself, had it been set on its own, instead of part of this story arc that felt so dissonant with what *Torchwood* used to be – a character-driven, sex-friendly and slightly camp show. Fans were excited after months of promotion and eager to see their favourite characters again. What they felt they had been given instead was a gripping drama that happened to involve their favourite characters and then emotionally destroyed them. Considering some of the comments that came in response to the series following the death, it becomes obvious how important characters are for viewer identification:

> No storyteller should cater to their audience's *whims*, but no storyteller should forget the fact that the relationship between a storyteller and their audience involves faith, trust and love. What the audience gives a storyteller is critical and needs to be respected; we're not mindless drones and we're not punching bags. A storyteller, when they begin their story, is asking us to care. To care about the characters, the world, and the story they are spinning. They are asking us to be emotionally involved so all the bullshit about 'it's just TV' and 'over reaction' is just that – bullshit. The grief and upset (and appreciation, because there are plenty of people who loved this story) are there because we care, because we've invested in the story. We've done what any good storyteller wants – we *believe*... As a person who consumes a lot of media, I'm simply

astonished. What the hell were the creators thinking? Why in god's name would I want to be made to feel *that* bad? Why would I want to watch every character I care for – that the creators have bent over backwards to make me care for – be destroyed?[29]

There are two things that attracted me to Torchwood. And they are intrinsincly [*sic*] tied together. One, the characters. Human, flawed like any person you meet in your day to day. Petty, some times. Broken beyond belief, some most all of them. Layered, three-dimensional. Lovable, even when being absolute twats (yes, I still love Owen, always knew there was something behind his facade). And well, kudos to the actors for making so much out of so little given by the writers, in some cases. Tied to the humanity of the characters, which is something we don't get to see in most shows, is the attitude that seems to run through both S1 and S2, that whoever you share your bed with, it just doesn't matter. It wasn't just the throwaway comments we sometimes get in Doctor Who, which always make me smile because, hey, small things as they are, they are something better than just pretending everybody conforms to heteronormative stuff.[30]

These quotes support my argument that the strength of the diversity portrayed in the show appealed to individuals as it presents an egalitarian social structure in a still real, often brutal world. It is through this diversity that viewers can form attachments to characters and, therefore, to the show. *Torchwood*'s main characters, across all four seasons, subscribe to a slightly different way of thinking and as such they can act as representatives for individuals who often feel marginalised. Toshiko and Esther are the clever introverts who find they struggle to say quite what they mean. Owen and Rex stand for the acerbic types who mask their true feelings with a show of misanthropy. Gwen and Vera are the well-meaning people just looking for a little magic to break the routine. And Ianto is anyone who ever felt forgotten in the back of a room, knowing he or she is capable of so much more. Jack, of course, is everyone's hero, not so much a vehicle for identity as an ideal, flaws and all. The characters are all given agency in their own right, and given their moment to shine regardless of their gender or sexuality. There's a frank openness to each of them and yet something always seems to lurk under the surface, and that is an attractive feature for many viewers. The characters all have unique flaws as well, a real sense of that 'nobody

is perfect' ethos, and that kind of realism appeals to viewers who might not exactly feel they fit into the standard, conventional roles society presents. After all, the characters in *Torchwood* don't subscribe to such rules.

As *Torchwood* exists in a representative real world, it highlights the globalised nature of modern society of which multiculturalism is a natural result, and represents diversity as tradition co-exists with multiple minority perspectives in the show's reality. It is incredibly engaging for viewers to see representations of co-existing diversity, ranging initially from Owen's London background, Toshiko's Japanese heritage and naturalised ethnicity, to Gwen and Ianto as local, and Jack's unidentifiable Otherness; to the juxtaposition of the differences between the UK and the US characters in 'Miracle Day'. Overall, across the show's series, all characters fit into the team and function in their own productive ways. Because these categories are made highly visible, it is thus also immediately clear that the perceived differences are not obstacles. In fact, their differences are often their strengths, giving them insight that allows them to make certain decision and save the day. It is because they are different that they can be heroes. This notion of acceptance also goes a long way in establishing a sense of community and camaraderie amongst fellow fans. As author Jody Lynn Nye attests,

> [fandom] is more accepting of a wider range of people than almost any other subgroup I have ever met. All genders, races, body types, political parties and religions are welcome (or at least tolerated) under the 'do unto others as you would have others do unto you' mantra. Since many, if not most, have been ostracised in their ordinary environments, they work hard not to reject others.[31]

Essentially, *Torchwood*'s representation of these issues made people feel included and accepted. As fandom is about uniting people, the show's treatment of things that can still be 'taboo' in many aspects of mainstream society makes it appealing and welcoming to those who perhaps feel marginalised. *Torchwood* gives power to everyone, regardless, and openly derides the compulsion to neatly label and define people, and in everything it does it seem to say 'go forth and live your life by your own code.' That's an intriguing concept that I think originally attracted many people to the

show, resulting in a, generally speaking, open-minded and forgiving fandom.

> Fan culture finds that utopian dimensions within popular culture are a site for constructing an alternative culture. Its society responsive to the needs that draw its members to commercial entertainment, most especially the desire for affiliation, friendship, community.... The characters in these programmes devote their lives to goals worth pursuing and share their hours with friends who care for them more than life itself. The fans are drawn to these shows precisely because of the vividness and intensity of those relationships; those characters remain the central focus of their critical interpretations and artworks.[32]

In conclusion, I argue that *Torchwood*'s handling of complicated issues such as gender and sexuality in such a matter-of-fact way, particularly in its first two seasons, endeared the show to many fans and contributed to its status as a cult programme. By approaching the issues through various characters and situations, the show allowed for 'space to the subjectivities, identities and pleasures of audiences'.[33] *Torchwood* dealt with unreal things but because it was essentially character-driven, it felt more real, or rather more relatable, than a lot of shows that claim to be realistic drama. It focused on the team in all its incarnations, and left the greater scope morality tales to its parent show *Doctor Who*, so that its initial concern is in simplest terms mainly how alien involvement affected normal people and how they dealt with it; that humanity has remained the crux of the show throughout all four seasons. As such, I would suggest that characters provide the means of connection and as soon as an audience identifies with the characters and the issues portrayed, and indeed feels indebted to those characters for perhaps changing the way they view those issues, that's when a strong fandom is formed and a show gains the edge as cult television.

Notes

1. Nick Hornby, *31 Songs* (London, 2003), p. 11.
2. Cameron Crowe, Director, *Almost Famous*, 2000.
3. Jes Battis, 'Transgressive TV', in S. Abbott (ed), *The Cult TV Book*, (London and New York, 2010), p. 78.

4. Henry Jenkins and John Tulloch, *Science Fiction Audiences: Doctor Who, Star Trek and Their Fans* (Florence, 1995), p. 123.

5. Richard Tarnas, *The Passion of the Western Mind: Understanding the Ideas that Have Shaped Our World View* (New York, 1993), p. 283.

6. Mary McNamara, 'Critic's Notebook: The Side Effects of Binge Television', *LA Times*, 15 January 2012. Online. Available http://www.latimes.com/entertainment/news/la-ca-netflix-essay-20120115,0,693395.story (1 February 2012).

7. Margaret Morse, *Virtualities: Television, Media Art, and Cyberculture* (Indiana, 1998), p. 100.

8. Jenkins and Tulloch: *Science Fiction Audiences*, p. 159.

9. Brian Longhurst, *Cultural Change and Ordinary Life* (Buckingham, 2007), p. 43.

10. Henry Jenkins, '"Strangers No More, We Sing": Filking and the Social Construction of the Science Fiction Fan Community', in Lisa A. Lewis (ed), *The Adoring Audience: Fan Culture and Popular Media* (London, 1992), p. 208.

11. David Lavery, 'Introduction: The Semiotics of Cobbler *Twin Peaks'* Interpretive Community', in D. Lavery (ed), *Full of Secrets: Critical Approaches to* Twin Peaks (Detroit, 1995), p. 4.

12. Battis: 'Transgressive TV', pp. 78–9.

13. Miranda J. Banks, 'A Boy for All Planets: *Roswell, Smallville* and the Teen Male Melodrama', in G. Davis and K. Dickinson (eds), *Teen TV: Genre, Consumption, Identity* (London, 2004), p. 20.

14. Fred Botting, *Gothic Romanced: Consumption, Gender and Technology in Contemporary Fictions* (New York, 2008), p. 131.

15. Judith Butler, 'Performative Acts and Gender Constitution', in J. Rivkin and M. Ryan (eds), *Literary Theory, An Anthology* (Malden, 2004), p. 910.

16. Butler: 'Performative Acts and Gender Constitution', p. 901.

17. Tracy Little, 'High School is Hell: Metaphor Made Literal in *Buffy the Vampire Slayer'*, in J.B. South (ed), *Buffy the Vampire Slayer and Philosophy: Fear and Trembling in Sunnydale* (Chicago: La Salle, 2003), p. 284.

18. Kathleen Battles and Wendy Hilton-Morrow, 'Gay Characters in Conventional Spaces: *Will and Grace* and the Situation Comedy Genre', *Critical Studies in Media Communication* 19/1 (2002), pp. 87–105, p. 89.

19. Butler: 'Performative Acts and Gender Constitution', p. 900.

20. Merri Lisa Johnson, 'Introduction – Ladies Love Your Box: The Rhetoric Of Pleasure and Danger in Feminist Television Studies', in M.L. Johnson (ed), *Third Wave Feminism and Television: Jane Puts It In A Box* (London and New York, 2007), p. 3.

21. James Connor, *The Sociology of Loyalty* (New York, 2007), p. 117.

22. John G. Cawelti, *Adventure, Mystery and Romance: Formula Stories as Art and Popular Culture* (Chicago, 1976), p. 38.

23. Roz Kaveney, 'Gen. Slash, OT3s, and Crossover – The Varieties of Fan Fiction', in S. Abbott (ed), *The Cult TV Book* (London and New York, 2010), p. 246.

24. Longhurst: *Cultural Change in Ordinary Life*, p. 110.

25. Both through fan sites and online campaigns like www.saveianto.com and mainstream media. See No author, 'Fans aim to save sci-fi character', *BBC News Online*, 24 July 2009. Online. Available http://news.bbc.co.uk/2/hi/8166655.stm (24 February 2012).

26. blush_violently (2009), 'No Subject, Bring Out Your Dead'. Online posting at http://xtricks.livejournal.com/96515.html?thread=448003#t448003 Available email: blush_violently@livejournal.com (30 January 2011).

27. flohkatie (2009), 'No Subject, Bring Out Your Dead'. Online posting at http://xtricks.livejournal.com/96515.html?thread=446467#t446467 Available email: flohkatie @livejournal.com (30 January 2011).

28. Petra Witowski (2009), 'No Subject, Bring Out Your Dead'. Online posting at http://xtricks.livejournal.com/96515.html?thread=441603#t441603 Available email: rallyemadartep@livejournal.com (30 January 2011).

29. xtricks (2009), 'Bring Out Your Dead'. Online posting at http://xtricks.livejournal.com/96515.html Email withheld (30 January 2011).

30. kelticbashee(2009), 'No Subject, Bring Out Your Dead'. Online posting at http://xtricks.livejournal.com/96515.html?thread=448771#t448771 (30 January 2011).

31. Jody Lynn Nye, 'Hopelessly Devoted to Who', in L. M. Thomas and T. O'Shea (eds), *Chicks Dig Time Lords* (New York, 2010), p. 105.

32. Jenkins and Tulloch: *Science Fiction Audiences*, p. 55.

33. Christine Scodari, 'Possession, Attraction and the thrill of the chase: Gendered mythmaking in film and television comedy of the sexes', *Critical Studies in Media Communication* 12/1 (1995), pp. 23–39, p. 25.

THE SHAPE-SHIFTER: FLUID SEXUALITY AS PART OF *TORCHWOOD'S* CHANGING GENERIC MATRIX AND 'CULT' STATUS

Craig Haslop

Introduction

It has been argued by theorists such as Kuhn,[1] Pearson[2] and Riemer[3] that science fiction often enables us to imagine possibilities, providing a space for creating visions of what the human race could become both positively and negatively. In terms of sexuality, the BBC TV series *Torchwood* transports ideas of fluid sexuality from Captain Jack Harkness' fifty-first century to our own world, at least in the first two seasons. Indeed feedback from my own focus group research suggests that for the majority of respondents it offered liberatory notions of sexual identity and sexuality. However, a reading of the show as simply science fiction is complicated by close textual analysis and by focus group interpretations of the series which suggest that *Torchwood* includes elements of crime, hospital drama and soap. The narrative combination of the 'unearthly' with the everyday helps the show to break new ground in terms of sexual representation for science fiction and more generally in TV drama/

soap. However, as discussed throughout this book, the series has also been labelled by media and fans as 'cult', and through audience responses I want to trace how the innovative representation of fluid sexuality might have fitted into the show's classification (and sub-cultural fascination) as a cult series and then its later move to a more 'mainstream' position. In this chapter, then, I draw on my focus group research[4] and textual analysis to argue that a nexus of interrelationships between the show's *Doctor Who* connections, its ascension up the BBC channel hierarchy and a self-conscious hope by the production team for 'cult' status, have influenced the series approach to, and the destiny of, fluid sexual representation as part of its changing generic make-up.

I start by thinking broadly about the series' liberatory potential for my research respondents and then how they defined its generic make-up. I then consider how narrative elements of the series have shifted as it has moved up the channel hierarchy and where sexual representation fits into this generic matrix. Finally, I look at the notion of 'cult' TV and consider, through my own textual analysis and my participants' readings, how we might see the series this way and the role that depicting fluid sexuality might play in the programme's construction as 'cult'.

Torchwood: breaking sexual generic boundaries

During 2010 and 2011, I conducted a total of five focus groups in London and Brighton[5] with the broad aim of investigating different aspects of audience readings in relation to the representation of fluid sexuality in *Torchwood*. On the whole, all five groups welcomed the representation of fluid sexuality in the series:

> Pilot Focus Group – Ruth[6]: I think the emphasis seems to be more on the flirtation than it is on the relationships ... so you don't have to deal with the mental repercussions of it, or the emotional repercussions, it is sort of separated ... sex is a fun activity from being in a relationship ... so if you sleep with someone of the same sex some time it doesn't matter that's just sex ...
>
> Pilot – Ross: It's very progressive.
>
> Group One – Julie: I thought it was quite refreshing to see that portrayal of sexuality and identity, it just felt it was a bit contrary to

the norm to how it is often portrayed in the media, it just felt as if it was a good angle it was just refreshing or something different it felt as if it moved away from this thing of heteronormativity.

Whilst there were one or two exceptions, on the whole, *Torchwood*'s portrayal of bisexuality without labelling was perceived as positive by my respondents who were self-identified as straight and gay or queer. As John Corner[7] argues, however, when considering media texts and audience readings, we need to think carefully about 'genre' and how it can organise meanings when making interpretations. With that in mind, I wanted to explore how genre was related to my participants' perceptions of the sexual representations in the series. The series had been for the most part classified as science fiction by the media[8] but also as a 'sexy *Dr Who* spin-off'[9] or as '*CSI* Cardiff'[10] and 'cult'.[11] Whilst most of my participants initially interpreted the show as science fiction or as relating to *Doctor Who* (and, in that sense, as part of the science fiction genre) this is complicated by their readings that *Torchwood* also displayed a number of other generic traits. Various members of the focus groups highlighted that there were elements of crime, hospital drama and notions of the 'everyday' in the series:

Hospital Drama

Group One – Chris:. It kept switching genres though elements of science fiction elements of Casualty you know oh god we have got ten minutes before this person dies so all these different elements ...

Welsh

Group One – Chris: There is a brief focus on regionality as well the Welshness of Gwen, and her boyfriend is wearing the Welsh Rugby shirt.

Group Four – Debbie: Well I always find it funny that they are looking at Cardiff, I mean I lived in Wales for many years of my life and I really liked it was in Cardiff and it was a Welsh character ... you always see the location, again that's back to the earth type of thing, and to me the fact that they put it really away from the norm, which is London...

Crime

Group 2 – Harry: Some of the thing in the office was a bit *Prime Suspect* for me but between two guys.

Everyday life

Group 1 – Rose: I saw the science fiction of the show quite separate to the sexuality side; I didn't really see that one covered up the other. That's the premise of the show but there is a normality to the show because of its setting and so you don't see it as a Dr Who style or something scientific as Dr Who, it does have a normality to it but I didn't think that science fiction underplayed the sexuality part of the show.

The focus on the everyday, being 'Welsh' and drawing on crime and hospital drama arguably complicates media classifications of the series as simply 'Science Fiction'. Moreover, it questions the idea that *Torchwood* is only fantastical and therefore we can only read its representations of fluid sexuality as somehow part of the future/unreal. This fusion of genre helps to place *Torchwood* in a relatively unique position generically as a show that is partly TV science fiction, and in that sense pushing boundaries in a genre that has not been known for its sexual experimentation (or, as Sobchack has noted, in film).[12] However, its inclusion of various other genres means that the representation of fluid sexualities without labels is also seen to be grounded on earth, in the here and now. In that sense it breaks with past sexual representations in relation to crime drama where it is near on impossible to think of a detective who is queer, and in soap where representation is nearly always seen through the 'coming out' story,[13] and thus immediately situated in more traditional ideas of labelled sexual identity. Of course, in production terms the inclusion of a number of different generic elements to broaden audiences is not necessarily a new strategy (see for example Parks on *Buffy the Vampire Slayer*[14]). With this in mind I want to consider next some of my focus groups' responses regarding plurality of genre and how fluid sexuality is situated in relation to this.

Multiplication of genre

The strategy of including a number of generic strands in *Torchwood* did not go unnoticed by some of my respondents:

> Pilot Group – Lizzie: It would be too niche without that (sci-fi), people would think it was a show about sex rather than a show about sci fi. mmmm … nurr … mmm … I suppose it's sort of how they would interpret it … sort of if you like sci-fi … errr … I can't out what I am thinking … [taps her head … laughs].
>
> Craig Haslop (CH): It's ok it is getting late.
>
> Shauna: You mean if it's a sci-fi show then people who like sci-fi will kind of watch it.

Lizzie and Shauna are demonstrating an understanding of TV marketing strategies and the importance of genre as part of attracting sufficient audiences. This narrative and promotional technique arguably enabled the BBC to open up the text to a wider audience who might not be so interested in science fiction in general but who could engage with *Doctor Who* or crime-fighting narratives. Feuer[15] argues that this generic multiplication is necessary due to the diversification of TV channels available in the UK. This has meant that TV series would have to cater specifically to types of audience members who watched the channel in question and thus all its programming would have to appeal to them. Programme makers need some narrative guarantees that they can draw upon different audience tastes within niche markets, which are already considerably smaller than previous mass audiences when only four to five analogue channels were available in the UK (see also Garner and James in this book).

Ireland[16] envisages the idea of generic hybridity from the point of view of the narrative. He argues that (the) audience(s) can be seen as a presence in the *Torchwood* text; the author's voice no longer alone in the diegesis but in a textual 'fight' with a knowing viewer. He notes, for example, the self-conscious 'name dropping' included in *Torchwood* such as a reference to *CSI* in the narrative of the first episode of Series 1. In doing so, Ireland[17] also implicitly suggests that the production team is drawing these audiences into this fight and in this way adds to the argument that the series, at least in

season one (BBC3) and season two (BBC2), shows their awareness of the need to pull on various audience tastes within a niche market. It had to 'spar' with *Doctor Who* fans but also with those more interested in gritty crime series and more general science fiction fans. This is evinced through the various references made both in the narrative and the dark *mise enscène* of the series reminiscent of so many industrial science fiction cityscapes in film including *Dark City*, *Batman* and *Blade Runner*. However, further analysis of some of my respondents' feedback and the changing narrative across the four *Torchwood* seasons suggests that there have been shifts in the generic elements in *Torchwood* as it progressed up the BBC channel hierarchy. Next, I consider these in general terms, but also more precisely in relation to the positioning of sexual representation in the show's generic matrix.

Genre and sex 'changing' across the channels

Some participants who had seen the series before or were more committed viewers noted that it had changed from series to series in terms of genre and representation of sexuality:

> Pilot Group – Martha: In the early series everyone is bisexual and it's all very edgy but the later on they seemed to put less of that in ... in my experience.
>
> Phil: Yes, and the new series (referring then to Series 3 – CH) they did last year – it was a lot more serious and the sexuality wasn't as pronounced but maybe that's cos' it was short. I got hints of it but ...
>
> Nikki: I think that's cos' it was primetime. (Series 3 – CH)

Here the respondents are highlighting what they note is a shift from Series 2 to 3, moving it away from its 'edgy' tone and reducing the sexual content of the series. Ireland rather astutely notes that the number of references to *Doctor Who* escalated considerably in Series 3 once the series was promoted to a primetime BBC1 spot.[18] It was once again aware of its audience; its move to BBC1 meant it had a higher profile but it also needed to draw a broader range of viewers and in that sense younger adult *Doctor Who* fans might not be enough. Instead it would need to pull in teenage *Doctor Who* fans allowed to stay up and watch it post 9 pm as well as

older *Who* fans who might have shunned *Torchwood* when it was part of the younger BBC3 schedule, and then the arguably more alternative BBC2 TV listings. In terms of sexual content, an analysis of the themes of the episodes in Series 2 versus Series 3 further highlights the way sexuality was positioned and dealt with differently. The opening of season two ('Kiss Kiss Bang Bang' 2.1) which is also the episode screened for this research, contained a number of references to fluid sexuality as well as both heterosexual and homosexual kissing. In particular Captain Jack is shown to be 'multisexual' through his kissing of both Captain John and Gwen in the same episode. These fluid sexual tropes continue throughout the season with references to sex included in the episode 'Meat' (2.4) and 'From Out of the Rain' (2.10).

Torchwood morphs in Season 3

The opening of Season 3 stands in stark contrast to the second season both in general generic terms but also in relation to sexuality (see also Vermeulen in this book). For the first time in its narrative history the term 'bent' is used by Ianto's sister, labelling Ianto's sexuality. This is problematic on a number of levels. Firstly, in some ways it denies the validity of the notion of fluid sexuality by suggesting that it is more acceptable because Ianto is attracted to a person, rather than to anything physical. Secondly, it also brings the series back to a more conventional trope of past gay and queer TV – the 'coming out' ritual. Davis and Needham[19] and Herman[20] note the proliferation of gay characters 'coming out' on our TV screens over the last 20 years. This depiction in some ways, however, has become the predominant way of representing gay characters in 'mainstream' TV – a tendency to foreground the 'identity-making' element of sexuality. Thirdly, Series 3 of *Torchwood* also seems to follow another unfortunate reccurring theme of past gay representation. Ianto as the new 'queer' who has just 'come out' gets killed at the end of Season 3, causing an outcry amongst fans and sparking the creation of a (non-diegetic) memorial at the quayside in Cardiff. In this way Ianto 'got it' and followed so many (passive-identified) queers in film and TV before him. Davis and Needham[21] have noted that the move from 'gay' representation to 'post-gay'[22]

TV representation can perhaps be characterised by a shift away from 'identity'-focused themes, including coming out, towards a more taken-for-granted approach to sexuality. This is a move that the production team and the BBC made prior to Series 3. However, once the series moved to BBC1, they almost took a metaphorical sexual representation step backwards. Indeed the generic make-up of the series changed in other ways which are not directly of sexual representation, but are related to it.

Out of the (fluid sexual) dark, into the (heteronormative) light

This shift to more normative notions of sexuality and sexual identity is coupled with a transition to a more family-oriented set of tropes. This change starts boldly with the Series 3 overarching subtitle 'Children of Earth' firmly rooting the series in familial structures, something that previous series had only attempted to do through Gwen and Rhys's heterosexual relationship. Gone are the heavy rains and wide night-time cityscapes reminiscent of the aforementioned dark and brooding industrial dystopian science fiction narratives. Instead, in Season 3, *Torchwood* literally moves out into wider popular culture in its new primetime BBC1 position and, in terms of narrative, steps into the light by setting most of the action in the daytime. If we consider the remits of BBC3 and BBC2 versus BBC1, the changing dynamics of genre and sexual representation might not be so surprising. Table 1 below shows the aims or priorities of the three channels which *Torchwood* has inhabited.

The key differences here arguably are that BBC3 has a focus on a younger audience and is a developmental area for the other BBC channels. BBC2 notes in its aim that it wants to be 'bold and creative' whereas BBC1 needs to appeal 'across the range to everyone in the UK'. In this way we can see how the pressures of escalation up the channel hierarchy also exert generic forces and that caught in this interplay between the production team, the BBC and the need to draw in ever wider audiences, is the need to alter sexual narrative tactically. In some ways it is positive that the production team were able to continue themes of sexuality and sexual identity into the BBC1 version of the show, and perhaps represent a more emotional

BBC3

Aim: 'BBC Three is a mixed genre channel for young audiences.

We have three key priorities:

- The channel needs to be disciplined about focusing on the young - its centre of gravity will be 16–34 year-olds: people who are young in spirit and mindset.
- BBC Three is 'Never Afraid to Try new Stuff' and that's why we will continue to innovate with breakthrough comedy, stand-out entertainment, brave documentary and intelligent factual formats. Our content needs to have potential to innovate across platforms.
- BBC Three should provide an environment for the development of new ideas and talent and for existing talent to take risks, becoming a genuine laboratory for BBC One and BBC Two.'

Source: http://www.bbc.co.uk/commissioning/tv/what-we-want/service-strategies/bbc-three.shtml – accessed 12 September 2011

BBC2

Aim: 'BBC TWO is a mainstream channel. Distinguished by a spirit of bold creativity as its defining characteristic and armed with curiosity and wit, we are here to provide stimulating television to a broad but demanding audience.'

Source: http://www.bbc.co.uk/commissioning/tv/what-we-want/service-strategies/bbc-two.shtml – accessed 12 September 2011

BBC1

Aim: BBC One is about aiming for the very best in production values, story telling and talent in all genres. We want a rich-mix of programmes with scale and ambition that will appeal across the range to everyone in the UK.

Source: http://www.bbc.co.uk/commissioning/tv/what-we-want/service-strategies/bbc-one.shtml – accessed 12 September 2011

element to alternative sexualities and sexual identity. Indeed the show was reported by the media as a surprise success for BBC1.[23] However, it seems the more radical and challenging ideas of fluid sexuality had to be sacrificed for this move. In this way we can say that whilst alternative sexuality at the beginning of *Torchwood*'s televisual life may have been a way to draw in niche groups from an already tightly defined digital audience, in the short life of groundbreaking fluid sexual representation it has already become

a TV commodity, disposable for the opportunity of top channel ratings.

At the same time that the series moved along the channel ranks, the series also started to be labelled as 'cult' TV. In the next part I will consider further the commodification of fluid sexual representation and how it might interrelate with *Torchwood*'s development (or eventual classification) as 'cult' TV. I will examine the idea of *Torchwood* as a 'cult' text from my research participants' point of view, the media's use of the term and in terms of narrative features and ask how the series' shifting generic make-up including sexual representation is interrelated to its 'cult' status.

Torchwood as cult and culting *Torchwood*

A key challenge for academics such as Le Guern[24] and Jancovich and Hunt[25] who have addressed what makes a TV series cult, has been attributing who endows a text with 'cult' status and what the process entails. The origin of the word – 'cult' – has religious or faith-oriented connotations. This ties into the idea of fans of cult-shows such as *Nighty Night* or *Star Trek* which spawn dressing up parties and recounting of particular lines amongst fan groups. It is difficult not to make comparisons of ritual between those kinds of activities and for example attending mass where particular religious sets of words are spoken again and again. But, as Le Guern[26] notes in his essay on the topic, this would be to oversimplify the cultural process and its antecedents that work together to help construct the term as it is used in everyday life. Both Le Guern[27] and Jancovich and Hunt[28] note that as well as the activity of fans or consumers of cult texts including shared knowledge or fetishisation of elements of the text which can be seen as contributing to its 'cult' status, TV or film is often allocated this status by the media. This certainly seems to be the case in relation to *Torchwood*. The series is now referred to as 'cult' as a matter of course by the media when reviewing or discussing latest news around it.[29] In this way, then, whilst elements of the series might have come together to help it gain 'cult' status in the media, the idea of the series as 'cult' is also fuelled by the media. Teasing out what comes first in this process of cultural reproduction is probably almost impossible. However, we can say that there are

elements of a TV show relating to narrative and consumption prac-
tice which seem to contribute to its likelihood to be assigned the
rather ephemeral label of 'cult'. Certainly some of the fan practices
inspired by *Torchwood*, such as the creation of the Ianto memo-
rial near the Millenium Centre in Cardiff, would suggest that it has
become 'cultish' with fans. It is also discussed extensively online
alongside its parent show *Doctor Who*, a show with a long 'cult'
history. However, other academics suggest that there are generic
features which can help to identify whether a TV series or film is cult
and I these are clearly applicable in relation to *Torchwood*.

Textual cultism

Umberto Eco posits that a cult movie text is made so by its inclusion
of generic elements of just about every other film.[30] He does so by
analysing *Casablanca* and highlighting from this review the 'arche-
types' present across the film which mirror many other genres. If we
pursue his argument, *Torchwood* seems to follow his definition. As
highlighted, it contains an array of TV texts within its own diegesis
including hospital drama, soap, crime thriller, science fiction and
comedy. Indeed, arguably notions of the 'cult' can be seen in some
of the ways that my participants conceived of the series.

> Group 3 – Rich: Yeah it would make me think of a comic book...
>
> Graeme: Yeah.
>
> Rich: ... to me, it just goes bang, bang, bang.
>
> Sally: That one scene and maybe because he's obviously the Spike
> character from Buffy ...
>
> Greg: Yeah.
>
> Graeme: Oh yeah.
>
> Mandy: Oh, was it?
>
> Sally: ... that scene was exactly from Buffy, when he and Buffy
> and, you know, do the fighting, that sort of reminded me of it.

Here, then, participants highlight the 'comic book'-like nature of
the series. This, I want to suggest, is an important comparison;
comic books are well known for their 'cult' status. Many comics we
think of from *Beano* to *Silver Surfer* to *2000AD* have variously been

classified as cult. Moreover, my participants go on to talk about the way the show interrelates with other science fiction and indeed 'cult' texts including *Buffy the Vampire Slayer*. In this way, then, whilst none of my participants defined *Torchwood* as a 'cult' series, they did recognise the references made to other cult series such as *Buffy* through the inclusion of James Marsters in the series and even read some of the scenes as a further inference to the series. In terms of genre, then, earlier I noted how there are self-conscious elements of the text which reference science fiction series helping to appeal to relevant audiences. This inclusion of references is also to TV texts which have been variously labelled as 'cult'. My participants also noted other elements of the text which made it 'stand out' for them and I want to think about this next in relation to 'cult'.

When the absurd becomes cult

Jancovich and Hunt[31] assert that one of the ways a TV text becomes cult is the process of opposition to the mainstream.[32] *Torchwood* can also be said to fit into this definition in some ways through its original positioning as a BBC3 programme. Here, as mentioned earlier, the series was able to be promoted as 'innovative' and go against the grain of its parent show *Doctor Who* through the use of violence, gore and alternative sexuality. Indeed some of my respondents highlighted that they found the foregrounding of sexuality and its 'playfulness' as being unusual and for some that meant that the text wasn't very palatable:

Group 3 – CH: Okay. Alright, so some people haven't really watched much of it or Sally hasn't watched it at all, so how would you describe it?

Sally: The sexual references were almost farcical, there were just so many and so just ridiculous (laughter) that it was hard to take them seriously.

CH: Okay.

Sally: And he just came across – I don't know what the character is normally like – but what his sexual preference was almost irrelevant, he hit on three people in one show... it was just like kind of it just seemed kind of farcical.

In this way then, for some participants the sexuality of the show and some of the 'farce' in the series lowered the quality of the text. These readings of the episode were in the minority but they do fit with some of the media's assessments of the series, including the self-proclaimed media expert Charlie Brooker's review of the series which also positions the sexuality of *Torchwood* as containing 'thundering absurdities'.[33] Whilst one reading of this is that the series does not tackle sexuality in a more serious way, another is that this is an unusual and therefore distinctive approach to the portrayal of these issues. This also feeds into Le Guern's ideas of what cult is, specifically his suggestion that one element that contributes to making a text cult is the way consumers read it:

> This consists not of mistaking 'operetta for great music', to borrow a phrase from Pierre Bourdieu, but of finding interest and value in the material that critics and good 'taste' have left by the wayside: defects become qualities, kitsch becomes a stylistic perfect, and stereotypes become a makers mark[34].

The rather outlandish approach to sexuality highlighted by constant innuendoes (and even references to sex with poodles!) immediately marks the programme as unusual and, as some of the comments by my respondents suggest, off-putting to some. However, as Le Guern[35] also notes, what can be seen as 'low quality' or farcical to some can be read by others as interesting. As its growing audience ratings demonstrate, *Torchwood* was able to build from an unusual innovative series on BBC3 towards a successful 'mainstream' series on BBC1. In this way, a combination of positioning of the show on a youth-oriented channel, the use of 'cult' tropes including references to other cult series, cult science fiction *mise en scène* and the inclusion of what for some was 'outlandish' fluid sexuality all go together to at least give the text 'cult' markers.

The 'cult' of 'cult'

Whilst it is hard to situate the point at which a text becomes 'cult', we can say that 'cult' status seems to be achieved through viewers fetishising texts which are not necessarily intended to be 'cult'. However, a more self-conscious approach to the creation of this text

in relation to the 'cult' of 'cult' seems to exist. Placing within the text narrative references to other shows which have been labelled as 'cult' is one part of this. Indeed before the series went on air, Russell T. Davies himself was reported to have declared aims to make the series 'cult' and referenced *The X-Files* and *This Life*, two other series often referred to as cult, as part of his ambitions.[36] He later denied this assertion.[37] Of course the nature of 'cult' means that what might be an attempt to create cult through the inclusion of radical fluid sexuality could also be read by many as simply awkward TV. In that sense, cult still relies on the audience for its status. Nevertheless, arguably fluid sexuality is one element of what has helped *Torchwood* become 'cult' in its original BBC3 and BBC2 positions, in that sense, to borrow from Bourdieu,[38] adding to its 'cult' 'capital'. As Thornton notes regarding the possibilities of Bourdieu's capital, Bourdieu suggests there can be subcategories of capital.[39] 'Cult capital' can in the same way as Thornton's 'sub-cultural capital' 'confer status on its owner in the eyes of the... beholder'.[40] In this case, it helped *Torchwood* progress from BBC3 to BBC1 and, even against the tide of the economic crisis and cuts to programme making, it is at least part of what has helped it survive into season four, albeit with additional funding from US company Starz. In this way, fluid sexuality in *Torchwood* can be seen as part of its 'cult capital', and through its adaptation to more conventional tropes of sexual identity in the later two seasons, it has already been commodified as such.

Conclusion

I have argued that *Torchwood* is a stand-out text in relation to innovative sexual representation in TV science fiction. Moreover the mixing of genres with more everyday themes through its regional base, hospital drama and soapy elements also challenges ideas that its radical sexual representations are only 'out of this world'. In the dialectics of genre, where crime meets soap meets science fiction, new possibilities of fluid sexual representation emerged, at least in the show's early seasons. I noted that the genre of the series and its sexual representation shifted as it moved from BBC3 up the channel hierarchy to its latest position on BBC1. It seems that fluid sexual

representation has been caught up in the changing generic matrix necessary for niche to 'mainstream' channel hopping. In the bigger picture of the history of sexual representation on TV, *Torchwood* has taken us firmly into what Davis and Needham[41] have termed the world of 'post gay' representation, only to retreat backwards as it moved 'mainstream'. Potentially this is just a kink in the pluralisation of sexual representation away from the proliferation of 'identity' related stories; a step back after two steps forward.

There are elements of *Torchwood*'s narrative which imply that there is a self-conscious effort by those involved in making the series to make it part of the 'cult' of 'cult'. In the end it is (or should be) the consumers and fans of the series that endow a show with 'cult' status and I have argued it is some of the unusual features in relation to sexuality that helped *Torchwood* to stand out and begin to be seen as 'cult'. I have suggested that fluid sexual representation could be seen as 'cult capital' for the makers of *Torchwood*. This relationship between cult and sexuality begs wider questions about the construction of 'cult' TV and sexual representation. Where else in the history of the construction of 'cult' TV could we see connections between cult status and innovative sexual representation? For example, how, if at all, is Willow's coming-out story implicated in the continued labelling of *Buffy the Vampire Slayer* as cult? In what ways could the 'fluid sexual' storylines of Channel 4's teen dramas *Skins* and *Misfits* be connected to their fast-growing cult statuses? Whilst there is a growing body of research about the development of 'cult' TV, the relations explored here suggest that the role of sexuality in 'cult' TV is an area which seems ripe for further consideration.

Notes

1. Annette Kuhn, *Alien Zone: Cultural Theory and Contemporary Science Fiction Film* (London and New York, 1990).
2. Wendy Pearson, 'Science Fiction and Queer Theory', in E. James and F. Mendlesohn (eds), *The Cambridge Companion to Science Fiction* (Cambridge, 2003), pp. 149–62.
3. James D. Riemer, 'Homosexuality in Science Fiction and Fantasy', in D. Palumbo (ed), *Erotic Universe: Sexuality and Fantastic Literature* (Westport, CT, 1986), pp. 145–61.
4. I only focus on part of my research here which centres on the relationships between sexual representation, genre and cult TV.

5. Each group consisted of between four and six people. The groups were recruited through snowballing methodology and advertising in online forums. The groups were not chosen to be 'representative' but it was hoped that participants from different backgrounds could be included to offer a range of voices in the research. The focus groups lasted for one hour 45 minutes which included a screening of episode one of season two 'Kiss Kiss Bang Bang'.

6. All the respondents taking part in the research have been made anonymous; all names referred to in this chapter are pseudonyms.

7. John Corner, *Studying Media* (Edinburgh, 1998).

8. No author, 'Torchwood Creator Russell T Davies Says The Doctor Who Spin-Off Could Return', *The Mirror*, 18 August 2009. Online. Available http://www.mirror.co.uk/celebs/news/2009/08/18/torchwood-creator-hints-at-fourth-series-115875-21605886/ (11 September 2011).

9. Michael Deacon. '*Torchwood:* Late Night Doctor Makes Timely Return', *The Telegraph*, 12 January 2008. Online. Available http://www.telegraph.co.uk/culture/tvandradio/3670443/Torchwood-Late-night-Doctor-makes-timely-return.html (11 September 2011).

10. Dan Martin, 'The Spin-Off Doctor', *The Guardian*, 21 October 2006. Online. Available http://www.guardian.co.uk/media/2006/oct/21/tvandradio.theguide (11 September 2011).

11. Cult Hub, 'Torchwood – Miracle Day Preview'. *Cult Hub*, 11 July 2011. Online. Available http://www.culthub.com/torchwood-miracle-day-preview/2110/ (13 September 2011).

12. Vivian Sobchack, 'The Virginity of Astronauts: Sex and the Science Fiction Film', in A. Kuhn (ed), *Alien Zone: Cultural Theory and Contemporary Science Fiction* (London, 1990).

13. Glyn Davis and Gary Needham, *Queer TV: Theories, Histories, Politics* (London and New York, 2009).

14. Lisa Parks, 'Brave New Buffy: Rethinking TV Violence', in M. Jancovich and J. Lyons (eds), *Quality Popular Television: Cult TV, the Industry and Fans* (London, 2003).

15. Jane Feuer, 'Genre Study and Television', in R. Allen (ed), *Channels of Discourse, Reassembled* (Chapel Hill and London, 1992), pp. 138–60.

16. Andrew Ireland, 'Playing to the Crowd: Torchwood Knows We're Watching', in A. Ireland (ed), *Illuminating Torchwood: Essays on Narrative, Character and Sexuality in the BBC Series* (Jefferson, NC, 2010).

17. Ireland: 'Playing to the crowd'.

18. Ibid.

19. Davis and Needham: *Queer TV.*

20. Did Herman, '"I'm Gay": Declarations, Desire, and Coming Out on Prime-Time Television', *Sexualities* 8/1 (2005), pp. 7–29.

21. See Davis and Needham: *Queer TV.*

22. The notion of the 'post-gay' period was suggested by Alan Sinfield (*Gay and After*, London, 1998) and is characterised by a shift away from identity politics towards a more taken-for-granted approach. Davis and Needham in *Queer TV* have adapted this idea in their consideration of UK queer TV.

23. Christian Cawley, 'Torchwood Surprise', *Kasterborous*, 28 July 2010. Online. Available http://www.kasterborous.com/2010/07/torchwood-surprise/ (13 September 2011).
24. Phillipe Le Guern, 'Toward a Constructivist Approach to Media Cults', in S. Gwenllian-Jones and R. Pearson (eds), *Cult Television* (London and Minneapolis, 2004).
25. Mark Jancovich and Nathan Hunt, 'The Mainstream, Distinction and Cult TV', in S. Gwenillian-Jones and R. Pearson (eds), *Cult Television*, (London and Minneapolis, 2004).
26. Le Guern: 'Toward a Constructivist Approach to Media Cults', pp. 3–26.
27. Ibid.
28. Jancovich and Hunt: 'The Mainstream, Distinction and Cult TV', pp. 27–44.
29. See Cult Hub: 'Torchwood – Miracle Day Preview'. See also Ben Rawson-Jones, 'Cult spy icon: Ianto Jones (Torchwood)', *Digital Spy*, 13 January 2008. Online. Available http://www.digitalspy.co.uk/tv/s8/torchwood/news/a84205/cult-spy-icon-ianto-jones-torchwood.html (13 September 2011); and Levi Neuland, 'Torchwood – Immortal Sins', *We Love Cult*, No date. Online. Available http://www.welovecult.com/2011/review/torchwood-immortal-sins/ (13 September 2011).
30. Umberto Eco, '"Casablanca": Cult Movies and Intertextual Collage', *Substance*, 14/2 (1985), pp. 3–12.
31. Jancovich and Hunt: 'The Mainstream, Distinction and Cult TV', pp. 27–44.
32. A term which is also problematic and slippery, as highlighted by Jancovich and Hunt, but for the time being here I use the term to refer to the way fans of cult and the media position a text against popular shows which might be seen as less innovative or do not inspire 'cultish' fan reaction.
33. Charlie Brooker, 'Charlie Brooker's Screen Burn', *The Guardian*, 28 October 2006. Online. Available http://www.guardian.co.uk/media/2006/oct/28/tvandradio.broadcasting (4 July 2011).
34. Le Guern, 'Toward a Constructivist Approach to Media Cults', p. 10.
35. Ibid., pp. 3–26.
36. Hugh Davies, 'Dr Who Goes in Search of Sex in Cardiff', *The Telegraph*, 18 October 2005. Online. Available http://www.telegraph.co.uk/news/uknews/1500882/Dr-Who-goes-in-search-of-sex-in-Cardiff.html (12 September 2011).
37. No author, 'Russell T. Davies Talks *Torchwood*'. *Radio Times*. Online. Available http://live.radiotimes.com/content/show-features/torchwood/russell-t-davies-talks-torchwood/ (12 September 2011).
38. Pierre Bourdieu, 'The Forms Of Capital', in N. W. Biggart (ed), *Readings in Economic Sociology* (Oxford, 1986).
39. See Sarah Thornton, *Club Cultures: Music, Media and Subcultural Capital* (Cambridge, 1995).
40. Thornton: *Club Cultures*, p 11.
41. Davis and Needham: *Queer TV*.

SELECT BIBLIOGRAPHY

Abbott, Stacey (ed). *The Cult TV Book* (London: I.B. Tauris, 2010).

Briggs, Asa. *The History of Broadcasting in the United Kingdom* (Oxford: Oxford University Press, 1995).

Barron, Lee. 'Out in Space: Masculinity, Sexuality, and the Science Fiction Heroics Of Captain Jack', in Andrew Ireland (ed) *Illuminating Torchwood: Essays on Narrative, Character and Sexuality in the BBC Series* (Jefferson, North Carolina: McFarland, 2010).

———. 'Invaders from Space, Time Travel and Omnisexuality', in Tobias Hochscherf and James Leggott (eds) *British Science Fiction Film and Television: Critical Essays* (Jefferson, North Carolina: McFarland, 2011).

Barrowman, John and Carol E. Barrowman. *Anything Goes* (London: Michael O'Mara Books, 2008).

Barrowman, John with Carole E. Barrowman. *I Am What I Am* (London: Michael O'Mara Books, 2009).

Battis, Jes. 'Transgressive TV', in Stacey Abbott (ed) *The Cult TV Book* (London: I.B.Tauris, 2010).

Battles, Kathleen and Wendy Hilton-Morrow. 'Gay Characters in Conventional Spaces: *Will and Grace* and the Situation Comedy Genre', *Critical Studies in Media Communication* 19/1 (2002), pp. 87–105.

Becker, Christine. 'From High Culture to Hip Culture: The Transformation of the BBC into BBC America', in Mark Hampton and Joel Wiener (eds) *Anglo-American Media Interactions, 1850–2000* (New York: Palgrave Macmillan, 2007).

Bennett, James. *Television Personalities: Stardom and the Small Screen* (London: Routledge, 2010).

Bennett, James and Su Holmes, 'The "Place" of Television in Celebrity Studies', *Celebrity Studies* 1/1 (2010), pp. 65–80.

Berger, Richard. 'Screwing Aliens and Screwing with Aliens', in Andrew Ireland (ed) *Illuminating Torchwood: Essays on Narrative, Character and Sexuality in the BBC Series* (Jefferson: McFarland, 2010).

Bignell, Jonathan. *An Introduction to Television Studies* (Routledge: London, 2004).

Bird, S. Elizabeth. *The Audience in Everyday Life: Living in a Media World* (London: Routledge, 2003).

Blake, Linnie.'"You Guys and Your Cute Little Categories": *Torchwood*, The Space-Time Rift and Cardiff's Postmodern, Postcolonial and (Avowedly) Pansexual Gothic', *The Irish Journal of Gothic and Horror Studies* 9 (2009). Available at http://irishgothichorrorjournal.homestead.co./Torchwood. html (4 October 2011).

Blandford, Steve, Stephen Lacey, Ruth McElroy and Rebecca Williams. *Screening the Nation: Landmark Television in Wales*, BBC Trust and Audience Council Wales (2010). Online. Available http://culture.research.glam. ac.uk/news/en/2010/mar/15/screening-nation-wales-and-landmark-television-rep

Bonner, Frances. *Ordinary Television* (London: Sage, 2003).

Botting, Fred. *Limits of Horror: Technology, Bodies, Gothic* (Manchester and New York: Manchester University Press, 2008).

———. *Gothic Romanced: Consumption, Gender and Technology in Contemporary Fictions* (New York: Taylor and Francis, 2008).

Britton, Piers D. *TARDISbound: Navigating the Universes of Doctor Who* (London: I.B.Tauris, 2011).

Butler, David (ed). *Time and Relative Dissertations in Space: Critical Perspectives on Doctor Who* (Manchester: Manchester University Press, 2007).

Chapman, James. 'Not "Another Bloody Cop Show": *Life on Mars* and British Television Drama', *Film International* 7/2 (2009), pp. 6–19.

Clarke, M.J. 'The Strict Maze of Media Tie-In Novels', *Communication, Culture and Critique* 2 (2009), pp. 434–56.

Cooke, Lez. *British Television Drama: A History* (London: BFI, 2003).

Corner, John. *Studying Media* (Edinburgh: Edinburgh University Press, 1998).

Creeber, Glen. *Serial Television: Big Drama on the Small Screen* (London: BFI, 2004).

Daunton, Martin J. *Coal Metropolis: Cardiff 1870–1914* (Leicester: University of Leicester, 1977).

Davies, Russell T., with Benjamin Cook. *Doctor Who, A Writer's Tale: The Final Chapter: The Definitive Story of the BBC Series* (London: BBC Books, 2010).

Davis, Glyn and Gary Needham. *Queer TV: Theories, Histories, Politics* (London and New York: Routledge, 2009).

Debrett, Mary. *Reinventing Public Service Television for the Digital Future* (Bristol: Intellect, 2010).

DeSanto, Barbara and Jo Petherbridge. 'BBC America: How Britain Won the Colonies Back', in Danny Moses, Melanie Powell and Barbara DeSanto (eds) *Public Relations Cases: International Perspectives* (London: Routledge, 2002).

Donnelly, Kevin J. 'Between Prosaic Functionalism and Sublime Experimentalism: Doctor Who and Musical Sound Design', in David Butler (ed) *Time and Relative Dissertations in Space* (Manchester: Manchester University Press, 2007).

Dyer, Richard. *Stars Second revised edition* (London: Routledge, 1998).

Eco, Umberto. '*Casablanca*: Cult Movies and Intertextual Collage', in Ernest Mathijs and Xavier Mendik (eds) *The Cult Film Reader* (Maidenhead: Open University Press, 2008).

Ellis, John. *Visible Fictions: Cinema, Television, Video* (London: Routledge, 1992).

Espenson, Jane. 'Playing Hard to "Get" – How to Write Cult TV', in Stacey Abbott (ed) *The Cult TV Book* (London and New York: I.B.Tauris, 2010).

Evans, Elizabeth. *Transmedia Television: Audiences, New Media and Daily Life* (London and New York: Routledge, 2011).

Ferris, Kerry O. 'The Next Big Thing: Local Celebrity', *Sociology* 47 (2010), pp. 392–95.

Feuer, Jane. 'Genre Study and Television', in Robert Allen (ed) *Channels of Discourse, Reassembled* (Chapel Hill and London: University of Carolina Press, 1992).

Garner, Ross P., Melissa Beattie and Una McCormack (ed). *Impossible Worlds, Impossible Things: Cultural Perspectives on "Doctor Who", "Torchwood" and the "Sarah Jane Adventures"* (Cambridge: Cambridge Scholars Press, 2010).

Gray, Jonathan. *Television Entertainment* (New York and Abingdon: Routledge, 2008).

———. *Show Sold Separately: Promos, Spoilers, and Other Media Paratexts* (New York and London: New York University Press, 2010).

Gray, Jonathan, Cornel Sandvoss and C. Lee Harrington (eds) *Fandom* (New York: New York University Press, 2007).

Griffin, Jeffrey. 'The Americanization of *The Office*: A Comparison of the Offbeat NBC Sitcom and Its British Predecessor', *Journal of Popular Film and Television* 35/4 (2008), pp. 154–63.

Grant, Peter S. and Chris Wood. *Blockbusters and Trade Wars: Popular Culture in a Globalised World* (Vancouver: Douglas and McIntyre, 2004).

Gwenllian-Jones, Sara. 'Starring Lucy Lawless?', *Continuum: Journal of Media and Cultural Studies* 14/1 (2000), pp. 9–22.

———. 'The Sex Lives of Cult Television Characters', *Screen*, 43/1 (2002), pp. 79–90.

Gwenllian-Jones, Sara and Roberta E. Pearson. 'Introduction', in Sara Gwenllian-Jones and Roberta E. Pearson (eds) *Cult Television* (Minneapolis: University of Minnesota Press, 2004).

Hardy, Jonathan. 'Mapping Commercial Intertextuality: HBO's *True Blood*', *Convergence: The International Journal of Research into New Media Technologies* 17/1 (2011), pp. 7–17.

Harrington, C. Lee and Denise Bielby. *Soap Fans: Pursuing Pleasure and Making Meaning in Everyday Life* (Philadelphia, PA: Temple University Press, 1995).

Hills, Matt. *Fan Cultures* (London: Routledge, 2002).

———. 'Recognition in the Eyes of the Relevant Beholder: Representing "Subcultural Celebrity" and Cult TV Fans', *Mediactive* 2 (2003), pp. 59–73.

———. 'Defining Cult TV: Texts, Inter-texts and Fan Audiences', in Robert C. Allen and Annette Hill (eds), *The Television Studies Reader* (London: Routledge, 2004).

———. *The Pleasures of Horror* (London and New York: Continuum, 2005).

———. '*Doctor Who* Discovers … Cardiff: Investigating Trans-Generational Audiences and Trans-National Fans of the BBC Wales Production', *Cyfrwng: Media Wales Journal* 3 (2006), pp. 56–74.

————. 'Televisuality Without Television? The Big Finish Audios and Discourses of "Tele-Centric" *Doctor Who*', in David Butler (ed) *Time and Relative Dissertations in Space* (Manchester: Manchester University Press, 2007).

————.*Triumph of a Time Lord: Regenerating Doctor Who in the Twenty-First Century* (London and New York: I.B. Tauris, 2010).

————. 'Mainstream Cult', in Stacey Abbott (ed) *The Cult TV Book* (London and New York: I.B.Tauris, 2010).

————. 'Subcultural Celebrity', in Stacey Abbott (ed) *The Cult TV Book* (London and New York: I.B.Tauris, 2010).

————. 'Doctor Who', in David Lavery (ed) *Essential Cult Television Reader* (Kentucky: University Press of Kentucky, 2010).

————. 'Torchwood', in David Lavery (ed) *Essential Cult Television Reader* (Kentucky: University Press of Kentucky, 2010).

————. 'Listening from Behind the Sofa?: The (Un)Earthly Use of Sound in BBC Wales *Doctor Who*', *New Review of Film and Television Studies* 9/1 (2011), pp. 28–41.

Hills, Matt, and Rebecca Williams. '"It's All my Interpretation": Reading Spike Through the "Subcultural Celebrity" of James Marsters', *European Journal of Cultural Studies* 8/3 (2005), pp. 345–65.

Hilmes, Michele. *Network Nations: A Transnational History of American and British Broadcasting* (London: Taylor and Francis, 2011).

Holdsworth, Amy. *Television, Memory and Nostalgia* (Basingstoke: Palgrave Macmillan, 2011).

Hollows, Joanne. 'The Masculinity of Cult', in Mark Jancovich, Antonio Lázaro Reboll, Julian Stringer and Andy Willis (eds) *Defining Cult Movies: The Cultural Politics of Oppositional Taste* (Manchester: Manchester University Press, 2003).

Ireland, Andrew (ed). *Illuminating Torchwood: Essays on Narrative, Character and Sexuality in the BBC Series* (Jefferson, North Carolina: McFarland, 2010).

————. 'Playing to the Crowd: Torchwood Knows We're Watching', in A. Ireland (ed) *Illuminating Torchwood: Essays on Narrative, Character and Sexuality in the BBC Series* (Jefferson, North Carolina: McFarland, 2010).

Jancovich, Mark. 'A Real Shocker', in Graeme Turner (ed) *The Film Cultures Reader* (London: Routledge, 2001).

Jancovich, Mark and Nathan Hunt. 'The Mainstream, Distinction, and Cult TV', in Sara Gwenllian-Jones and Roberta E. Pearson (eds) *Cult Television* (Minneapolis: University of Minnesota Press, 2004).

Jaramillo, Deborah. 'The Family Racket: AOL Time Warner, HBO, The Sopranos, and the Construction of a Quality Brand', *Journal of Communication Inquiry* 26/4 (2002), pp. 59–75.

Jenkins, Henry. '"Strangers No More, We Sing": Filking and the Social Construction of the Science Fiction Fan Community', in Lisa A. Lewis (ed) *The Adoring Audience: Fan Culture and Popular Media* (London: Routledge, 1992).

————. 'Interactive Audiences?', in Virginia Nightingale and Karen Ross (eds) *Critical Readings: Media and Audiences* (Maidenhead: Open University Press, 2003).

————. *Convergence Culture: Where Old and New Media Collide* (New York and London: New York University Press, 2006).

Jenkins, Henry and John Tulloch. *Science Fiction Audiences: Watching Doctor Who and Star Trek* (London: Routledge, 1995).

Jenkins, Tricia.'(Re)Writing *Alias*: An Examination of the Series' Fan Fiction and Media Tie-Ins', in Stacey Abbott and Simon Brown (eds) *Investigating Alias: Secrets and Spies* (London and New York: I.B.Tauris, 2007).

Johnson, Catherine. *Telefantasy* (London: BFI, 2005).

————. 'Tele-Branding in TVIII: The Network as Brand and the Programme as Brand', *New Review of Film and Television Studies* 5/1 (2007), pp. 5–24.

————. 'Cult TV and the Television Industry', in Stacey Abbott (ed) *The Cult TV Book* (London and New York: I.B.Tauris, 2010).

————. *Branding Television* (Abingdon and New York: Routledge, 2012).

Jowett, Lorna and Stacey Abbott. *TV Horror: Investigating the Dark Side of the Small Screen* (London: I.B.Tauris, 2013).

Kaverny, Roz. 'Gen. Slash, OT3s, and Crossover – The Varieties of Fan Fiction', in Stacey Abbott (ed) *The Cult TV Book* (London and New York: I.B.Tauris, 2010).

Krämer, Peter. *The New Hollywood: From Bonnie and Clyde to Star Wars* (Wallflower: London, 2005).

Kuhn, Annette. *Alien Zone: Cultural Theory and Contemporary Science Fiction Film* (London and New York: Verso, 1990).

Langer, John. 'TV's Personality System', *Media, Culture and Society* 3/4 (1981), pp. 351–65.

Lavery, David. 'Introduction: The Semiotics of Cobbler *Twin Peaks*' Interpretive Community', in David Lavery (ed) *Full of Secrets: Critical Approaches to Twin Peaks*, (Detroit: Wayne State University Press, 1995).

————. 'Introduction' in David Lavery (ed) *The Essential Cult TV Reader* (Lexington: The University of Kentucky Press, 2010).

Le Guern, Phillipe. 'Toward a Constructivist Approach to Media Cults' in Sara Gwenllian-Jones and Roberta E. Pearson (eds) *Cult Television* (Minneapolis: University of Minnesota Press, 2004).

Longhurst, Brian. *Cultural Change and Ordinary Life* (Buckingham: McGraw Hill, 2007).

Lury, Karen. *Interpreting Television* (London: Hodder Arnold, 2005).

Kristeva, Julia. *Powers of Horror: An Essay on Abjection*, trans. Leon S. Roudiez (New York: Columbia University Press, 1982).

MacDonald, Andrea. 'Uncertain Utopia: Science Fiction Media Fandom and Computer Mediated Communication', in Cheryl Harris and A. Alexander (eds) *Theorizing Fandom* (New York: Hampton Press, 1998).

Magr, Paul. 'My Adventures', in David Butler (ed) *Time and Relative Dissertations in Space* (Manchester: Manchester University Press, 2007).

McElroy, Ruth. '"Putting the Landmark Back into Television": Producing Place and Cultural Value in Cardiff', *Place-Branding and Public Diplomacy* 7/3 (2011), pp. 175–84.

McElroy, Ruth and Rebecca Williams. 'Remembering Ourselves, Viewing the Others: Historical Reality Television and Celebrity in the Small Nation', *Television and New Media* 12/3 (2011), pp. 187–206.

Messenger Davies, Máire. *Dear BBC: Children, Television Storytelling and the Public Sphere* (Cambridge: Cambridge University Press, 2001).

Miller, Jeffrey. *Something Completely Different: British Television and American Culture* (London: University of Minnesota Press, 2000).

Mills, Brett. 'My House Was on *Torchwood*! Media, Place and Identity', *International Journal of Cultural Studies* 11/4 (2008) pp. 379–99.

Mittell, Jason. 'Narrative Complexity in Contemporary American Television', *The Velvet Light Trap* 58/Fall (2006), pp. 29–40.

Moran, Albert. 'Introduction: "Descent and Modification"', in Albert Moran (ed) *TV Formats Worldwide: Localizing Global Programs* (Bristol: Intellect, 2009).

Morse, Margaret. *Virtualities: Television, Media Art, and Cyberculture* (Indiana: Indiana University Press, 1998).

Murray, Susan. 'Selling TV Formats', in Douglas Gomery and Luke Hockley (eds) *Television Industries* (London: BFI, 2006).

Ndalianis, Angela. 'Television and the Neo-Baroque', in Lucy Mazdon and Michael Hammond (eds) *The Contemporary Television Series* (Edinburgh: Edinburgh University Press, 2005).

Nelson, Robin. *State of Play: Contemporary "High End" TV Drama* (Manchester: Manchester University Press, 2007).

Newman, Kim. *BFI TV Classics: Doctor Who: A Critical Reading of the Series* (London: BFI, 2005).

Parkin, Lance. 'Canonicity Matters: Defining the Doctor Who Canon', in David Butler (ed) *Time and Relative Dissertations in Space* (Manchester: Manchester University Press, 2007).

Parks, Lisa. 'Brave New Buffy: Rethinking TV Violence', in Mark Jancovich and Joanne Lyons (eds) *Quality Popular Television: Cult TV, the Industry and Fans* (London: British Film Institute, 2003).

Parsons, Paul. *The Science of Doctor Who* (Baltimore: Johns Hopkins University Press, 2010).

Pearson, Robert. Bright Particular Star: Patrick Stewart, Jean-Luc Picard, and Cult Television', in Sara Gwenllian-Jones and Roberta E. Pearson (eds) *Cult Television* (Minneapolis: University of Minnesota Press, 2004).

Pearson, Roberta. 'Observations on Cult Television', in Stacey Abbott (ed) *The Cult TV Book* (London and New York: I.B.Tauris, 2010).

Pearson, Wendy. 'Science Fiction and Queer Theory', in Edward James and Farah Mendlesohn (eds) *The Cambridge Companion to Science Fiction* (Cambridge: Cambridge University Press, 2003).

Perryman, Neil. 'Doctor Who and the Convergence of Media: A Case Study in "Transmedia Storytelling"', *Convergence: The International Journal of Research into New Media Technologies* 14/1 (2008) pp. 21–39.

Petley, Julian. 'Public Service Broadcasting in the UK', in Douglas Gomery and Luke Hockley (eds) *Television Industries* (London: BFI, 2006).

Porter, Lynnette. *Tarnished Heroes, Charming Villains and Modern Monsters: Science Fiction in Shades of Gray on Twenty-first Century Television* (Jefferson and London: McFarland, 2010).

Rabkin, Eric S. 'Science Fiction and Future of Criticism'. *PMLA* 119 (2004), pp. 457–473.

Rawcliffe, Daniel J. 'Transgressive Torch Bearers: Who Carries the Confines of Gothic Aesthetics', in Andrew Ireland (ed) *Illuminating Torchwood: Essays on Narrative, Character and Sexuality in the BBC Series* (Jefferson, NC: McFarland & Company, Inc, 2010).

Reeves, Jimmie L., Mark C. Rodgers, and Michael Epstein. 'Rewriting Popularity: The Cult Files', in David Lavery, Angela Hague and Marla Cartwright (eds) *Deny All Knowledge: Reading the X-Files* (London: Faber and Faber, 1996).

Riemer, James D., 'Homosexuality in Science Fiction and Fantasy', in Donald Palumbo (ed) *Erotic Universe: Sexuality and Fantastic Literature* (Westport, CT: Greenwood, 1986).

Ross, Sharon M. *Beyond the Box* (Oxford: John Wiley, 2008).

San Martin, Nancy. '"Must See TV": Programming Identity on NBC Thursdays', in Mark Jancovich and James Lyons (eds) *Quality Popular Television: Cult TV, the Industry and Fans* (London: BFI, 2003).

Sinfield, Alan. *Gay and After* (London: Serpent's Tail, 1998).

Sobchack, Vivian. 'The Virginity of Astronauts: Sex and the Science Fiction Film', in Annette Kuhn (ed) *Alien Zone: Cultural Theory and Contemporary Science Fiction* (London: Verso, 1990).

Steemers, Jeanette. *Selling Television: British Television in the Global Marketplace* (London: BFI, 2004).

Strange, Nicki. 'Multiplatforming Public Service: The BBC's "Bundled Project"', in James Bennett and Niki Strange (eds) *Television as Digital Media* (Durham: Duke University Press, 2011).

Studlar, Gaylin. 'Midnight S/Excess: Cult Configurations of Femininity and the Perverse', in J.P. Telotte (ed) *The Cult Film Experience: Beyond All Reason* (Austin, Texas: The University of Texas Press, Austin, 1991).

Thornton, Sarah. *Club Cultures: Music, Media and Subcultural Capital* (Cambridge: Polity Press, 1995).

Turner, Graeme. *Understanding Celebrity* (London: Sage, 2004).

Walker, Stephen James. *Inside the Hub: The Unofficial and Unauthorised Guide to Torchwood Series One* (Tolworth: Telos Publishing, 2007).

———. *Something in the Darkness: The Unofficial and Unauthorised Guide to Torchwood Series Two* (Tolworth: Telos Publishing, 2008).

Wicke, Jennifer. 'Vampiric Typewriting: Dracula and Its Media', *ELH* 59/2 (1992), pp. 467–493.

Wilcox, Rhonda and David Lavery. *Fighting the Forces* (Maryland: Rowman and Littlefield, 2002).

Williams, Rebecca. 'Cannibals in the Brecon Beacons: *Torchwood*, Place and Television Horror', *Critical Studies in Television* 6/2 (2011), pp. 61–73.

Wolfe, Susan J. and Courtney Huse Wika. 'Policing the Rift: The Monstrous and the Uncanny', in Andrew Ireland (ed) *Illuminating Torchwood: Essays on Narrative, Character and Sexuality in the BBC Series* (Jefferson, NC: McFarland & Company, 2009).

Wood, Tat. 'Empire of the Senses: Narrative Form and Point-Of-View in *Doctor Who*', in David Butler (ed) *Time and Relative Dissertations in Space* (Manchester: Manchester University Press, 2007).

LIST OF TELEVISION SERIES & FILMS

Television Series

Absolutely Fabulous (BBC, 1992–2004)
All Star Family Fortunes (ITV, 2006–)
Angel (WB, 1999–2004)
Animals at Work (BBC, 2009–)
Any Dream Will Do (BBC, 2007)
Ashes to Ashes (BBC, 2008–2010)
Avengers, The (ITV, 1961–1966)
Bad Girls (ITV, 1999–2006)
Band of Brothers (HBO/BBC, 2001)
Battlestar Galactica (Sci-Fi, 2004–2010)
Beadle's About (ITV, 1986–1996)
Being Human (BBC, 2008–)
Blackpool (BBC, 2004)
Bones (Fox, 2005–)
Breaking Bad (AMC, 2008–)
Buffy the Vampire Slayer (WB, 1997–2001; UPN, 2001–2003)
Castaway (BBC, 2000–2001)
Changing Rooms (BBC, 1996–2004)
Children in Need (BBC, 1980–)
Coal House (BBC Wales, 2007)
Coupling (BBC, 2000–2004)
CSI: Crime Scene Investigation (CBS, 2000–)
CSI: Miami (CBS, 2002–2011)
CSI: New York (CBS, 2004–)
Curb Your Enthusiasm (HBO, 2000–)
Dancing on Ice (ITV, 2006–)
Dark Angel (FOX, 2000–2002)
Doctor Who (BBC, 1963–1989; 2005–)
Edge of Darkness (BBC, 1985)
Episodes (Showtime/BBC, 2011–)
Extras (BBC, 2005–2007)
Fades, The (BBC, 2011)
Fawlty Towers (BBC, 1975–1976)
Firefly (FOX, 2002)
Footballers' Wives (ITV, 2002–2006)
Game of Thrones (HBO, 2011–)
Gormenghast (BBC, 2000)
Graham Norton Show, The (BBC, 2007–)
Ground Force (BBC, 1997–2005)
Hamish MacBeth (BBC, 1995–1997)
Hex (Sky, 2004–2005)
House (FOX, 2004–2012)
How Do You Solve A Problem Like Maria? (BBC, 2006)
I'd Do Anything (BBC, 2008)
Inspector George Gently (BBC, 2007–)
Jekyll (BBC, 2007)
Larry Sanders Show, The (HBO, 1992–1998)
Law and Order (NBC, 1990–2010)
Law and Order: UK (ITV, 2009–)
League of Gentlemen, The (BBC, 1999–2002)

Life on Mars (BBC, 2006–2007)

Lost (ABC, 2004–2010)

Luther (BBC, 2010–)

Misfits (Channel 4, 2009–)

Monty Python's Flying Circus (BBC, 1969–1974)

Nighty Night (BBC, 2004–2005)

Office, The (BBC, 2001–2003)

The Office: An American Workplace (NBC, 2005–)

Primeval (ITV, 2007–)

Prisoner, The (ITV, 1967–1968)

Pushing Daisies (ABC, 2007–2009)

Robin Hood (BBC, 2006–2009)

Sarah Jane Adventures, The (BBC, 2006–2011)

Scream If You Know The Answer (Watch, 2010–)

Sex and the City (HBO, 1998–2004)

Sherlock (BBC, 2010–)

Simpsons, The (FOX, 1989–)

Skins (Channel 4, 2007–)

Smallville (WB, 2001–2006; CW, 2006–2011)

Sopranos, The (HBO, 1998–2004)

Spartacus: Blood and Sand (Starz, 2010)

Spooks (BBC, 2002–2011)

Star Trek (NBC, 1967–1969)

Strictly Come Dancing (BBC, 2004–)

Supernatural (WB/CW, 2005–)

Surprise Surprise (ITV, 1984–2001)

Teachers (Channel 4, 2001–2004)

This Life (BBC, 1996–1997)

Tipping the Velvet (BBC, 2002)

Tonight's the Night (BBC, 2009–)

Torchwood (BBC, 2006–2009; BBC/ Starz 2011–)

True Blood (HBO, 2008–)

The Vampire Diaries (CW, 2009–)

Viva Laughlin (CBS, 2007)

Walking with Dinosaurs (BBC/ Discovery Channel, 1999)

Weakest Link, The (BBC, 2000–2012)

Wild at Heart (ITV, 2006–)

Will and Grace (NBC, 1998–2006)

X-Files, The (FOX, 1993–2002)

Films

Almost Famous (Cameron Crowe, US, 2000)

Batman (Tim Burton, US, 1989)

Blade Runner (Ridley Scott, US, 1982)

Casablanca (Michael Curtiz, US, 1943)

Dark City (Alex Proyas, US/Australia, 1998)

Dr. Strangelove (Stanley Kubrick, US, 1964)

Independence Day (Roland Emmerich, US, 1996)

Quatermass and the Pit (Roy Ward Baker, UK, 1967)

Sophie's Choice (Alan J. Pakula, US, 1982)

Village of the Damned (Wolf Rilla, UK, 1960)

INDEX